Why
Won't
Going
Lunch
Anymore

# Why I Won't Be Going to Lunch Anymore

*21 Stories of the Santa Fe Painter's Life*

**By Douglas Atwill**

**S**UNSTONE
PRESS

**SANTA FE**

This book is a work of fiction. Names, characters, and incidents either are products of the author's imagination or are used fictitiously.

Sunstone books may be purchased for educational, business, or sales promotional use. For information please write: Special Markets Department, Sunstone Press, P.O. Box 2321, Santa Fe, New Mexico 87504-2321.

---

Library of Congress Cataloging-in-Publication Data:

Atwill, Douglas.
  Why I won't be going to lunch anymore: twenty-one stories of the Santa Fe painter's life / by Douglas Atwill.
    p. cm.
  Includes bibliographical references and index.
  ISBN: 0-86534-426-4 (hardcover)
1. Painters—New Mexico—Santa Fe—Biography. 2. Painting, American—New Mexico—Santa Fe—20th century. 3. Atwill, Douglas—Friends and associates.  I. Title
ND235.S3A78 2004
759. 189'56—dc22
                    2004000983

---

**Published in**

SUNSTONE PRESS
POST OFFICE BOX 2321
SANTA FE, NM 87504-2321 / USA
(505) 988-4418 / *ORDERS ONLY* (800) 243-5644
FAX (505) 988-1025
**WWW.SUNSTONEPRESS.COM**

**For Robert,**
**who made these stories happen.**

# CONTENTS

# Preface

It was an evening at Fiesta-time. Don't tell me which ones are artists, my sister-in-law said, let me guess. We took a close inventory of the room, an animated cocktail party for thirty at my neighbor's house. That attractive woman with the spiked red hair, that lovely old man with expressive hands in the wicker chair, that handsome man in riding boots, the gloomy middle-aged spinster with the dry sherry, the heavy-set woman with circular ear-rings, the Englishwoman, the Italian man, the Navajo, the tall woman with the small head, the woman in bull-fighting costume and the stylish young man in a sixteen-button suit. Those are the artists among them, she said, with a tone of authority. She was wrong, of course, because *all* of them were artists, the whole room full.

Ask any people on the street what an artist is really like and you get much the same answer. They are always tormented, ego-washed, choosing queer clothes and exaggerated haircuts, sleeping late, never paying their bills, playing loud music, depositing piles of ignitable rubbish on the floors of their studios, disappointing their long-suffering companions, yearning for public love and shocking the innocent, church-going bystander. Everybody knows these things. Artists are monsters. Newspapers,

books and TV tell us that they are and thus it must be true. With these stories I will suggest that this is not always the case.

So if you cannot recognize artists by how they look or what they do outside the studio, what does distinguish them from accountants, dentists or the men on the street? There are three sure signs.

*Don't tell me what to do.* Short or tall, my painter friends have one attribute in common: a classic, ongoing discomfort with authority. Tell an artist he must do this, merely suggest he might be happier doing that, and watch the predictable fireworks. Where they might listen to small hints of guidance from another painter, they will never welcome or accept it from outsiders.

*Please, dear, get out of my studio.* They all share a determination to make time for their art, usually to the detriment of their loved ones. You've forgotten to keep the cat's bowl full once again and Grandmother Atwill's beloved Minton plates pile up in the sink, spaghetti sauce gluing them together. Forget it. Since there is no hope of assuaging the unhappy ones around you, be true to the work at hand, the unfinished canvas on the easel.

*I can't get it quite right.* What is in the mind of an artist is always more beautiful, more telling, more truthful than what he can portray on the canvas. It is a lifelong pursuit, but the chase is more important than anything else. Others will be left behind if they try to follow.

It is this painter contingent, with or without stylish haircuts or clothes with curious collars, that concerns me in these stories. They work at their easels, battling the demons that strive to bring a tremble or a moment of indecision to a sure hand. A lonely struggle seen by few witnesses, but, on the other hand, owing little in the way of dues to anybody else.

They are the artists, but also they are the Santa Feans. Trying to make sense of the work of notable artists that went before, the traditional *plein air* landscapists, the modernists and finding a way to acknowledge the vast beauty that surrounds them, they must stake out their own version of what it is to make art, confounding the conventional wisdom again and again. These are tales of their striving for what it is that makes them different, accomplished. Surely there is a Latin term for 'seize the brush?'

—Douglas Atwill
Santa Fe, December 2003

# Why I Won't Be Going To Lunch Anymore

Although it was just before noon on a faultless day in late summer, I had a distinctly uneasy feeling about what would happen at my destination. I was driving in the foothills above Santa Fe to lunch at Donald Strether's, a lesser known but successful painter of small, modernist abstractions and a dedicated scoundrel. As I drove I mulled over one of my favorite subjects, the making of a living at art and particularly how this Strether made his own ample income from his small paintings.

I painted for a living myself, as did many of my friends. With more than a thousand artists living and working in Santa Fe, it was not so unusual an occupation as it might have been elsewhere. Since the difficulties of harvesting a livelihood out of art were so numerous, my sympathies were always on the side of the artist, even this Strether.

Of all the schemes for carving a living from art, his was one of the more effective. He painted seldom, awaiting the call. When it came, he worked four or five weeks to produce a single canvas. Then he patiently bided his time until he could place that one small painting for an enormous sum. I thought of a garden

spider waiting for the single meal of the summer, the meal that would provide until the end of winter. He never started another painting until the last one had been purchased.

In the interim, Strether gardened, sunbathed, meditated, socialized, attended the opera and chamber music concerts and worked on his spare but elegant adobe house. He was tall and darkly handsome and was often included as the extra man at Eastside dinner parties. He discreetly let it be known that a new gem was now available, waiting to grace the walls of some fortunate sitting room. Word spread like thin syrup among the party givers and goers alike.

Hostesses found his brooding nature irresistible and quietly championed his cause. His gloomy demeanor, as if in purgatory already, only added to his charm. They relished providing collectors for his treasured paintings while giving no hint of collusion or design. Allies in the Great War of Art, collaborators in a glamorous cause, they casually seated him next to the lonely bejeweled widow, the CEO's unhappy wife, the sensitive bachelor or the newly enriched of any sort. By meal's end the hook was quite often deeply sunk.

The process of a new acquisition had begun. Strether found the gender of the collector unimportant; lunches, dinners and picnics would follow, with overtures of love and promises for an end to loneliness. At the end of several weeks, the purchase of the painting was just one part of many adventures of a summer dalliance. The new collector left town with fond sensual memories, luggage filled with grass-stained clothes, a new painting and a diminished bank account. Happiness, maybe, too.

To celebrate a sale, Strether booked a few weeks in Mykonos, sunning and cavorting. On his return, he answered the

frantic calls from the new collector, explained his absence and assuaged the worry with soothing words. He devoted the next months to carefully distancing himself from the new collector, letting down gently. Then came the decisions about a new painting and the season to come.

Gertrude Branch was a dedicated ally to his cause. Earlier that day we talked on the telephone and she told me, "Donald is a sublimely sensitive person, deserving particular care. His wounds from childhood will never be healed. So sad, so deeply scarred. So damnably attractive."

I said, "Get off it, Gertrude. Remember, unlike a lot of people we know, I get along with Donald and enjoy the illicit things we do at his lunches."

"I suspect otherwise. Your face is a blank sometimes. I can't see what you're thinking when I look across at you."

"You, of all people, should respect that," I said.

"Nonetheless, I understand this new painting is a triumph on its own and just waiting to be placed."

"And what do we do this time?"

"We'll see that Donald sells his painting, that's what. My connections are very valuable for Donald. After all, it was I who introduced him to Paul Farthing and his group and Ambrosia Noad, with her millions."

I was included at the Farthing luncheon earlier that year, an occasion that late spring which netted Strether a handsome sum. "So who is it in the cross-hairs today?" I asked.

"An important novelist. Twenty weeks on the bestseller list. And, more importantly, he has banking money from his grandfather. He and Donald met at my opera benefit, which you declined, and this luncheon today was concocted on the spot.

**15**

Yesterday they had a picnic alone on the Big Tesuque and dinner at the Compound. The painting will sell itself." I could imagine the firm set of Gertrude's jaw.

"A remarkable painting."

She was quick to answer. "Is that envy in your tone? Not at all becoming, dear boy."

"But what about me? Don't my paintings need your launching ceremonies? A hoist from you now and then could do wonders." I could not resist testing Gertrude a little although I hated the process of selling a painting myself, much preferring to pay a gallery to act on my behalf.

"Rubbish", she said, "you would survive in the strongest sea. Quite distinct from Donald, you thrive on adversity."

"One of your discards would do. Perhaps a minor heiress with blank walls."

"Stop complaining. You're lucky to be included." She hung up the receiver with a bang.

With the connivance of Gertrude and others, Strether disposed of a steady stream of his richly priced gems. There were no bargains in that simple adobe studio. A whole year could be lived upon the proceeds of one sale, including his sojourn in the Greek islands. This year, with the Farthing sale already under his belt in April, Strether just might be in for a double-header.

Mine was the role of the Judas Goat. I had proven valuable on an earlier midday affair when I quite by chance expounded on the Minoan influences of terra cotta and pale blue in Strether's colors. It clinched a sale that had been dangerously at sea. I saw Gertrude's eyes narrow as she reassessed my worth upwards. Thereafter I was usually included when another Strether was ready, to lure the new victim forward.

At first blush, I felt guilt at taking part in this charade, but in time, I found a rationale for my actions. The rich of this world are fully able to take care of themselves financially, and perhaps emotionally. It's the artists of the world who need help.

I later expanded my Minoan touches to include a short lecture on the classical proportions of Strether's panels, the impeccable quality of his surfaces and the subtle O'Keeffean overtones in his shading. I quite relished these professorial touches. The more shameless the trickery, the more I embraced it.

Today was the debut of another painting. Strether rose early to set things straight with a phone call to tell me about his new piece. He spoke almost in a whisper, every word a special confidence. "I saw a glorious sign in the sky early one morning, three stars in a row and the whole painting appeared in my mind," he said. Considering that all of his paintings were exactly the same motif, a blue square in the middle of a mottled brownish rectangle, it was no great feat to have it appear fully clothed in the mind. I asked him to describe it.

"A blue doorway in an earthen wall. Colors and composition had already been worked out, as if from on high. The blue of opportunity, a new life and the earthen colors of the status quo. I saw the exact texture on the linen."

I knew this celestial assistance would become a major theme at dinner parties. "As our friend, Mozart. Whole symphonies downloaded like so much email?"

"You're making fun of me now. But it really happened."

I felt my nose for growth as I said, "I'm sorry. I can't wait to see it."

Strether said, "There are new ideas in this piece. The stars in the doorway."

The stars were definitely something new and this was his calculated way of letting me know that the stars would be the subjects of my dissertation after lunch. If I lectured convincingly on their stunning originality, I could pay for my lunch and continue to be a member of the Strether cabal.

"Stars. How exciting."

"Think about it," he said. "We'll gather at twelve." He rang off.

Strether had no sense of humor at all and I always felt bad after I flung a bit of sarcasm his way. He was strangely without the usual defenses. Furthermore, he was dishonest only on the large matters, while maintaining scrupulous uprightness on all the other, smaller issues. It confused me that a thousand small blessings could make up for one major crime. What exactly was the meaning of moral turpitude and was Strether born without it, arriving in this world with a chromosome missing? Did luring the gullible rich into parting with some of their hoard really constitute a sin?

As long as I proved a capable shill, I would be included in future lunches and I would be given moneyed contacts to exploit later on my own, after the Strether purchase was safely in the bag. I repeated in my mind what I remembered about Orion and Betelgeuse and the mid-winter meteorite showers as I parked the car below his house.

Strether's house was simple and classic, without modern heat and only rudimentary electrical outlets and plumbing. Its high, elegant windows gave a full view of a pristine valley below. The multi-paned windows were recycled from the Sisters of Loretto School razed for downtown development and the walls were surfaced in authentic mud plaster. In the courtyard was an

ancient juniper, a remnant of the primordial tree cover of the area. Lunch was set in its shade at a pine table with pottery and glassware from Mexico, Georgian silver forks and cotton napkins.

Indoors, I could see that the others were there already: the novelist, Gertrude and Strether, who was pouring white wine from a pitcher into more Mexican glassware. The novelist saw me first and smiled a welcome.

"So much talent at a small luncheon. How delicious," he said.

"It's good to see you again. Isn't this a wonderful house?" I said.

Before he could answer, Gertrude sensed something amiss, information not given to her. She said, "What's this? I hadn't realized you knew one another."

"When you said novelist I didn't know you meant Willard Chivers here. We met last week at the Halcyon Gallery." I patted Willard on the arm, while Strether disappeared into the kitchen.

Gertrude was not satisfied, however, staring pointedly at me. She was a short, heavy woman with costly processed hair a color somewhere between rosé wine and straw. When required to, as she did then, she could pull together the ranging parts of her frame into stiff uprightness, a definitive version of social outrage. "Indeed. Are there suddenly dozens of novelists in town? A literary convention, perhaps?"

Since Gertrude's thrust required a parry, I thought over what my answer would be. Willard and I had met the week before at the opening night gallery reception for a young landscape painter. There was a crush at the bar and we bumped elbows as we reached for the same plastic cup of wine. He laughed and I noticed he had straight white teeth. Expensive teeth. He was a

slim man, aging well, with bright blue, friendly eyes. He had the long narrow frame of an ascetic monk from Athos.

We talked a bit and I told him that I was a painter, too. I invited him to go see what remained of my one-person show at the Ludlow Gallery. "The reviewer in *The New Mexican* termed me a 'Minor Mannerist Landscapist, worth watching,'" I said. I thought that was a humorous comment and I saw him smile, too, as he wrote down the address of the Ludlow Gallery. We parted ways when friends of his arrived to take him to dinner.

Gertrude, who seldom gave benefit of a doubt to anyone, suspected something other than this innocent encounter. Her bright eyes stayed on my face as I formed an answer for her.

Mercifully, Willard interrupted with, "No matter, it's too nice to loiter inside. Let's go to the terrace." He took Gertrude's ample arm with "My dear" and propelled her through the French doors. He had expertly cut short her questions for the moment. "Donald says you terrorized the Red Cross in Paris during the war. Tell me all."

Nodding and smiling at Gertrude's oft-repeated tale, Willard showed his patience and kindness. The hardship of war, particularly her own, was her favorite subject and she carried on until we were seated at table. Lunch was a cold poached salmon, a large bowl of salad greens from the patch Strether grew out back, a peasant loaf and Spanish white wine in the Mexican glasses. Apple tart and espresso followed.

On the surface, Strether's persona was that of a simple, ethical man of the arts. He eschewed chemical pigments in his work. He was concerned with the encouragement of traditional adobe architecture and was a keen proponent of solar design, heating his house only with a wood stove. He gardened to have

organic vegetables for his guests, and he entertained simply but with style. Small but annual contributions arrived in his name at the opera and chamber music festival. Was it so terrible that he bilked the rich with his questionable paintings? If the well to do were foolish enough to fall into his ethical and aesthetic traps, was he so bad?

There was a pause in the conversation as we finished the coffee. Gertrude, in whose presence lapses of prandial chatter were forbidden, took the opportunity to start the real proceedings. She put her heavily ringed hand on top of Strether's, long-fingered and thin. "And now, what treat awaits us in the studio, my dear? I have several yawning blank walls since the museum people came to wrest away my gifts, the Gaspards."

She ably played the coquettish game that she just might buy the painting herself. It was intended to put the victim off his guard and make him feel comfortable, unsuspecting in the company of peers. I wondered if Willard was fooled by our provincial games. Didn't he sense the glowing red dot on his forehead?

We gathered up our glasses and walked slowly along the path to the separate adobe studio. It was one large room with north-facing windows and a high ceiling. The painting was under a white cotton cover on the easel, encased in the shaft of bright sun from the skylight. Strether seated Gertrude in the one chair, a regal Spanish design with gilded finials, and motioned the two of us to the long window-seat with cushions.

He then pulled off the cover with a flourish. He said nothing as we stared at the small canvas, which was even more austere and plain than I anticipated. There was, as expected, a row of three stars high in the cerulean blue doorway. The

background was an expertly applied wash of earthy light terra cotta.

Willard, always polite and well-bred, started with, "How elegant, Donald. It's most impressive." He was not showing any of his cards at this time.

Gertrude made a humming sound while she gave her well-practiced expression for viewing serious art. I thought of an old, blonde iguana on a limb, blinking.

It was time to get my part started. "Stars in the doorway, Donald. What can they mean?" Did I sound as if I was reading from a script?

Strether replied in his softest tones, "I never put into words what all can see. The painter should paint and let the image speak for itself, others can do the talking and writing."

"Quite so. Well, the stars must imply a new day or a change coming in the heavens. A spring apocalypse, perhaps?"

"I couldn't say."

So, I jumped into my discourse about the blinding of Orion and the stormy weather that attended him. Clearly, it was Arthur Dove and the Modernists, rather than Matisse or Bonnard, who were the forebears for this painting. The breaking of images into related shapes and planes was the key to this canvas. More down this avenue and it seemed as if I had just got going when I saw Gertrude scowl and Willard force down a yawn. This was not going to be an easy sell.

Strether, however, appeared to be in another world, nodding now and then in enjoyment of my monologue. Both Gertrude and Willard looked glassed over. So I continued, directing my comments to the only one paying attention.

"Your surfaces, Donald, are becoming even more refined, more splendid as your compositions get more spare. The Shaker quality of simple refinement."

Strether clearly looked pleased. I went on for a few minutes more, then wrapped it all up with, "What do you think, Willard?"

He wore an inscrutably polite expression, revealing nothing. He knew, however, that some sort of reply was expected. "I would buy it in a snap, Donald, as it is a lovely change of direction from the others I have seen in the fine houses all over town. All, I might add, to be coveted.

"But..." he said. Gertrude's eyes sprung back to life. "I just this morning bought three Mannerist landscapes at the Ludlow Gallery. I had been looking at them since my friend here sent me there last week and I could not decide among them. I wanted them all. So now, all three are being shipped to my new house in Sag Harbor. And that exhausts the art budget for this summer."

Strether said, "I see." He and Gertrude looked at me with matching blank expressions. A silence followed, ended only when Gertrude maneuvered herself up from her Spanish throne and thanked Strether profusely for lunch. He accompanied us all down the hill to the car park.

Gertrude between breaths pumped out platitudes about what a town for art Santa Fe was and what a coincidence that Willard chose my small paintings. She would have given me her narrow-eyed look of disapproval if the path had been smoother. It was an awkward end for the occasion, in spite of hugs and good-byes all around. Strether remained silent as we embraced without warmth and studiously avoided looking at me again. I was sure I would never be included in another lunch at Strether's.

For the rest of the day I had mixed feelings about how events appeared to tarnish my good name, albeit a conspirator's good name. I was now indelibly the traitor and the ingrate. Should I have insisted that Willard return my paintings so he could buy Strether's? Was there something I could have done to set things right? I slept restlessly that night: the sleep of the unjustly blamed, the sleep of the newly unfrocked.

As one door closed, another cracked open ever so slightly. When Gertrude called me the next day, it was apparent that the Strether lunch had wrought a subtle change in the murky currents of Santa Fe art. She had quickly sensed these small but important rearrangements, which now had me recast in a somewhat more elevated position.

"What a bore that Willard fellow was. Mind you, I am relieved you snagged something out of it all. Despite poor Donald. The Ludlow Gallery is fortunate to have you." She paused a moment to consider the unfolding events. "We must have lunch next week with Ambrosia. She's back in town for the rest of the summer and needs a project. You, I think." As the mechanics of art purchasing in polite society shifted ever so slightly, Gertrude was not going to be left stranded alone with Strether on an unpopular peninsula.

# The Supine Pueblo Maidens

It should have been a festive day, this St. Valentine's Day, but instead it was a gloomy, cold one with snow starting at first light and continuing in a steady descent throughout the morning. Magnus Morrison saw only two people go by the window of his Canyon Road gallery for the past three hours. There had been one sale so far this month, a small drawing of Flanders poppies framed in silver gilt. Morrison thought this was going to be a lean year for the painters of Santa Fe and he was glad to have a little saved from the summer months.

For the preceding two hundred years the adobe house that held the Morrison Studio Gallery had been a modest residence, housing a family of woodcutters. When Santa Fe started to grow, they moved away to a mountain village where the rest of their extended family lived and they leased the house to Morrison with the understanding that he tend the apple trees behind the house. He painted happily in the back rooms opening onto the orchard and set up the front room as a gallery for his own work. A generous window allowed passing tourists to peek in and decide if the Morrison product was worth a visit.

In the summer months, tourists often did visit his gallery. He was compelled to hire an assistant to sit the space while he

painted new work in the back room. Otherwise he would have no time to paint at all.

She was a Miss Harkness, who lived in a one-room apartment in the hacienda down the street and saw Morrison's sign in the window. She gave him a persuasive presentation speech on why he would benefit both financially and mentally from her employ. Her qualifications to sell paintings included two years study at the Philadelphia Museum School in the 1930s and a life-long love for art in general, with emphasis on the Fauves and the Post-Impressionists. She had worked for years in Philadelphia to separate department store customers from their money in Ladies' Scents and her commanding height made prospective buyers pay attention.

Morrison was immediately convinced of her worth and it was now the third winter of their time together. He had come to a grateful appreciation of her talents for converting his canvases and drawings into ready cash. From May through November she came each afternoon to tend the Morrison Studio Gallery, giving his enterprise an air of quality and distinction. No other studio galleries on the road had a near full-time employee, staff usually consisting of the artist himself or his spouse. If Santa Fe afforded a livelihood for painters, it gave Morrison a better one than most, not ignoring the excellence of his work.

Winters brought commerce to a trickle but not to a complete standstill. In the colder months Morrison often had a few nice sales and he kept Miss Harkness on two afternoons a week just to catch those few. This February day was one of her scheduled days even though good sense said to close until after the storm. Morrison thought it mean-spirited and penurious to

deprive her of the opportunity to make her commission because of a natural event, snowfall.

She arrived promptly at one in the afternoon, stooped under the low front door jamb and made the cascade of harness bells hanging on the door come to life.

"Good afternoon, Magnus. What a glorious gale we're having, a fury from the white heart of the Arctic itself."

Of an age between old and elderly, Miss Harkness was straight-backed and thin, with a hairdo seldom seen west of the Mississippi in those years, an overstated Marcel of henna red. In this community where personal appearance mattered little to most of the artists, she looked like an exotic crane blown out of her own breeding grounds by global winds. She believed in dressing warmly, for even in summer a chill lurked to diminish her health. Today she was enveloped in great swards of persimmon wool garments and oxford shoes of burgundy leather. Her departure from the Philadelphia department store included a lifetime supply of designer scarves, which she used in stylish variety.

Morrison said, "I thought of calling you to stay in. Not a chance of a sale today, I'm afraid, Miss Harkness, but since you're here...."

"Nonsense, Magnus, cultured people of means go out in all weather."

She dusted the snow off her cape, scarf and tam and folded them for the coat cupboard. Adjusting her dress with a few pulls and smoothing her collar, she was ready to take the helm of their little ship.

Morrison was not convinced by her cheerful assessment of the day's catch. "The only two that struggled by this morning

looked unpromising, even though they peered for a long time at my *Evening Light on the Sangres* scene through the window."

"I'm sure that an exceptional and moneyed collector or two will find our door and we'll finish the day with a noteworthy sale. I'll make a fire to cheer things up."

"Good idea."

Morrison turned to leave, but Miss Harkness was not done. "What if I just rearrange a bit, perhaps put a Pueblo maiden in the window?"

"Fine, fine, I'll just be in the studio." He went into the back room and closed the door. He had learned never to leave the studio door open, as visitors to the gallery invariably were drawn to invade his workspace. Particularly women wanted to come in and see, and they frequently left an aura that cut right across whatever he was working on. Magnus claimed to be sensitive to an atmosphere left by others in his studio. It could ruin an entire morning of painting.

Miss Harkness busied herself dusting the paintings on the wall as the corner fireplace took hold. She went to the small closet that held the racks of undisplayed paintings and pulled out the next to last painting of a Pueblo maiden. It was a small painting framed with a rococo gold fillet. A young Nambé Pueblo girl lay nude on a striped blanket, baskets and corn clusters filled the outer corners of the composition. Her flat, imperious gaze was as bold as Manet's Olympia among the savages.

The choice of the Pueblo maiden was an open indication that Miss Harkness, despite her façade of optimism, thought today was going to be difficult. The maidens invariably were well received and would sell out completely if displayed one after another. Miss Harkness devised a scheme to squirrel away the

maidens for difficult times, an insurance policy to be rationed out only on the slowest of days. However, the supply was dwindling.

Morrison had never actually seen a Nambé Pueblo maiden. On hot nights one summer the motif kept appearing in his mind, a lithe young woman resting on a red and white striped blanket in diverse poses. His favorite version included the supine maiden with a tablita headdress in her hand, connoting that she had only just a moment before disrobed. Somehow, the impression that she had been loitering there without clothes was not so appealing.

He made no progress in converting his idea into actual paintings, but it took on a nagging intensity in his thoughts. He calculated the girl's body proportions, making her slightly shorter than art-school guidelines of seven heads tall. Her body weight crept up until he had fixed the vision as an enticing, nubile girl, surrounded by the Indian artifacts he knew from museums and local shops.

Sunlight from the small pueblo window made a line across the canvas in his mind, up and over her body in a golden-white stream. In the final version of his fantasy he included a section of the window itself, with a darkness that caused an indentation in the shadow. Could that suggest that a tribal elder peered in on this unsuspecting youngster? The painting only awaited a model for his work.

Then at lunch one day he saw a young woman sitting alone at an adjoining table who closely matched his mental image. Her body was ripe like a plum, her stove-black hair cut in straight bangs and in a single horizontal line around her neck. She was stocky but not yet fat, her chubby wrists encircled in silver bracelets. He almost saw the marks of the tablita on her dark hair.

He could not avert his eyes and after a while he realized his stare had caused her discomfort.

Morrison leaned over and asked her quietly, "You aren't by any chance from Nambé Pueblo?"

"Of course not. I'm Polish, from Brooklyn."

"You quite favor the Nambés, you know, your hair and your size," he said.

"They live north of here?"

"Indeed. I'm a painter, my studio just down the street. If you had the time and the inclination, would you pose as a Nambé Indian for me?"

"Without clothes?"

"Yes."

"No funny business?"

"No funny business, I assure. I could pay you well."

"Okay, I'm almost broke."

That was several summers ago, before Morrison hired Miss Harkness. The woman, named Milla, came afternoons to his studio to pose in the set-up he had arranged by the window. Sunlight streamed in by mid-afternoon and the fixated shapes in his daydream version merged with the real scene in front of him. He was transported to a woman's chamber in the pueblo for several hours until the light changed.

In a creative passion, he painted canvas after canvas, each a variation on his theme and he scratched out numerous sketches of the scene. He now remembered the time fondly as a sensual feast, not so much of Milla herself but of the pueblo image that she stood for. She was a messenger, an icon to be valued for what she symbolized rather than what she was.

They took their breaks away from the easel in the deep green shade of the orchard. After initial awkward tries at conversation, they both came to an ease sitting in silence under the trees. In summer months that followed, the scent of fallen green apples brought it all back to Morrison.

By the end of August he had a dozen of the pictures finished and several in various stages of completion. Milla planned to leave in September and Morrison asked her to stay on for a while. He suspected at the time that this was his finest hour, that he would never paint this well again. She left, nonetheless. The combination of hand, heart and mind had fused to give him a group of magical paintings as none before.

When he started to display them in his gallery space, Morrison saw the paintings go one after another, usually sold soon after they were displayed. All the framed sketches sold in the first autumn. His interest moved along to other motifs, landscapes of the mountains nearby and gardens from his neighbors' courtyards. These were subjects that took longer to sell and Morrison felt challenged to make them as attractive to buyers as he could, but they never matched the popularity of the maidens.

Miss Harkness dusted off the next to the last maiden. After centering the canvas on the easel at the window, she adjusted the spotlight to a small focus. Reaching just outside the front door to a pinon pine there, she pulled off a needled branch to adorn the top of the painting. She thought the twig gave emphasis to the archaic nature of the scene and added poignancy to its presentation. From her days in Philadelphia, she knew the importance of display. The pinon's branches nearest the door were almost picked clean.

The snow outside had shifted from a fine white dust to large wet coins falling with deliberate slowness, sticking on every surface. By three in the afternoon darkness was winning and the few automobiles that drove by had their headlights on.

Morrison at his easel heard the bells, followed by voices in the gallery, but only Miss Harkness's words were understandable behind the closed door. Sharp syllabic definition was one of her small vanities, but even then only part of the exchange was clear.

"...such a canvas is a life-long *(something)*...both the Metropolitan and the Art Institute insisted that... *(something)* *(something)*...Impeccable taste.... The lovely skin tones as only an ethnic Tewa woman...." And then a very long silence. The bells on the door indicated a hasty departure.

Morrison was sure that no sale had been consummated. He painted on, refining the stems and leaves of a large garden painting, a motif he reserved to keep his spirits up on gloomy winter days. He heard the bells on the door again.

Another visitor to the gallery could mean that Miss Harkness' assessment might be right. This time he heard nothing of the conversation, and he lost interest in eavesdropping and returned to the details of a complicated umbel of yellow bloom.

He worked on for half an hour more and quite forgot the matters of commerce in the front room. Miss Harkness's knock on his studio door startled him. How was it that she could knock so much louder than men?

"Come," he said.

"Magnus, can you visit with some sweet people from Indiana, the Piersons? I'm sure you'll want to meet them," she said.

The term "sweet people" was their code word for "buyers," usually very substantial buyers. In this way, Miss Harkness could interrupt Morrison in the studio by saying he must meet some sweet people from Portland or Houston and this meant they had already bought a painting. Buyers of smaller paintings were referred to as "interesting people." People only considering a purchase, needing heavy encouragement, were called "charming people." Morrison could then judge just how much time to waste in pleasantries.

The Pierson couple came in behind Miss Harkness, peering around the studio with obvious delight. Morrison's work place held many tableaus and props to interest collectors: baskets and pots, feathered head-dresses, war shields, dried floral arrangements, and a long row of coat-hooks with Indian costumes.

Mrs. Pierson spoke first. "Mr. Morrison, we love your work. Especially the Nambé Pueblo pieces."

"Call me Magnus, please." He took Mrs. Pierson's hand, smiling. "How nice of you."

Miss Harkness interceded, "The Piersons had the discerning taste to buy the very last pair of your Pueblo maidens. They will join the rest of the Pierson Collection at the Art Museum in McPherson, Indiana."

Miss Harkness' face betrayed nothing of her feelings. "The Piersons would like to organize a museum exhibit of your work next winter in McPherson. The museum would pay for everything and you could stay right with the Piersons."

Mrs. Pierson said, "Herbert and I have been collecting in New Mexico since the Thirties. We have Maria pots, Gaspards, Sharps, Ufers and all the *right* artists of Taos and Santa Fe. Our small Victor Higgins may be his very best and we're hoping to

bag a John Sloan view of the cathedral. You would be in good company, we can assure you."

What a horrible idea, Morrison thought. "Thanks, so much. Give me time to think about it."

"Of course, Magnus. Give it your earnest consideration. We sponsor these exhibits every few years to share our new purchases with the people of Indiana. We'll be at La Fonda Hotel for the rest of the week," Mrs. Pierson said. Already Morrison was regretting giving permission to use his first name.

"I'll be in touch soon."

Miss Harkness wrapped the two small paintings in several layers of brown paper and the Piersons departed into the swirling storm, heading farther up Canyon Road to other studios and galleries. Morrison wondered who else would be included in the Pierson collection this day.

"I object, Miss Harkness, to being something people from Indiana want to 'bag,' like a ten-pointed elk or a champion-sized zebra," Morrison said.

"Quite right, Magnus. I gave them no encouragement at all in what your answer might be. You must turn them down completely."

"Good, because that's exactly what I am going to do."

"Mrs. Pierson seems to be the guiding light at the museum. It must be a very small, very provincial museum, but whatever she wants, they do, she told me."

"Women like her use the museum to add luster and value to their own collections. It's totally a matter of dollars, despite how much she throws around the compliments. Deposit the check tomorrow, will you please, Miss Harkness. Then, we'll say no."

"Yes, Magnus." Miss Harkness turned off the lights and put the "Closed" sign in the window. She walked away into the dark afternoon.

The snow continued for several more days. In the quiet gallery Morrison thought about the sale of the last two of the Nambé paintings. Surely, there was one of those incomplete versions in his racks, one he could supply with final changes to add one more to the series. He went to search for it but with no success. Then he recalled using those canvases for another, more favored motif, painting over Milla's legs or arms with thick loads of gesso.

How had he not saved one or two of his best paintings from the past years? Why was it so important to sell the work that came from that high plateau of his painting years? Now they were all dispersed to places like California and North Carolina, the last two now in the hands of those Piersons from Indiana. Why was earning the dollar so necessary that he brought upon himself this sense of loss?

He should have called Miss Harkness, after all, giving her the day off. He knew that he could never rekindle the flame of excitement and skill of those summer afternoons by the orchard with Milla. Now, they were a just remote memory under the falling snow.

# The Gilded Square

"Let's go to the opening at Halcyon Gallery tonight," Charles said. "It's the new work by Julia Brownell and I saw a piece of hers that I liked at the restaurant last night."

Charles McKenna could be counted on to get me out of the house and off to summer events in Santa Fe. He was an old friend who visited me every summer for a month or so, savoring the change from his patterns in New York City. His choice in activities usually differed widely from the staid, museum-centered events of my own life.

"Very well", I said, "but let's not stay. It'll be a crush of people, hot and steamy. And Halcyon never has good wine."

"Art would wither if you were left to water it," he said.

"I'm not sure art is what we'll see at a Brownell showing."

"Envy, envy." He shook his finger at me.

Charles hit the nail on the head. I was envious of Julia Brownell, a fellow painter in Santa Fe. Her vast success had eclipsed all the other young painters of the time, including me. Some years she had two exhibits a year, selling everything on the walls with collectors arguing loudly over a popular piece. This was at a time when there were few galleries in Santa Fe and keen competition for representation. Some were happy for her, but her

patrician, overbearing demeanor and arrogant behavior set most against her. It seemed vastly unfair that she had beauty, ability and success all on her side. I held that art should entail struggle, deprivation, and lonely travels in the wilderness, none of which guided Brownell.

Charles and I walked down to the exhibit at the gallery just off Santa Fe's plaza. Although it was only five in the afternoon, the crowd spilled out the front door onto the sidewalk and we could hear the roar of gallery talk from down the street.

"Let's make straight for the bar," I said. "It's always in the far back."

"Follow me," said Charles plunging into the gossiping throng.

I learned from experience to keep moving in an opening night crowd until you made it to the far innards of the gallery. Then, with a small glass of white wine you could slowly work your way to the street. This was the sociable part of an art exhibit where you exchanged opinions with other artists, I preferring the anti-Brownell faction on this night.

It was hard to see her work since only narrow vistas were available between the gossiping groups. I pushed my way to the outside perimeter between the throng and the paintings, a narrow walkway on which I could view the work itself. The large paintings, six feet square, had a theme of gold and gilding. Brownell gold-leafed sections of these panels, while other portions she filled in with gold radiator paint from a spray can and commercial, grainy golden paints. All of the paints she used were sloppy and wet, long drips falling straight down to the bottom of the pictures, now dried with small nubbins at the end of each drip.

The canvases were entwined in circulations of string and small rope, which in turn were gilded or covered with golden papers right over the twine. Sections of deep yellow wood, faux gold, had been pasted on here and there, and many golden rings of varying diameters were enmeshed under translucent golden gels. More areas of gel had glitter imbedded in them. Long strips of gilded masking tape went this way and that, taped right over the welter of other elements.

I was appalled. She had paid no attention to the traditional methods of painting, flaunting any attempt at technical excellence. Charles had quite an opposite view.

Above the din he said, "I think they are brilliant. I must have one."

"Why in the world?"

"I can just imagine one of them in my new apartment. New and exciting. My New York friends will be so envious."

"Not people from Santa Fe?"

"No, I wouldn't think so. We New Yorkers are more concerned with ideas and new concepts as the origins for art. You Santa Feans are more comfortable with simple landscapes of local nature, thematic work, and Indian related canvases."

"Ouch. Are we really that provincial?"

Avoiding an answer, Charles pulled away from me and my opprobrium, and by evening's end he was the owner of Brownell's "Gilded Square No. 9". After the purchasing paperwork, he insisted that we go talk to her, that I introduce them. When the circle around her dissipated for a moment, we closed in for a talk.

I made the introduction. "Julia, this is Charles McKenna."

"Oh, they told me you just bought Number Nine. The best of the lot, I think."

Charles beamed with satisfaction. "I think you're wonderful. Such intriguing work. So joyous and exuberant."

"You have a good eye, Charlie," she said.

"The use of gold was a clever idea."

"I loved doing them, finding ever cheaper paints. The best were the golden poster paints from Woolworth's. They have chunks of unmixed glitter and they drip with lovely, riverine abandon. These paintings will become nightmares for art restorers." She laughed.

At least she admitted they were archivally poor. What would happen to that masking tape and poster paint in a few years? Peeling up and falling off in expensive drawing rooms the nation over.

"Are you ever in New York?" asked Charles.

"Next month, Charlie."

"Call me, I'll take you to lunch." He gave her a card.

She smiled, saying neither yes nor no. We pressed through the crowd to the cool street outside.

Charles went back to New York that Sunday, and he asked me to take delivery of the painting at the end of the exhibit. Since he was between apartments in the city, I offered to warehouse it for him until his new place was ready. The men from the gallery helped me in with the large panel. Charles had suggested that I hang it on the wall of my entry hall, but I liked the entry exactly for its emptiness. I relented, however, because there was nowhere else for it and I asked the gallery men to hang it where he indicated.

It immediately commanded attention in my hallway, catching the morning rays of the sun and projecting an Egyptian-

like radiance in my small adobe. In the cooler hours of the early evening, portions of it contracted, emitting twanging and plucking sounds like a primitive ceremonial instrument. My exquisite Mexican Colonial pine table in the hallway seemed to hiss in disapproval when I walked between it and the new Brownell.

My three cats, a testy old female and two younger more active males, inspected it in turn, standing up on the wall to smell the bottom. When I discovered a piece of the painting on the floor, I accused them of pulling it off. My disapproval was faint-hearted as I was secretly pleased they shared my dislike.

When other pieces fell off on their own, I had to apologize to the cats for my suspicions. Small sections continued to cascade down onto the floor from time to time and I regularly glued them back on, sometimes hunting without success for their original sites.

The work on Charles's apartment spread from weeks into months, but he called regularly to update me on its progress. He always asked if I now liked the Brownell better, feeling uneasy with it in the hands of an infidel. I assured him I was a trustworthy bailee, but one with strongly differing views from which nothing would dissuade me.

Charles created an amiable new setting for the Brownell panel. He bought an ormolu French writing table and lines of Mycenaean gold cups to echo its glitter; one wall of his sitting room was papered in Indian tea papers with pressed-in strips of real gold leaf. It would be a parlor of complete aureate beauty, he said.

"So how is my painting? Are you loving it yet?" he asked on the phone.

"Not yet, its charms continue to elude."

"Soon, maybe."

"Maybe. But you should know that the cats seem to have accepted it, as they don't try to pee on it anymore."

"Well, there you are, then. Just a matter of time and you won't want to defile it either."

"And it has stopped making that notice-me, notice-me twanging sound when I have parties." I had a hard time explaining that quality when it did sing its scratchy song in the cooler temperatures of the early evening, startling my more highly wired dinner guests.

"So it's beginning to love your house. Poor thing, soon to be moved again. By the way, I found a New York gallery for her work. They want to give her a show next year."

"You've seen her then."

"Yes, we had lunch a few weeks ago. She told me that the Santa Fe exhibit had been purchased almost entirely by out-of-towners."

Finally one day the movers were there to claim the Brownell and ship it off to New York City. I had to admit the wall all but hummed a song of emptiness in the first few days after its departure. I hung one of my larger garden paintings with bright colors in that location but it curiously did not take command like the Brownell did. It annoyed me that the absence of her painting was stronger than the presence of mine.

I tried other paintings and objects there but nothing really felt right. Is that all that Art is about? The perpetual ownership of a hanging space? Even now, years later, when I pass down the hallway, I feel that particular spot has been deeded for time immemorial to the gilded square.

# The Deathbed of Cecily Brompton

One day in the summer of her ninety-first year, Cecily Brompton, after a lifetime of good health, avoiding minor colds, broken bones or major illness of any sort, took to her bed at the unaccustomed hour of nine in the morning, feeling very unwell. Her bedroom, a small cell with an iron-frame single bed, adjoined the Santa Fe studio where the work on her newest painting was not going well.

The household staff did not notice her departure from the studio, as they provided her complete privacy during the morning hours, her best hours for painting. She had trained the staff to make no noise or disturbance during these important early hours. At noon, the cook, Isabel Rodriguez, was instructed to check quietly into the studio. If work was going well there, she adjusted the serving of the midday meal accordingly.

The entire staff was aware of the necessity for seamless quiet in the home studio of the most important woman artist of the western world, as the art magazines had it. Brompton herself rankled at the adjectives "woman" and "western," preferring to think of herself as the most distinguished painter alive, not merely an American female version of greatness. After all, Picasso, Matisse and O'Keeffe were all dead. Since her paintings sold for vast sums

soon after they were delivered to her New York gallery, who could question her self-assigned spot at the top of the list? Collectors on both sides of the Atlantic lined up to purchase a prized new Brompton, an icon for success on sitting room walls the world over.

The four people who comprised the Brompton household, the cook, maid, driver and gardener were justly proud of their employer and furthered the cause of art and fame like a trusted palace guard. Isabel Rodriguez was the liaison between Brompton and the rest, nurturing the pride of servitude and quelling any disturbances. Few people got past this phalanx without permission to interrupt Brompton's work.

The staff had learned to assess the situation without words; they sensed the direction work in the studio was taking and awaited Brompton's re-emergence from her workplace at whatever hour she chose. So that was how the staff missed the start of Brompton's malaise and her odd retreat to her mid-morning sickbed.

For two hours she slept fitfully, dreaming of brightly costumed dancers emerging from and retreating into a roiling wall of mist. She had this dream several times before and now, waking around eleven in the morning, made a painter's practiced effort to remember the bold black and white patterns of the dancer's costumes and small details of the dances. The sketchbook on the bedside table was full of quick renderings of dream images.

As she came up through the levels of sleep to awareness, the curious situation of her in bed at this hour startled her away from this happy reverie of remembrance. What did this being in bed at mid-morning mean? Was this unfamiliar weakness a prelude to something dark and final? Was this her deathbed?

She had always imagined she would go suddenly. As the years went by she formulated ever more dramatic scenarios for this finale: a private plane, solid maroon in her vision, plummeting down to winter seas off a storm-tossed coast, perhaps the rocky Atlantic side of Cornwall; a pistol shot from a crazed, foreign admirer in a Turkish military uniform, handsome with elaborate epaulettes and black boots; or, her favorite, because of its visual tension, a motor accident, the Mercedes with her at the wheel careening off an icy curve into an ultimate, smoky spiral down to the Rio Grande River, exploding in the dark New Mexico night, a night of festivities elsewhere. A satisfying show of concluding drama. A flamboyant death to match her eminence, not the slow wasting away that this morning in bed foretold.

A death at home in bed was for a rich dowager without artistic worth, not the painter that the world idolized, the artist that women everywhere took as a role model for female success in a man's world. Furthermore, it would be a bore to die slowly in bed with wailing servants and long-faced associates to visit you, and then to depart with an audience of dull and sanctimonious faces. It would be a flat, atonal finale to what had been a glorious symphony. As she arrived at full consciousness, Brompton was very dissatisfied with this turn of events.

The cook found her. Isabel, after she saw the studio empty, quietly opened the closed bedroom door, let out a short cry to find Brompton in bed. In a flash she knew what it portended.

"Senora, you are ill." she said, half a question.

"Yes, Isabel, it would seem so." Brompton was annoyed with herself and her tone was clipped and harsh.

"I will call Dr. Harmon," she said as she came near to feel Brompton's forehead.

"Don't fuss, Isabel." She brushed her hand away. "I'll have lunch here in the bedroom. Only broth and some toast, please."

This was the day the staff knew would come, the end to their comfortable world. Cecily Brompton would die soon, Isabel thought, leaving their days empty but perhaps their bank accounts full of the expected bequests. The staff had discussed this day and what their inheritances might be.

Patricio, the driver, told the others that his legacy would be the largest as the Senora had always been in love with him. He said he saw her admiring him in the mirror when they drove in the Mercedes about Santa Fe. Cecily Brompton admired male beauty and all the drivers before Patricio had been handsome and young. Patricio counted on a large inheritance.

Isabel disagreed, saying that she and the Senora were like sisters, sharing decades of secrets and stories. The maid and the gardener knew their bequests would be smaller, but, considering Senora's great fame and wealth, they knew that some substantial sum would come their way.

Now that this sad day was almost here, Isabel lost her voice to a whisper. She backed out of the bedroom door.

"Yes, Senora. I will call Dr. Harmon. Now."

Thus the rhythm of her terminal days was set: insubstantial meals with naps throughout the day and fitful nights of sleep, short daily visits from Dr. Harmon. Weeks went by and there was no change in this pattern, excepting the increased volume of worried visitors. Her condition worsened as the number of bedside guests grew.

The new painting remained unfinished in her studio, the brushes stuck in the thickening paint of her palette. No one was allowed into her studio. Her gallery owners made several visits,

her lawyer, her banker and a few of the few friends she had left. Isabel, hurling Spanish invective on their heartless heads, sent writers from the art magazines away with gusto.

On the fifth week of Brompton's time in bed, Isabel arrived one morning with a bouquet of wildflowers, obviously picked along the road. She had a conspiratorial smile. "Your second-cousin, Carlos, is here to see you, Senora."

"Isabel, I don't have a second cousin."

"Maybe you don't remember that your great-aunt's daughter, Mrs. Barrington, had two children, Carlos and Emilia. She was married to the man from Barcelona." Isabel enjoyed pronouncing that with a rolled 'r' and a long 'th' sound. How family charts flowed in the Rodriguez family was very important to Isabel, and to lesser degree family charts in general. Where people fit into the scheme of things mattered to her. The fact that she knew more about the Senora's family than she herself pleased Isabel enormously.

Brompton said, "That's nonsense, Isabel. Send him away."

"But the *povrecito* has come all the way from *España* to see you, to help you to get well."

"So he's a healer, as well as a cousin. Amazing lad. Isabel, he's only an imposter."

"He's very charming and very handsome, Senora."

"Oh, very well. Bring him up." Isabel knew what mattered to the Senora.

In a few minutes, the door opened and Isabel presented Carlos with a proud flourish, as if she had cooked him up in the kitchen herself. She watched as Brompton looked up at the redheaded, brown-eyed young man. He sat down in the bedside chair reserved for visitors, putting his large hands on his knees;

his lanky frame rested uneasily in the small, creaking chair. Isabel left and closed the door quietly.

Brompton said, "So you're my cousin. Indeed."

"Sorry about that. It's only a small lie."

"They are the worst, those small lies. Nations fall because of them."

"I knew I needed to be family to get past Mrs. Rodriguez and my Spanish is good enough to convince her."

"Your Spanish must be very good, then. If you're not a cousin, who are you?"

"I'm here to look after you," he said.

She laughed quietly and said, "I wish I'd heard those words sixty years ago".

"I can make your life easier and help you paint. That is, to get *back* to painting."

"I've never needed help painting. I detest someone else in my studio."

He was insistent. "But you may need help now."

"That's true, alas." Brompton paused and considered the young man. He appeared to be serious and concerned. What exactly could he do to help? Nobody had ever been able to assist her in the studio, so why now?

She continued to look at him in silence and he showed no outward signs of nervousness or guilt. Brompton set great store in her ability to watch a face and judge character. Carlos did not appear to be a thief or assassin. At worst, he seemed only an opportunist. Appraising her own position, Brompton thought that if she continued staying in bed, she would certainly be dead in a month or two, if only from boredom.

"Carlos, is it?" He nodded. "How did you know I was ill and not painting? Did a bright star appear on the western horizon?"

He smiled. "Your gallery people in New York told me. I was there studying your latest paintings. I'm a beginning painter myself."

"What makes you think you are competent to assist me in any way? What do you know of my work?" she said. He smiled broadly again and Brompton tried to remember the Spanish words for the adage that the best passport in life is great beauty.

He said, "I've looked at your paintings a long time. I spent weeks at the Tate, going back day after day. And the same at the Beaubourg and the Whitney."

"And what did you find?"

"I see great beauty in Number Three Forty-Seven and Number One Nineteen. Both at the Whitney. I also think it would be a shame for the world if you did not paint more in the vein of Number Four Eighty-Nine, now on display at the Tray Gallery on Madison Avenue. You have more to paint, I am sure."

Brompton was impressed with this young man. Those numbers, the only titles she ever gave to her work, were among her dozen favorites in her entire *oeuvre*. She was not sure, herself, why she liked them so much better than the rest. Nowhere were these listed and to nobody had she ever told these foremost choices. He must have come up with these opinions on his own. This young man had said the magic words, and even if he were a scoundrel and a pretender, she would now have to see what he could do.

"Carlos, let's see how I feel in the morning. I am tired now. Isabel will find you a guest room. We'll talk more tomorrow." She closed her eyes and the interview was over. Carlos left quietly.

**48**

The next day Isabel noticed a marked improvement in the Senora when she came into the bedroom. Her intuition had told her that there was a good quality in this young man who said he was a cousin but was not a cousin, something good for the Senora. If Isabel did not believe his cocked-up stories in broken Spanish, she did believe in omens and Carlos was a true omen. Isabel asked, "Would Senora take breakfast today?"

"Yes, Isabel. Some strong coffee. Eggs and sliced oranges, like before. And a muffin with the English marmalade." Afterwards, Brompton spent a minute or two in front of the mirror. The white dress instead of the black one. Her hair, pure white, was long and abundant and still looked right just combed and knotted into a bun. Her face was wrinkled from so many years in the western sun, but her neck was firm and her chin without sags.

She considered with approval her legs, slim and well turned after all the years of standing at the easel. She thought if the deathbed was really calling for Brompton, it was getting an unusually well-preserved specimen. How fortunate death was.

She walked slowly into her studio and, from a chair, looked at the unfinished canvas on the easel. Now, after these many weeks, she saw it with a new eye and judged it a surprisingly good start. The long lines of the composition had life; they had those vibrations that came like voices, sometimes, and never on demand. Could she pick up the moment again and continue?

A great tired cloud overcame her previously excited thoughts. It would be too much work to get the energy level up again, up to a point where the brush flowed with paint like a long-distance runner. The paints on the table must be discarded, new ones and new brushes brought from the shuttered cabinets against

the wall. Maybe this was all a bad idea. Go back to bed and say goodbye.

Carlos came in the other door. "You look unhappy."

"I am. This will not work. Let's not even try."

"Sit down, please. I will clean up your paints and brushes. I won't take twenty minutes." Without her prompting, he went to the sidewall cupboards and selected brushes and paints. He discarded everything on the table and started arraying the tubes behind the marble slab Brompton used as an easel.

"Cool colors on the left," Brompton said as Carlos was about to put them on the right.

Carlos then scraped the dried paint off the marble with a razor and washed it clean with turpentine. He placed the linseed oils, thinners and mediums behind the paints and looked at Brompton for approval.

She nodded. "There's a brush you've thrown out that I want back. It has a chisel end, maybe an inch wide. I am sure it can be restored."

He found it, heavily encrusted, and without comment, took it with him as left the studio.

Brompton had to admit now that the painting table was in order again, her spirits returned. Maybe Carlos would work out. Only as a studio aide, of course. She painted an hour that morning and there was a definite seam between where she left off weeks before and this new work. But Brompton thought the seam had validity. What was, was. She did not attempt to hide it, but continued on with her long vibrating lines, top to bottom. Here it was, a painting that documented her life with a validating division between work shut down and work regained.

The next day she painted for half an hour longer, with Carlos sitting quietly against the far studio wall. This was the studio that Brompton had kept secret from the world for half a century. It was rumored to be the ultimate in spare and elegant beauty, which art publications around the world yearned to photograph.

It had high ceilings of white beams, unadorned walls on three sides with high casement windows on the east. No memorabilia strewn about, only pristine whiteness on every surface. Even the easel had been painted white.

Her view of the Sangre de Cristo Mountains was devoid of neighboring houses or roadways. It was a panorama unchanged in the forty years of her occupancy, unchanged since ancient times. The morning sun streamed in at an angle, lighting the wall opposite the easel wall.

Brompton had been zealously private all these years, never sharing her workspace. Now this young Carlos sat impassively in the corner of the studio while she painted. After the first few days of this arrangement, Brompton in her mind extended Carlos's temporary visa and thought she would allow him to stay only until this painting was done. Perhaps for a week more at the most.

Carlos was a quick study with her preferences. He learned she wanted the marble palette to be clean each morning before she arrived. He washed the brushes each night, finishing with a soapy wash to rid all trace of the linseed oil, then a clear water rinse. Tubes were returned to their strict arrangement of violet, blue, green, yellow, orange, and red, left to right, earth colors and whites on the far right.

One day Brompton asked Carlos, who was startled from his reverie against the wall. "Do you believe that beauty continues after death, Carlos?"

He was quick to respond. "Maybe that is the only true beauty."

Brompton chuckled, "That is a very Zen approach to an answer. So you think that the beauty that survives death is the only true beauty?"

"Of course."

"So how does beauty survive the buffeting of suffering, envy and greed that surround everything, especially after the creator of that beauty has gone?"

"True beauty has its own power and survives as long as someone thinks it exists," Carlos said.

"I believe that, too."

As the days went on, Brompton enjoyed the give and take of ideas from Carlos. They alternated the roles of the inquisitor, questioning the other as the neophyte. Sometimes they turned the qualities of life upside down and threw them like paper gliders back and forth. She finished the painting with the frontier in the middle of it and started another, this time including a mock frontier two-thirds the way across.

Her health grew imperceptibly better, evidenced only by the longer morning hours she could work in her studio. Carlos never left her side in the studio and many mornings there was only silence. She took long afternoon naps and was often too weak to have dinner.

He never asked a question first, waiting for Brompton to introduce a mental puzzle like a seminar professor announcing the subject of the day's discussion. They spent a week on the nature

of truth and several weeks on whether reality is, in fact, illusion. Brompton favored the role of the investigator while Carlos fell naturally into that of the Artful Dodger, slinking around an open response. Isabel often heard laughter from the studio as she passed by the closed door, a strange sound in her years with the Senora.

One day Brompton asked Carlos, "Why, in the scheme of things, is it that I have had so much more success than other painters?"

"You have accumulated merit in a former life. It now shows itself."

"It's not that I am better than the others? It's just that I came with a large metaphysical bank account of merit, a spiritual inheritance?"

"Yes, you have enormously good karma from another life," he said. "But you are, also, better than the others."

Weeks grew into months and months finally into a year. Brompton painted six new paintings in that time, inching along. Isabel beamed a continuing consent of what she had conjured, bringing light lunches and, when Brompton felt well enough, spare evening meals for the two of them.

Isabel told others in the staff that the Senora had taken strength from the young omen. Carlos was a young bull who brought new life to the old sacred cow, she said. Sometimes a young male in the pasture could do service for all the old females, if only with fanciful ideas. The maid blushed.

The New York gallery came with a private jet to collect the six canvases, planning an exhibit in the winter season. Brompton left Carlos alone in the studio and spent a morning in discussion of business matters with the gallery people. Then they were gone, people and paintings all, and the studio was empty

again. She came back to the studio in the early afternoon and found Carlos still there.

"I think they've found a good home," she said, sitting in the chair next to Carlos.

"The paintings?"

"Yes."

"They are beautiful. They deserve a good home."

"What will you do now, Carlos? Do you want to stay on?"

"As long as you need me. I would still like to paint again myself, though."

She paused, put her hand on his arm, and then walked to the door.

"I'll get the studio ready for tomorrow, then."

'Yes. Thank you, Carlos."

Brompton did not go back into the studio again. Her condition worsened that night and a few mornings beyond Isabel came wailing down from the Senora's bedroom with the dark news. The day of death had come.

The staff received the generous bequests they had expected, and Isabel was quick to point out to Patricio that her inheritance was several times the amount of his. The last will and testament set up the house and studio as a foundation with the staff to be kept on indefinitely. There was a coming and going of lawyers, accountants and gallery people. Carlos was not mentioned in the will at all, and no provision was made for his staying on with the Brompton Foundation. To this he showed no reaction.

Isabel felt sorry for him, but not sorry enough to share any of her own bequest. After a month in the mourning household, Carlos left Santa Fe and returned to New York. He got work in a Soho gallery, helping with installations and doing light sales work.

Months passed and he went forward with his life, planning to paint again himself. He thought of renting a studio, but waited with prudence until his commission check from the gallery grew larger.

Then one day a messenger arrived at the gallery with a personal letter for Carlos. It was a blank paper folded around an invitation to the opening night of the latest exhibit at the Tray Gallery. The printed card read *"Cecily Brompton, The Final Work. (Numbers Four Ninety through Four Ninety-Five). Opening Reception by Invitation Only."*

Carlos was puzzled about this exhibit. Brompton had told him that they were sold and found a good home. So what was this exhibit all about? He showed up at the appointed hour and viewed the paintings, the six of them widely spaced on the walls of the gallery space.

A crowd started arriving as he studied each painting in turn. He thought back to the mornings in Santa Fe in the light-suffused studio and the happy progression of days as each of these canvases came into being. Perhaps it was time for him to spend a year at the easel himself.

At first he did not read the card beside each of the paintings, remembering each as they were painted. The motif of the frontier in the center of each painting was a bold departure from her earlier work. Carlos heard the words "frontier," "border," and "divergence" in the conversations around him. Clearly her collectors understood the importance of these last canvases.

After an hour in the gallery, he bent down to read one of the cards. It said: *"Number Four Ninety-One, Collection of Carlos Barrington, Not For Sale."* He checked the other cards and they all attributed his name as the collector.

"Brompton asked me to list these paintings this way," said the gallery owner when questioned by Carlos. "She said that they are yours but she wished to have this exhibit, nevertheless."

"But surely they are part of her estate," Carlos said.

"No," the gallery owner replied. "On my last visit with her in Santa Fe, Brompton gave me a letter of intent clearly passing title to you. She instructed me to issue a sales receipt and to pay the necessary taxes immediately on my return to New York, which I did. As the last and probably best work, the paintings will demand a premium price should you decide to sell." The gallery owner's eyes glistened with anticipation.

Carlos paused a long time before answering. "I don't believe I do want to sell."

"These six paintings are an amazing burst of final genius. A super-nova of concluding light from Brompton. You are a very lucky young man."

Carlos nodded his assent. Beauty had, in its own curious way, survived death. He politely took his leave of the gallery owner and walked through the jostling crowds of a snowy Madison Avenue.

# Tokyo, of Course

Because her studio sign is small and overgrown by a neighbor's shrub, people looking for Marian Yamaguchi sometimes get lost and end up knocking on my door seeking direction, so I draw a small map and send them off back down the street. Marian is a friend and a dedicated painter who lives and works in Santa Fe. She is a widow of many years and her work, somewhat Japanese, vaguely modern, is well received by an international following of admirers.

Her long-time studio gallery is a block away from mine, around the corner on Delgado Street. If someone buys a canvas or drawing at the Yamaguchi Studio because of my map, she sends an assistant with a gift for me wrapped neatly in rice paper with raffia. It is a small piece of pale green porcelain, something crafted from black bamboo or one of her smaller unframed sketches. At home I have a shelf devoted to Marian's offerings from the sales that my maps generate.

She surprised the artist community by marrying Lewis Goldfarb, a widower from Trenton, New Jersey. This is a curious, intercontinental match; she is small and deliberately graceful, moving with quiet, inborn elegance and he is tall, raw-boned and cheerily awkward. The top of her head is the on level with his

elbow. Maybe because of this disparity, the union agrees enormously with them both. Lewis adopted with enthusiasm all things Japanese in honor of his new wife, selling his poultry business in the East and moving with gusto into a life as the artistic spouse.

While Marian works in the studio, he now tends the incipient moss garden at the side of their house and, following months of experiment, prepares very acceptable sushi and teriyaki. His bonsai collection grows and after a year of searching catalogs he orders from Kyoto several pair of gray cotton gardener's pajamas and two-toed clogs. I see him in the side garden attired thus almost every summer morning with his special bonsai secateurs and straw peasant's hat. Marian's friends consider her a very lucky woman, and for their anniversary she presents Lewis with an elegant black kimono with white piping around the collar. He has a broad smile of pride on the ceremonial occasions he wears it.

Lewis is tireless in the promotion of the works of his wife, whom he still refers to as "Mrs. Yamaguchi." Since her studio is several houses away from the moneyed crush of Canyon Road, Lewis spends hours at the corner, hoping to lure a collector off to Marian's secluded establishment. His tall stature in Nipponese regalia seldom fails to enchant the passing tourist and if the victim shows even minimal assent, Lewis drags him in an excitement of chatter to her door. Marian's calm determinism takes over from there. Many a visitor leaves with a canvas under the arm and smile on the face.

The fourth autumn of my stay in Santa Fe, Marian Yamaguchi is harvesting yellow pears from a tall ladder when she falls to her death. Our group of artists is stunned. Lewis

reverently performs a Shinto ceremony for the gathered friends, then instructs us in the launching of the paper boats with candles on the reservoir up Canyon Road. He grieves for many months and I don't see him again until the following summer.

At my studio door appears Lewis with a small package wrapped in rice paper with a raffia tie. I had earlier drawn a map to the Yamaguchi Studio for a prosperous-looking couple and this must be my reward. The package is even more expertly composed than Marian's were, as if sent by courier from an exclusive shop in the old country. He is tired and drawn.

"I want to thank you ever so much for sending customers by, like before," he says. "You know, things have been hard since Mrs. Yamaguchi passed on. People still love her work, though. She left so many unframed and unfinished pieces. They're much harder to sell than the finished ones."

"I understand, Lewis. I have some extra frames in the back. Would you like...?"

"No, no", he interrupts. "I can manage. Thank you all the same."

He looks around my studio with an attentive eye. "They say you are doing quite well here, and you haven't been here really all that long".

"Yes, I've been lucky, Lewis. Collectors seem to like what I do." I wonder if part of his visit is to ascertain if I might be siphoning off sales and collectors from the Yamaguchi Studio, now run totally by him. Perhaps I have secrets of display or framing or lighting that could account for my success.

After more scrutiny, he turns and walks to the door. I notice the gray pajamas are soiled and the two-toed clogs breaking apart.

We bow to each other and I watch him departing down the road with his own larger rendition of the quick-stepped Japanese walk.

That winter has a dozen snow storms, one after the other without respite. The task of snow-shoveling the sidewalk in front of the studio becomes tedious. This day, after a night of blizzard, is bright and white, sunlight raking across the pristine drifts. I shovel slowly, for a change enjoying the physical activity in brisk, clear air. Motor traffic is sparse so the silence envelopes each sound and amplifies it.

Another man and Lewis are bicycling slowly in the wheel-tracks toward me up Canyon Road. Lewis is wearing the black anniversary kimono. He cycles boldly erect, like a large, dark grasshopper. I can hear them talking a house away, wheels crunching as they follow single file, voices loud in the cold.

"And did you hear about the terrible fire in that department store downtown? It was truly awful. Dozens killed." It is Lewis's voice.

"Downtown where, Lewis?" asks his friend.

"Tokyo, of course," he replies.

# Fifty by Fifty

Mariana Benavides worked mornings for the painter Alabaster Prynne, doing the studio tasks that Prynne, at her great age, did not want to deal with anymore. She stretched canvases, cleaned the brushes and the knives, and she was learning the secrets of framing a canvas in Prynne's distinctive style. Prynne knew she had found a young jewel in Mariana, an agreeable sponge eager to absorb any of the studio knowledge that the older woman chose to divulge.

The morning was coming to a close when Prynne broke the silence that was customary in their working hours. "Mariana, my dear, how are you doing in your own work? What are you painting now?"

"I'm working on a large canvas. A scene of Santa Fe with the cathedral."

"Large? How large?" Prynne asked.

"Thirty six inches by twenty four inches. I bought a linen canvas at the art supply, already stretched."

"But that's not very large by modern standards, thirty six by twenty four."

"Papa says it is too large. He thinks that a *retablo* is just about the right size for a painting, any painting," Mariana said.

"Well, your papa is not wrong. He is, however, accustomed to working in the manner of the eighteenth century. Things were smaller then. Big pieces of anything were in short supply. Artists were lucky to find even a small piece of flat wood."

The two women continued work on the last of the canvases Prynne had ready for Mariana to stretch. Prynne held the frame square while Mariana pulled the linen fabric with the canvas pliers.

"So why is it better to paint large?" asked Mariana.

"It releases you as nothing else. A small painting can never be more than a painting; a large one can hope to be a universe or a new idea."

"How large?"

"At least fifty inches by fifty inches," said Prynne, describing with her long hands a canvas of that size.

"I will try one this week, Miss Prynne."

"Good. You're strong and can easily work on a panel of that size. There is the added value, Mariana, of your producing a piece that shocks, not expected from a young woman. A large size alone might be able to do that."

"That would please me."

"Take some of my stretchers and some of the primed canvas. You can pay me back when the painting sells. You'll love it so much, Mariana, you will never want to go back to the smaller sizes."

"Let me tell you what I have in mind."

"Absolutely not. Keep it a close secret until you show me the finished work."

Mariana left the Prynne Studio with her new supplies and walked a block up Canyon Road to her father's gallery, El Santero, subtitled Santa Fe's Best Family Art. For many years the Benavides

sold the *santos* and *retablos* carved and painted by their family artisans. Both her father's family, the Benavides, and her mother's, the Sanchez y Pinos, produced famous *santeros* for many generations.

Talent from both the Benavides line and the Sanchez line combined in Mariana; the judges at the annual Spanish Market picked the expert crafting of her *santos* for special mention when she was just fourteen. To have such ability in one so young was clearly miraculous, a gift from on high.

She worked for her father, a widower, at El Santero on most afternoons, selling the highly colored religious pieces that collectors expected from the Benavides clan. In the past years there had been a change in how pieces were produced for El Santero. Mariana's prodigious output had eclipsed that of her older brother, Juanito, and even of her father. Her artistic vigor was a major family asset, especially since their mother could no longer add to the family enterprise.

"Mariana, please stay here while I walk down to the bank with the deposit."

"Yes, Papa."

"If I'm late, my dear, please close up the gallery at five." He left with the small canvas bag under his arm like a purse.

Mariana knew that Papa would be late. The trip to the bank was customarily followed by several hours with his friends on the benches of the Plaza, and it could conclude with a look into the Plaza Bar. Papa could be very late on bank deposit days.

The tourist traffic was slow on Canyon Road, so Mariana retreated to the small studio at the rear of El Santero, where she could work and watch the front door. She put aside the pile of *retablo* blanks and put her thirty-six by twenty-four canvas on the

easel. The rest of the family preferred to work sitting at the kitchen table, but Mariana early on asked for an easel so she could paint standing up.

She attended to the last touches on her cathedral scene for a few minutes. The clouds behind wanted a thin white line on the sunny side and the church needed some red touches in the shadows. Painting in oils on canvas was a release for Mariana from the tight-fisted renditions of the *santos*. She took to the oily medium right from the start and now, ten paintings later, she showed a natural bent for easel painting. A few more minutes of deft tweaking on the cathedral and it was done.

Putting aside the finished cathedral scene, she stretched the large canvas. It was on the easel when Juanito came in the back studio door. The years of sitting at the kitchen table combined with the generous portions of beans and chile were already showing on Juanito, heavy for his young years.

"What are you doing?" he asked.

"A large, modern painting."

"You know that Papa doesn't approve of modern paintings."

"Go away."

"You've been listening to Miss Prynne."

"What if I have?" she said.

"Papa says you shouldn't spend extra time with people like her."

"I don't care. She's an artist, and Papa also says that talent is a gift from God. If that's so, God loves her very much."

Contradictions did not sit well with Juanito and that ended their exchange. He sat down at the studio table with a stolid thump and continued his work on the rays of light from *Nuestra Senora*.

Juanito's *retablos* of the blessed Virgin were sought for their painstaking detail, from collectors for whom painstaking detail was all that mattered. The delicacy of the nimbus around his Guadalupe images was unsurpassed by anyone else in the Benavides family. He returned to the comfort of working on it in times of personal stress, his own island of solace.

Mariana started to mix the colors for her painting. She admitted, but only to herself, that the project frightened her in a new way. She had faced and solved the many problems of replicating the traditions of the *santos*, giving them an authenticity that eluded the rest of her family. She knew all about the small pieces and how to make them sing.

Now, there were new dangers in this large canvas, unknown ideas and concerns that she must guide through or around. First, she realized that while standing at the easel in front of her large canvas she could not look at it all at once. She had to look left and then right, up and then down to take it all in. It seemed a massive ground of white, pristine and threatening. It could be a blizzard already or the sun-washed white wall of an Aegean house or the hallway of the Loretto nunnery. Maybe that was what Miss Prynne meant about its being a universe and the beginning of an idea.

She hesitated so long that Juanito, looking up from his nimbus rays, sensed her lack of direction.

"You're afraid, aren't you? Afraid of what Papa will say?" he said.

"Leave me alone, Juanito."

"So what is it going to be?"

"I think a landscape. But maybe not a real landscape."

Mariana was accustomed to painting with others of her family around.

She could not imagine working any other way, in fact. So Juanito's interruption of her thought process did not endanger her as it might an artist adapted to solitude in the studio. His attack actually galvanized her into making the first stroke, a red horizon line across the whole canvas, high with only a sliver of space for the sky and mountains.

She stood back and looked. She could hear Miss Prynne saying, *A good beginning and you're halfway there.* The old woman had a store of maxims about art that Mariana let come up in her mind like opera subtitles while she painted. They often steered her away from dangerous turns in the process of painting.

Juanito left the studio after an hour of work. Mariana felt that this part of her painting would come best if she was left to herself, without family comment. A trickle of customers, including the sale of a large *milagro,* slowed her painting. Papa would be pleased when he finally returned after sunset. Otherwise, she virtually had the afternoon to herself.

It was to be a landscape of the mind. A landscape of New Mexico, however, because that was the only landscape in her mind. Range upon range of distant mountains made receding purples above the horizon. Below that came successions of sienna hills dappled with pinons, barrancas, river banks with side choirs of chamisa and a foreground of grasses in many varieties. In several hours, she had the whole painting sketched in one coat of thin paint and it excited her as nothing else she had ever done. She knew that Papa would be angry about the drips on the floor, but Miss Prynne's voice was clear on that: *Neatness is the death of art.*

Something was still missing. Mariana sensed its lack, but could not identify it. Perhaps it would become apparent further on. With so much progress in a single afternoon, she quit at dusk with a feeling of pride and thrill. Promising as it was to her eyes, she knew it would be better to present the family with a finished painting than letting them in at this stage. *Keep the studio door locked.*

Hiding it in the basement was out of the question as one of the family went down almost every day for the supplies stored there. There was a false ceiling in El Santero; Mariana climbed the studio ladder and pushed open the trap-door. Her painting would be safe there until she could work on it again. She cleaned up her splatters on the floors and pushed the easel away against the wall.

Juanito came in the back door. "Where is it? You look guilty. Didn't work out, did it?"

"I gave it up." She felt that was not exactly a lie.

"Good. Papa will be happy. Then you can get back to family work again."

Mariana looked without expression at Juanito.

When Papa finally arrived after sunset, he went right to his bedroom in the back house where the whole family lived. Juanito and Mariana had already eaten and cleaned up the kitchen. If they sparred over the studio work, they worked together in the kitchen without quarrels since their mother died three years ago. Juanito had become a good cook, food being important to him, and Mariana was a quick study as kitchen help.

More often than not, it was a dinner for three at the kitchen table of the back house, except on the nights Papa made the deposit. Occasionally cousins or uncles and their families would join them. Juanito and Mariana kept the tradition of family dinners going, sensing its importance in Papa's recovery. The two children

knew the grief that Papa still felt and allowed his occasional misbehavior without comment.

For the next several days, she did not have time to work on her landscape. She spent mornings with Miss Prynne, but her thoughts were on the painting.

"*Ca va*, Mariana?" said Prynne.

"Well. I will show you my painting soon."

"It's wise to keep your own counsel now. Everything is too tender to touch, like new skin on a wound."

"Yes."

"Now, let's gesso those panels over there. They'll need three coats with sanding afterwards."

Then one afternoon when Juanito was out with his friends while Papa napped in the back house, Mariana saw an opportunity to work. She retrieved the canvas from the false ceiling.

Two hours were enough to turn the corner. She brought up details in the chamisas and the grasses, refined the shadows along the riverbank and the barrancas. It still needed something she could not put into words or thoughts. Maybe the next session. *Keep painting through the middle of a painting, don't lose momentum.*

It was a journey to a place she had never been. She was aware that she was on the right track, however much she hid her efforts in the ceiling. The next deposit day, Juanito was away again with friends and she had another entire afternoon for work. She made further refinements everywhere on the canvas, and replaced some whole areas of color with different colors, often only the thinnest change of shade. The purple-blue of the distant mountains, now more intensely blue, shone against the reddish earth colors below. Mariana thought she was nearly done, except for that something. Miss Prynne would know.

"May I show you, Miss Prynne?" she said on the phone.

"How exciting. Come right away," was the answer.

Closing El Santero early, she carried the canvas down Canyon Road, face away from the traffic, to the Prynne studio. The front rooms of the Prynne studio were reserved for display and viewing, so Mariana hung her painting on the wall across from the front door. To her it still looked lacking, unfinished.

Prynne came in the front door behind her. "I'll bring us some chairs, Mariana. This is an exciting day."

After they were seated, Prynne said, "Let's just look for a while."

Early on Prynne made a ceremony of viewing paintings with respect and silence. It was Mariana who brought the chairs when one of Prynne's canvases was done, so she understood this reversal of roles. The two of them often sat looking for several minutes and then discussed the work.

Prynne broke the silence.

"To start with, it's an impressive work for one so young. Do you like the fifty by fifty?"

"Yes. It's difficult to see it all at once when I'm at the easel."

"Exactly. I see some unfinished areas, there and there and there." Prynne got up from her chair and pointed to each. "Mystery is good in a painting. I would not change or refine them at all. That will be hard for you to resist, I know. It gives the viewer a little something to do, to find answers for himself to some of the unknowns."

Mariana knew that Prynne could see the ingredient that was missing, but she waited for her to bring up the subject.

"People from elsewhere are misled that New Mexico is all sunny days and bleached bones," said Prynne.

"What then?"

"In the years I sketched in Galisteo, I looked across the landscape there for long afternoons. There were always those treble notes and trills, high-lights and brightness, which you have captured admirably. Especially those hot grasses in the foreground. But I could always see a darkness somewhere to alleviate the brilliance, to give it gravitas."

Mariana did not know what gravitas was. She said, "What must I do?"

"Sometimes I saw a cloud's shadow moving somberly across. Or perhaps a maroon-black outcropping of lava rock. Or a group of junipers turned to a black-green in the midst of lighter green fellows. There are many ways that night finds its place in the day."

They sat looking in silence for a few minutes. Mariana asked, "Could I put a long dark shadow here?" indicating a place in the high background.

"That's for you to decide, dear. You're almost there, though. Be careful not to go too far. You mustn't spoil this wonderful start."

By the time she got the painting back in its hiding place in the false ceiling, it was dark. She went to the back house to help Juanito, who was assembling a chicken enchilada. While she chopped the onions and the cilantro, Miss Prynne's words reeled about in her mind.

Juanito, noticing her distraction, said, "You're still working on it, aren't you?"

"Yes. It's almost done."

"What do you think of it?"

"I think it is good, Juanito. At least, almost good."

"When are you going to show it to Papa?"

"Tomorrow. When it's done."

"I want to be there. By the way, it doesn't look exactly square to me."

"You're so cruel, Juanito. Why don't you help me?"

He smiled as he put the enchilada in the hot oven and said nothing. The subject was not brought up during dinner. Instead, Papa talked about family news: funerals, ailments and confirmations. Mariana was eager to go to bed, so she could get up early and work on her canvas.

Morning came. She left the back house quietly, hurried to the studio building and set up her painting on the easel in the studio. Considering Miss Prynne's advisement about darkness, she opted for a long black shadow in the far distance. It took half an hour to insert the shadow, an active thin line across the whole canvas, just below the horizon line. It skirted around some of the trees, enveloped others, widened and narrowed. Then the colors on either side of it needed slight changes, to make the shadow "sit" properly. Then the line itself, slightly lightened to make it sit even deeper. Finally, the fifty by fifty was done.

She stood back to observe. The dark shadow pulled the elements of her landscape together as nothing else, drawing the eye deep into the canvas across layers of grass and sagebrush. Miss Prynne was right as usual. Mariana felt an elation and a first glimmer of the fulfilling companion that art would become for her.

Then she heard Juanito and Papa talking as they approached the studio. The door opened and the two walked in.

"Good morning, Mariana," said Papa, not taking in the situation yet.

"Hello, Papa."

"Look what Mariana's been doing, Papa," said Juanito.

Papa first opened in surprise, then narrowed his eyes, seeing only the huge size of her canvas from his vantage. He came around to view the painting from Mariana's point of view. He stood in silence.

"It's so much larger than what we do. I don't know what to say," he said.

Mariana had expected his anger and now, for the first time, she felt guilt over her project. It was as if she had hit him and he was reeling. Papa was clinging to what remained of his family and she knew any change for him was a threat. Even her growing up was a threat. Now this open rebellion. Somehow the threat of a dangerous Papa disappeared and was replaced by a lonely, aging Papa this morning.

Juanito said, "She's going to be famous, Papa. We should be happy for her."

Mariana could barely believe her ears. Juanito supported her after all. The three of them stood for a few minutes just looking at the large painting, which seemed to burst with light on the easel. Mariana knew that the secret Miss Prynne had given her of the power of a large painting was what made this possible.

"I am proud of you, Mariana," Papa said, putting his arm around her shoulder. "Juanito has just been telling me how hard you have worked. I would not have expected such a painting from a young girl."

"Thank you. I promise I will keep painting the *santos*, as well. I am sorry if I have hurt you." She kissed his cheek. She had a sense of herself growing taller and taller, and Papa diminishing, his slumped shoulders looking lower than ever.

"Your birth gave your mother pain. Now it is my time." He walked closer to the painting on the easel. "I do not know about modern art. Is this good?"

"It *is* good, Papa."

He said, "I thought so, but it doesn't look exactly square, as Juanito says. Look out for that on the next one. Now let us decide where we will hang it. A place of honor in the front gallery. After all, our sign says 'Santa Fe's Best Family Art'." If the star of Mariana was rising, the rest of the Benavides were not going to be left behind in the dark.

# Nature to Advantage Dressed

**A** fortuitous turn of events made the Venetian studio at Casa Marchment mine, if only for a while. Karl Hendrik said he had received a windfall bequest from a painter friend and was off to Europe for a year or so, leaving his studio empty. Remembering my interest, he called to ask if I wanted to sublet the studio. I took his offer in an instant. He made it clear, however, that it would be returned to him when he came back to Santa Fe.

I was excited and happy when I moved in on a spring morning in the middle of thundershowers, hail and lightning. My wet easel and painting table looked like lonely refugees in the vastness of that noble room. The sixty foot length of the sienna-red ceiling had beams picked out with lines of golden stars, and gondolier lanterns angled out from the walls. A skylight with windows recalling San Marco centered the room, and the rain made pelting noises on the glass. The storm outside tried to ruin the day, but all of Venice turned out in dark dress to greet me and I felt enfolded in their secret warmth.

My first task was the formality of an interview with the owner, Henrietta Marchment. She was the daughter of Victor Marchment, a loquacious landscapist who worked in Santa Fe in the thirties and forties. At his death, he left her the large house

and studios called Casa Marchment on Camino del Monte Sol. Since she needed the income, the rental of her father's studios was a necessity and she took to the role of landlady with a natural ease.

Henrietta agreed to the sublet because she knew and liked my work; she had remarked to Karl on the similarity of my Mannerist technique with that of her father. She also told him that I must come by her office for a discussion immediately on my arrival.

I walked around outside to the front door. Senora Dominguez, Henrietta's cook and housekeeper, answered the bell after a long wait. Senora was short and thin with an impressive single eyebrow across a pair of suspicious eyes. She opened the door only enough to peer out.

"I have an appointment...with Miss Marchment."

"*Sí*." She opened the door some more, perhaps only halfway, and led me down the hall to the library where Henrietta kept her office and met visitors. Senora announced me at the open door and slipped into the darkness of the hall beyond. Dozens of birds in cages took up screaming and clucking.

"Please sit here." Henrietta had a long face with the dark eyes of a Byzantine saint. I knew she had a hard time keeping Casa Marchment afloat, despite the six rental studios and occasional sale of a Marchment landscape. I admired her style in adversity.

She wore a floor-length dark maroon robe with a garnet-studded crucifix on a golden chain, which accented her Levantine coloring. There was a tall chair beside her desk, into which she motioned me and put her hand up, signaling to wait until the

noise subsided. We sat for a full minute, not looking at each other, before the birds settled down.

She was first to speak. "I am sorry to lose Karl to France. Nevertheless, he will return. He has told you about Casa Marchment, no? Our ways of doing things and the other painters here?" I nodded, so she continued. "Now tell me about you and the work you will do here."

"I've been in Santa Fe for five years, painting landscapes, mostly, but also gardens. Large paintings, five feet by five feet. I had to work days with a house builder at first, painting at night. But, for the last two years, I've been able to paint full-time.

"You must have been delighted. It's always exciting when an artist breaks from the shore."

"The Ludlow Gallery handles the work, and, so far, I've had good luck with sales. Having Karl's studio will let me do even larger paintings.'

"Oils?"

"No, acrylics. I painted with oils for years, but now I find acrylics more to my liking."

"You could go back to oils, if you chose?"

"I could, but it's doubtful. Acrylics seem right to me now."

"I would like to see some of your earlier oils. The smaller paintings like these in your catalog from the Ludlow Gallery." She held of a copy of an out-of-date catalog entitled "*Galisteo, the Landscape*". It was from my first solo show in Santa Fe. Karl must have given it to her.

"I was just unpacking things in the studio and there are five or six of those early oils left. Would you like to see them today?"

"Very much. I will come by this afternoon at three. Welcome to Casa Marchment. I hope you do good work here." Henrietta stood up with her palms down on the desk. The interview was clearly over.

I spent the rest of the morning uncrating more of my paint gear in the Venetian studio. Several years after Victor's death, Henrietta had the wisdom to take command of her major asset, the forty-room adobe house. She reconfigured the house so that six painters could have separate living quarters and one of Victor's graciously large studios en suite. The other studios had Moroccan, Chinese and Indonesian themes, built when Victor tired of the old studio and built his way into new inspiration. They were all large and impressive, but the Venetian studio was the one that set my mind afire when I first saw it. Now it was mine for a year or so.

I set the table with the tubes of paint going from violet-blue on the left, through the blues, greens and yellows to cadmium red on the right. Earth colors, siennas and ochres, and whites on the row behind. I cleaned the brushes and filled the cans with fresh water. I placed the first canvas for the new studio on the easel and watched its pristine anticipation. A new white canvas was a new chapter to life, surely an absolution from the wrongs, and the failures of paintings that went before.

When the storm quit in the early afternoon, sunlight streamed through the skylight, giving the center of the room a stage-like prominence and darkening the walls. I imagined I could smell the moisture from the Grand Canal, mixed with spices and aromas from the Adriatic lagoon.

Karl had left some canvas racks on the far wall, so I put away the white, unused canvases in the left slots and the finished

work on the right. The early oils I put aside against the wall.

Several had cobwebs and dog-hair, which I brushed off, and I dusted the front surfaces with a cotton cloth. All were landscapes of the Galisteo Basin with its ochres, red earth and burnt siennas. I placed them in a row near the skylight. Then I got to work in the small bedroom, arranging linens and clothes.

At three, Henrietta knocked. "You're settled already. Everything it its place." She walked over to the painting table and nodded approvingly at the order there. She had an odd, quick-stepped walk that took her quickly to her destination, then left her suddenly still at a slight angle from the upright.

"It won't last long that way," I said. "Once I start painting the table starts to look like a dog's breakfast."

"Every painter creates his own order." She saw the oil paintings against the wall and picked them up in turn for scrutiny, without comment. Two she brought to the center of the room and held them high under the brightness of the skylight.

"Papa loved painting the Galisteo Basin. The roads were poor there in the thirties, rough and muddy, so he packed in on horseback all over the basin. He always went with his man, Paulo Dominguez, the Senora's husband. Nothing was too difficult in his pursuit of beauty. Many wonderful paintings." She gave me an intense look as if inspecting for dirt behind my ears. "But here you have caught something of its dark charm."

Several weeks passed before Henrietta brought up Galisteo again. A simple breakfast in the main house was included in the studio rent at Casa Marchment. We were alone together in the kitchen, sitting opposite one another at the long pine table.

"It's so sad," she said.

"What?"

"Many of Victor's paintings were left unfinished at his death. I have over a hundred of these. They include so much beauty, now unseen in melancholy stacks. Looking at your work the other day reminded me of my important role as artistic executor."

"What is that?"

"I must see that his work, his version of beauty, is available to the rest of the world. Even unfinished the paintings of Galisteo resonate with his joy in the long lines of that landscape. It's sad to see them so neglected every time I go into his studio, like ghosts between this world and that."

"Could I see them sometime?"

"Perhaps."

Of course, she had lured me into being the one who asked, but I did not see that then. I did ask again a week later when we were alone at breakfast. She said maybe later.

In a few weeks, I brought up the subject a third time. At first, she did not answer me at all, merely turning around her coffee cup. We sat in silence as she gazed out the window, as if mulling over the legality of the request. When she finally did assent, it was only with a conspiratorial, "Come with me."

I followed her through the maze of rooms she kept as her personal quarters. Victor, lightly accusing himself of the imperial vice of over-building, added rooms as well as studios to his residence. A low doorway led to a small hall, beyond that was a long sitting room, and beyond that, more rooms still. All were dark with oaken furniture of Spanish design, and even though the rooms were impeccably clean, they smelled of wax, airless and unused. We came to Victor's studio, which she unlocked.

"Nobody comes here now. It was alive with visitors before father died. Now the museum people want to come by and a woman at the university wants to compile the *Catalogue Raisoneé*, but I tell them all no. I'm not ready to let in the hordes," she said as she pulled aside the long canvas draperies covering the north window.

Light flooded into the large square room, very unlike the Venetian studio. Walls and ceiling were painted a flat white; the floor was a pale flagstone. Shuttered cabinets for art supplies lined an entire wall, one cabinet with its door ajar. Neat rows of paint tubes filled the shelves from floor to ceiling. Victor had bought art supplies like he did everything else, with abandon and in abundance.

Rows of canvases were in a rack on the other wall. Two white-painted easels stood in the light by the north window with an unfinished canvas on each of them. They were Galisteo landscapes. Henrietta had set these up in advance for me, props for some yet-to-be-revealed drama. What else in that studio was I meant to take note of?

I recognized on the first easel the scene of red cliffs and gray-green underbrush in the foreground. It was a site I had painted too, a trek of several miles from the nearest road. The stream, cliffs and hills were in a finished state, touched by a raking, late afternoon light, but the sky portion of the picture was unpainted white canvas. A section of the right foreground was also unfinished. Victor used the same high horizon that I prefer, emphasizing the tumble of grasses, rocks and shrub in the foreground.

"I know this place. It's hard to get there, well down the river. I did several from the same point of view. Amazing how

unchanged these places in Galisteo are after fifty years. He captured it exactly."

Henrietta came close to the canvas. "You see the similarities?" She pointed, palm upwards, to the cliffs and hills, then turned to look at me. "He used a brighter, narrower brush and less medium in the paint itself, but there is a sameness of spirit. Undeniable. Your color choices are very alike and the scumbling of the foreground is almost exactly the same. Of course, his work is suffused with a lifetime of individual expertise which, in time, you may approach as well."

I picked up the canvas from the second easel. This was a view of the ruins of Pueblo Blanco with its pale, serpentine cliffs. The bottom third of the canvas remained only as a pencil sketch. Another difficult hike across badlands to get to this site.

"Also unfinished. A lovely fragment. A shard." Henrietta said.

The visit to Victor's studio inspired me to look through my sketches and photographs of Galisteo, and I started a large version of the major bend in the river there. It went well, so in the weeks following I continued a series of very large landscapes in a more contemporary style than in Victor's or my earlier oils. The Venetian studio was starting to become mine as the finished canvases built up in stacks against the walls. The spirits of Karl, Victor and all who went before were becoming faint.

I soon got to know the six other painters at Casa Marchment and their unique studios. Arla Putnam, particularly, was friendly to me and welcomed me in her studio, the one with the Balinese flavor. Arla told me that she was turned down when she submitted drawings for Henrietta's scrutiny, a necessity for most painters' acceptance into the Casa Marchment family.

"Blue ball-point. How could you?" were Henrietta's first words.

"I think ball-point drawings have a contemporary validity," returned Arla.

"Not at Casa Marchment."

Arla correctly read the finality in the older woman's statement. Even though she was to be later given a solo exhibit at the museum based on the brilliance of these same blue ballpoint drawings, she wisely took no offense.

"Give me a week, then. Don't rent the studio to anyone else. Okay?"

Henrietta agreed and Arla produced a completely new portfolio of sepia ink drawings using a bamboo nib, all portraits of Henrietta in period dress. One group had her at a French writing desk reminiscent of Colette. Others had her in elaborate Louis XIV apparel, a monarch with hand high on a bejeweled staff, cascades of hair in curled ringlets. Henrietta, susceptible to humor and flattery, accepted Arla on the spot.

On one visit to her studio, I saw a collection of Arla's new work, portraits of Senora Dominguez. "Are these for a gallery show?" I asked.

Arla was a small woman with brown hair and dark eyes; she had an impelling magnetism in her gaze. "Yes and no" she said. "I don't like painting on a deadline, so I wait until I have enough related paintings for an exhibit. I just keep plugging ahead until that happens."

The portraits of Senora were in different styles and techniques. Several were Picassoesque and some others favored Frieda Kahlo.

"What about that one?", I asked. It was a lustrous Pre-Raphaelite rendering of Senora at prayer under blooming apple trees, black ravens on power lines above.

"I did it just for fun. I wanted to try a slick presentation like Alma-Tadema, using all the traditional painting methods but with some modern elements."

"And that one?" Here was a Matisse-like interior with Senora in a dark green flowered dress, sitting boldly upright in front of yellow shutters, bright day showing through the slats.

"I admire Matisse and wanted to try out his ideas. I get bored with painting the same way all the time." And there were other versions of Senora as well: a Van Gogh one, a Bonnard one with an orange Senora falling out of bottom of the picture frame, and several unfinished panels that revealed Arla's impeccable drawing ability.

"You've captured the woman, although I think Henrietta would have been a better subject," I said.

"Senora has her afternoons free when Henrietta doesn't need her and she's very patient. I decided that if the subject remained the same and the style differs, it would become a show of painting technique."

"So Senora is inconsequential. She could have easily been a stool, an ashcan or a book?"

"Yes, I guess so. She and I have become buddies. She tells me stories of Old Santa Fe and she loves Henrietta totally."

"She worries me with those Andalusian eyebrows. Senora doesn't like men, I think."

"Underneath there's a real sweetie-pie."

"I'm not so sure."

As the months went by Henrietta avoided the subject of her father's work and I was busy with the concerns of my own paintings. A solo exhibit was scheduled at the Ludlow Gallery that summer so my focus narrowed to the matter of completing the agreed-upon number of canvases. The opening reception for my new work drew a crush of local people but few sales.

The days after a solo exhibit can be difficult for most painters, as they search around for new energy and new motifs. When the burst of energy that propels the artist through the exhibit relaxes, depression can set in.

The gallery sold two of my new Galisteo Bend landscapes on the opening night but the rest remained unsold, some twenty-four canvases. Several people at the reception told me that the paintings were too large for most collectors; only corporations or museums could handle work of those dimensions. In response to this, I was considering the prospect of switching to miniature canvases on the second morning after my exhibit. Henrietta knocked on the studio door.

"Good morning. Do you have a moment to talk?" she said. She sat in the chair opposite me.

"Yes. I was just sitting here, deciding what to do next."

"I thought that might be the case. Post-exhibit let-down?"

"Yes. I'm afraid so."

"I have a proposition for you. A diversion, perhaps. A project to get you back on the path." She looked around the studio. "Would you consider helping with the finish of a few of Victor's paintings? Don't say no right off the bat. I've tried to work on them myself, but I somehow lack the verve. The portions I've done look listless and unhappy, awkward even to my eye. I must destroy them."

**84**

I said nothing, thinking about the matter.

She continued, "I've always thought a woman could do anything a man can do, but these paintings have me flummoxed. I really believe only a man can finish them. They need a special touch of genius like Papa's and I am sure you are the one for the project."

"I don't know, Henrietta."

"I would pay you in cash so there would never be a record of it, and I would want you to use Papa's own brushes and paints, always in his studio." She paused and assessed the effect of her words.

Then she said, "You, of course, must find your own motives to finish another man's work. I would suggest it is a learning process. It also allows these forgotten canvases to be seen, appreciated. In a way..."

I interrupted, "Let me think about it, Henrietta. My motive, if I do work on them, would only be the money involved. Right now, I need it, what with the expenses of the show and lack of sales the other night. I'll let you know tomorrow."

She left and I did think about it all that day. I guessed it was not illegal to finish work already under way and I would not be signing his name like a forger. I rationalized that it was merely an expanded version of restoration, pushing the art of retouching to its outer legal limits. I briefly considered getting my job back with the building contractor, painting at night again. Since that was most unappealing, I agreed to take on the Marchment Completions.

The rest of the summer I worked each morning in Victor's white studio, enjoying the time in that light-filled space. I kept looking at a framed photo of Victor painting in Galisteo; he wore

a pale linen suit, tie and large hat and sat on a shooting stick in the shade of a dark umbrella. The Galisteo Creston brooded in the distance. Rodriguez was off in the out-of-focus distance in the shade of a tree with the horses.

The Marchment Completions were largely matters of finishing shrubs already started here and grasses there, and, perhaps, adding a stretch of pale blue sky across the top. On several pictures, I reconstructed major portions of the motif, blending the new with the old. I liked working with Victor's narrow brushes and I quickly got the rhythm of his distinctive brushstroke, a rectangle about 3/16 inches wide by 7/8 long. His old tubes of oils were more buttery and glossier than I remembered oil paints to be; I quite warmed to using them to best effect.

By the end of September, I had finished fifteen canvases and decided to end the project. Henrietta presented me with the total fee in cash, a bigger pile than I had ever seen before. Where had she found this heap of cash? Had she saved up this treasure from the proceeds of kitchen economies and from the sale of the authentic Marchment paintings? I decided the source of the money was not my concern.

With the cash, I paid all my living expenses for several years, until my paintings started to sell again. Henrietta observed the forging process all along, but never coached or suggested anything. I got to like her and looked forward to our breakfasts.

"So what do you think you'll do now?" she asked me one day at the long pine table.

"I think I'll do what Karl did, go to Europe."

"France steals all my painters."

The thought occurred to me for the first time. I wondered if Karl had worked on Victor's paintings, too. "Did you hire Karl, as well?" I asked.

"Of course. He had an adroit touch, particularly with the mountain scenes and the water paintings. Not a natural gift like you. We had to work on his adaptation of Victor's style, but he caught on after a bit. I never let him work on the Galisteo pieces, though."

"So Karl's bequest from a painter friend, the money to go to Europe, was really from you?"

"In a circuitous way it was from Victor Marchment," she said.

"And what about Arla?" I said, wanting to pursue the matter more fully.

"Yes. She did the Abiquiu and Black Mesa motifs."

"But all that talk about needing a man to finish them was just palaver?"

"Not entirely. Arla might as well be a man; she paints like one. Extraordinary artist. Can do anything well. She immediately understood the nuances of Victor's skill. She has a way with the sunset light neither of you men could have handled. In a way, she caught the polish and finesse of Papa's female side."

I moved out of Casa Marchment the next year when Karl returned. The large bend-in-the-river panels finally caught on with collectors and I built a studio for myself behind a small adobe house on Canyon Road. Eventually, I quit the Galisteo motifs and started to paint corners of my own garden. I lost track of Henrietta after a few years and heard nothing more about the sales of Victor Marchment's work.

The Fine Arts Museum was the beneficiary for all of Henrietta's estate when she died, some twenty years after my stay at Casa Marchment. I read in the paper that the house and studios were to become a branch of the museum, featuring the paintings of Victor Marchment. His canvases, which back then found a slow market, now sold easily for six figures at the high-end galleries downtown and a definitive book was in the works. The world knew about Victor Marchment now.

A year after the Marchment Annex opened, I saw an announcement of a symposium by assorted curators from museums across the nation. The theme of the lectures was "Sense of Place in Marchment Paintings." I thought it might be a good time for my first look at the new annex.

I called Arla to see if she would like lunch and a lecture. She and Karl had married a few years back, so she brought him along and afterwards the three of us headed up to familiar territory on the Camino del Monte Sol. All the studios and sitting rooms were now converted to gallery spaces, with Marchment paintings in about half the house. We looked briefly into Henrietta's library, strangely silent without the avian uproar. I hunted for bird droppings that might have survived the refurbishment, but the old floors were now pristine.

The other rooms of Casa Marchment were filled with the paintings of Victor Higgins, Walter Ufer and the other New Mexico painters from generations ago. It was the precisely right setting for Santa Fe and Taos landscapes. After the lecture, we toured the other galleries of landscape paintings, wondering which were the ones Henrietta had stage-managed to completion. There were no telltale ways to distinguish the authentic from the spurious.

I asked, "Do you know if Henrietta hired other artists at Casa Marchment?"

"No, I don't think so," said Arla.

"No, it was just the three of us," said Karl. "Henrietta complained to me of not finding suitable talent anymore. She said the art faculties of our country were long over-due for severe punishment."

We turned into the Venetian studio. Twenty paintings were widely spaced around the freshly painted walls of that large room. Museum technicians had lighted each canvas in a pool of warm light from overhead, retaining the center skylight to light a long refectory table displaying Indian pots and kachinas. One long wall displayed only Marchment paintings.

"That's one of mine," said Arla, pointing to a sunset scene. The sky was a bravura rendition of rectangular brush-strokes, the circles and globes of clouds depicted with interlocking clusters of square components. All the colors were suffused in the golden light of late afternoon. Arla had mastered the Marchment touch.

"And that," she pointed to another sunset scene. It had the same cloud forms composed of tesserae-like brushwork.

"Here the work of the woman who paints like a man," said Karl, smiling, as he pointed to her canvas expansively like a museum docent.

"Don't be unkind, Karl," she said. "Henrietta foisted that title off on me. I think I paint like a woman and I defy anyone to tell the difference between a painting by a man and a painting by a woman."

I interposed. "The difference is you can really paint, Arla. Ignore him. How long did you work on these?"

"I think these went quickly. The better ones always seem to."

"A couple of mine are over there," Karl said. Both were waterfalls along the Tesuque River: cool, foamy water with touches of violet under-painting showing through here and there. The bold iciness of the cascades played against dark rocks and water-edge grasses, all with that distinctive jumble-of-rectangles brushwork. He, too, had rendered a deft, believable version of the Marchment technique.

He said, "They look so legitimate, I almost don't recognize them. I honestly would not question a thing about Arla's or mine. Maybe it's this setting of Casa Marchment that validates them."

We found several of mine in the main hallway. Karl was accurate in saying that the paintings took on a genuine quality in this venue. But the more I looked, the more I realized that on their own, apart from the substantiating powers of the gallery presentation, all of our re-workings appeared incredibly authentic.

"I somehow don't feel so much the charlatan anymore," I said. "I can almost think of these as Victor's own work. I'm glad we came."

Henrietta had not sold any of our forgeries, leaving them in the canvas racks of Victor's studio. Time had wrought its magic on the surfaces we painted, melding them to the original portions and giving them a slight coating of dust and small flyspecks here and there. The paint on the thicker, impasto portions was starting to craze. I wondered if Henrietta gave our forgeries long exposures to the New Mexico sun to achieve this. Victor's technique was his signature. When the museum people took charge, there would have been no issue of authenticity for these pieces.

**90**

After all, they had the best provenance: the artist's own studio and a bequest from the artist's own daughter. Who would question such verity? Tests, should they ever be performed, would prove that the brushes and paints were similar to the other paintings and the linen canvas was of the period. Henrietta had truly preserved the beauty that Victor began and, with just a little help from her friends, proved herself a most skillful artistic executor.

On the way out we each bought a copy of the definitive book on the paintings of Victor Marchment at the museum shop, the *Catalogue Raisonneé*. The shiny cover contained a volume heavy with illustrations and essays.

In the sunlight outside, we were thinking the same thought as we quickly turned through the pages: had the official chroniclers been fooled as well? Arla with a broad smile opened her copy to the page with her painting and held it up for us see. She danced in circles as we headed to the car park, open book held high above her head. We wordlessly drove away with three smiles.

# A Fine Regional Painter

**S**axon Pollard scheduled a close succession of visitors for the studio, all to arrive after two in the afternoon. He felt down deep that it was going to be a good day, with several important matters to be settled. Perhaps, if the gods smiled, it would culminate in a major purchase by a noted Santa Fe collector.

He worked in the morning to set things straight, replacing the almost blank canvas on the easel with one that was nearly finished. Visitors liked to see art in action, but too little on the canvas could be confusing.

He tidied the painting table and refilled the pale-green Venetian glass bowl with the turpentine he used for washing brushes. The smell of pine resin filled the room. Guests often remarked on the wonderful aroma of his studio, redolent of creativity. He was proud of his studio, a work of art in its own right. This was the room that several books and magazines had immortalized as the high-water mark of Santa Fe style.

At mid-afternoon, the first to arrive was Rosalind Whitethorne, an Englishwoman and the arbiter of taste in Santa Fe. She would choose three paintings to be included in the Biennial Exhibit for which she was the sole curator. No one questioned Whitethorne's keen eye, honed to an edge before her Santa Fe

years when she wrote art columns for New York magazines and newspapers of note. A few years ago a publisher of art books pulled together her articles into a long volume and it was now very popular with the younger artists who had missed them the first time around.

Since both he and Whitethorne were included at dinners and luncheons in east-side Santa Fe, Pollard knew her socially, if not well. This lessened the fear that her knock on the studio door brought to a painter of lower rank. Pollard escorted her into his high-ceilinged studio and got her settled into a cushioned chair. Whitethorne was quick to ask for a hard chair without pillows.

She was small and wan, pale blue eyes with pink rims and thinning white hair cut in a pageboy. She wore a gray, polyester pants suit with a squash blossom necklace of sterling silver and chunky turquoise. If never effusive, she was always polite with Pollard on social occasions and acknowledged his reputation. From the start of this studio visit, however, she was all business.

"Pollard, tell me what you want me to see," she said in clipped tones. Whitethorne always referred to artists by their last names. She looked at the painting he had pulled out of the storage racks and leaned against the wall.

"I cannot, Rosalind, but I can tell you what inspired this piece."

"What, then?"

"The small stream in the mountains above Santa Fe, as it was in late September. It might be all streams or any stream. I went for the universality of the splashing water and surrounded it with the autumnal colors I like, an occasional touch of green for a remembrance of summer."

"Like a transcription?" she asked.

"Exactly. All these pieces describe a scene once-removed in my mind, as if a dear friend told me about them in long detail and then I painted them from that information."

Whitethorne did not respond but closed in on the canvas, pulling the straight-backed chair across to sit directly in front of the easel. She put on thick glasses with plastic frames. Pollard wondered why she was sitting so close to his work, her face not three feet from the large canvas.

What a strange way to be going about looking at art, he thought, particularly his large canvases. Didn't she know the best effect was from afar? Standing back the colors melded and grand design revealed itself. Surely in her New York years she had not looked at paintings in the Whitney or MOMA this way. Or had she? He dared not ask.

After a few minutes, he pulled another painting from the racks and leaned it against an adjoining section of wall. Without getting up, Whitethorn scooted her chair across to it, making a scraping sound on the Carolina heart-pine floor. Pollard winced. She sat, as before, closely in front. Pollard did not want to show the annoyance he felt, because Whitethorne was known for a temper and was, after all, solely in charge of selecting this Biennial. She sat focused into the very center of the picture in silence for four or five minutes, moving her eyes neither right nor left as far as Pollard could see.

"What else is there?" she asked.

Pollard retrieved a third painting. He was running out of fresh wall space to lean it against, so he propped it up in front of where she sat, switching this painting for the one already there. He watched as she peered even more stolidly at this new work.

She remained in the one spot and he refreshed the painting to be viewed at short intervals. This stopped the repeated abrasion of his floor and his nerves.

By three o'clock she had examined each of his twenty new paintings. No faint talk or idle chatter for her. She then asked Pollard the correct title and size for each of three she chose.

"You're a fine painter. We're lucky to have you in Santa Fe," she said and gathered up her coat and papers and left.

What a curious woman she was, Pollard thought. She chose the three paintings he favored least. How in the world could she see anything the way she looked at art, as if reading fine print? Or did she actually go out of focus or into a sort of trance to judge the pieces by some transcendental method, like the Pythia at Delphi?

It was an hour before the next visitor was expected. Pollard brewed a pot of chamomile tea and hustled to return the canvases to their racks. If Whitethorne's visit was an omen, this was not going to be as good a day as he hoped. He picked a long, horizontal woodland scene to place on the easel.

The next to arrive was the art writer, Wheaton Javierre, who had the final draft of his essay on the work of Saxon Pollard. His was to be the lead article to an exhaustive book with large color reproductions of the painter's recent work, to be printed in Singapore. Asia was the current printing source of preference.

Pollard found Javierre's earlier drafts to be too academic, lacking insight into the true heart and conviviality of his paintings. He vigorously red-penciled large sections of the monograph and mailed them off for correction. Although the mantle of "fine regional painter" spread easily on his shoulders, Pollard preferred to think of himself as a painter of growing national repute.

Pollard seated the writer across the studio desk and leaned forward in expectation. "Let's take a look at what you've done," he said cheerily.

"Actually I've done nothing, Saxon. In re-reading my essay and studying the prints of your images, I found my monograph to be perfect in every aspect. I haven't changed so much as a word."

"But what about your total omission of the heart and warm human emotion in my paintings? I wrote my detailed wishes on the last draft I sent back to you. You must have seen them."

"I did, but I don't think there *is* any heart in your work," said Javierre. "The value of your pictures is in their total lack of emotion. They have the extraordinary quality of being apparently painted by a computer or an automaton. Landscapes seen through the cheerless eye of an out-of-focus box camera with no poignancy whatsoever."

"That's ludicrous. Look at the warm colors played against blue waters in that painting, autumn holding its own against the onslaught of winter," Pollard said, pointing to the canvas he had just placed on the easel.

"It's beautiful, Saxon, but totally a piece for the mind. Most American gallery-goers would have no idea what this means. It looks like an uncontrolled mess of colors from their view."

"There is total control there." Pollard's voice grew chilly.

"But no heart, at all. Why try to masquerade as a feeling, sensuous painter when the world will remember you as cool, intellectual and uncaring of everything but your own idea? You could paint a junkyard or a parking lot as well as a forest, with the same cut of mind. You're much more a Mondrian than a Matisse."

"That's just not so."

"Take it for what it is. You are like the chilly older sister who knows the truth, knows how to express it, not the bubbly, beloved younger one with sausage curls and giggles. Dark truth versus blonde happiness. I think you should be proud to be a painter of intellect and reason."

"I resent those metaphors. And, furthermore, you cast me as a regional painter, when you know I am larger than that."

"But you're not a national name yet. You are a *fine* regional name. "

Pollard winced at that word and stood up, with hands on the desk. "Well, Wheaton, I guess we must agree to disagree. You persist in picturing me, quite incorrectly, as a provincial, bloodless wretch. I can't possibly use this material for my book."

"That's fine, Shirley Temple, but you still owe me five thousand dollars."

"Absolutely absurd."

"My contract says ten thousand if you print it, five if you don't. I really don't care which."

"Get out, Wheaton. Now."

"Well, I guess you can just send the check in the mail. Let's say within two weeks or you'll get a letter from my lawyer. It's iron-clad, our contract."

"I say, again, get out."

Wheaton walked quickly to the door and slammed it after him. Pollard avoided getting angry, whenever possible, because it took so long to get over and it was a total waste of energy.

Conflict in his studio might lurk on for many days afterwards. He had read that the Navajo burned green juniper branches to make a smoke that cleansed troubled interior spaces, so tomorrow he would do just that. Or maybe rose water should

be sprinkled about; a Hindu guru had told him about that as a way to purge bad spirits. Or maybe he would do both, to be sure.

In the meantime, he must compose himself for his third visitor, due exactly now by the clock. Billy was always late, so he laid flat on his back on the floor and took deep breaths, with knees bent. An old yoga trick. This often worked, and in a few minutes of this, he felt much better.

How dare Wheaton disobey his instructions and thwart the meaning of this important essay? If it was to be a success, Pollard now knew he would have to do everything himself, including the writing of the introduction and essay. Was there no intelligent assistance in this project, no one who could follow his lead? Why couldn't Wheaton see the tenderness and open heart so obvious, so vital in this new work?

The studio bell rang and it was Billy Blakely, one of Santa Fe's major collectors and the scion of a major family business. He had called yesterday, dying to see the new paintings. Pollard opened the door and ushered him in.

"Good afternoon, Saxon. I've heard the best things about your new pieces."

"Let me make you some tea beforehand."

"No thanks, I want a good stiffener when we're done."

Pollard replaced the hard chair that Whitethorne preferred with an Italian leather-cushioned one. Billy took off his fur-lined bomber jacket and found a pencil and leather-covered pad in his carryall. He was ready, he told Pollard.

The full course of paintings, one after the other, took only about fifteen minutes this round, as Billy waved his hand to have the paintings changed. Like Whitethorne, he said nothing about the individual canvases as they were displayed. Pollard watched

for surprise or delight when he displayed the three he had worked on the hardest, but Billy smiled the same courteous smile at each. He wrote nothing down in the small notebook he kept ready on his knee. Finally, Pollard displayed the painting that in his mind summed up the whole collection.

"What do you think, Billy?" he said.

"A triumph. An absolute triumph. I am sure they will simply fly off the walls of your show."

"Did you notice the stronger abstract quality in all the pieces? I am very excited with how loose and natural they are compared to my earlier work."

"And so you should, they are truly glorious." Billy stood up and put his bomber jacket back on. Adjusting himself in the studio mirror, he placed his carryall firmly under his arm. "Are you ready for cocktails? Let's go. You drive."

Pollard brought his old, classic Jaguar out of the garage and Billy hopped in. The drive downtown took only a few minutes, but there was a traffic knot in front of the Halcyon Gallery, where opening night gallery-goers spilled out onto the sidewalk. The Paradise Bar was just beyond. After a few minutes of snail's progress, Pollard found a parking space on the second time around the block and the two men started down the sidewalk to the bar.

"Saxon, do we have time for just the smallest peek into the Halcyon before our drink?'

"Certainly. It's Jack Falton's exhibit and I would like to see it too," Pollard said.

The crowd in the Halcyon Gallery was noisy and immoveable. The two men got separated while pressing their way through to the bar at the far back of the gallery. Pollard stopped to talk to his friends and associates on the way, all insiders in the

Santa Fe art world. No one looked at the paintings, large scenes of forests on fire with rampaging wildlife in the foreground.

"Jack's show is a knockout," Pollard told another gallery owner.

"Look at those red dots," she said, hiding her envy.

"I'm sure Jack will be in the South of France or Morocco by next week, savoring his success."

"Well-deserved, is all I can say."

After two more quick conversations, the groups of people opened up slightly and Pollard attained direct access to the bar. Billy must have already come and gone. Pollard stood near the bar for another twenty minutes chatting to a group from the Fine Arts Museum who were squiring their New York counterparts to this local exhibit. He had just engineered his exit, when Billy tapped him on the shoulder.

"Let's go. I'm parched for a real drink. White wine doesn't do the trick."

They pushed through the throng to the door and the cool of the street, shaking hands as they went. Just before the door Billy diverted to hug the featured painter and to whisper something in his ear. Then Pollard and Billy were on their way.

The bar was filled with refugees from the mob at the Halcyon. They found vacant stools at the far end of the bar and Billy quickly ordered Martinis for both of them.

"Stunning, is what I think. Absolutely stunning. The whole world in flames," he said.

"So you liked them?" asked Pollard.

"I must have. I bought the last four, just like that. Funny how it goes, isn't it?"

"How nice for Jack."

After two more drinks, Pollard paid the bill and suggested they leave. No, Billy said, he was going to wait a while and see who or what developed. Thanks, so much.

Pollard retrieved his car and drove slowly home, making sure he did not weave from side to side as he went. The newspapers that morning said that there would be roadblocks all over town for drivers under the influence of drink. It would not do for a fine regional painter to be pulled over.

# Two for the Price of One

For a few years in the early 1980s Santa Fe had a Council for the Arts charged with doing good works in the name of art, melding the secular community with the resident artists. The council conceived of projects wherein the product of the artists could benefit the non-artistic citizens. Most of us thought it a dangerous and foolish enterprise, but it thrived for a while despite our censure.

In one of their projects they chose pairs of painters from many volunteers to paint a single 50x50 painting, each twosome deciding between them just how to proceed with their own project. The council would hold an exhibit of the results in six month's time, auction all the paintings and contribute the proceeds to charity.

I thought what could be wrong with that? The charity was to benefit the children from the barrios so I volunteered. The council, in its august wisdom, directed me to work with Helena Touchstone, a woman painter of florid, imaginary landscapes. I knew of and detested her work: wildly colored landscapes with no technical discipline, scenes of hills, steep valleys, an omnipresent sun or moon and gaudy clouds. She painted with

dripping acrylics on canvas, running all the colors into one another. What a mess.

I thought the council had gone off its rocker. Two more dissimilar painters could not be found. I hated her strident colors, preferring the subtle, sophisticated, mixed colors I saw in the Western landscape. Not pastels, but colors that I blended from many sources to bring results such as sage gray-green, the gentle pinkish ochre of sand or the muted burnt sienna reds of a cliffside. Rich mixed colors, the colors of nature.

I was sure Helena Touchstone used her paint straight out the tubes, never mixing except by accident. Her large paintings were ablaze with unadulterated, chemical color. Paeans to toxic spills. Alizarin mountains and viridian bushes below with orange suns and cadmium yellow clouds above. She was the queen of heavy metal pigment and considered herself the female Van Gogh for the 20th century, a high priestess of color. I thought strongly about calling the whole thing off. Despite the charitable nature of the Council, maybe it was not worth the aggravation and the lost time dealing with such a woman.

I wrote a letter of unvolunteerhood to the council and left it to simmer with indecision overnight on my desk. I hoped for guidance from on high, but none came. When my community spirit resurfaced in a day or two, I gave in and called her studio number. "Helena, do you want to meet in your studio? Decide about the project?" She did, and as anticipated, we argued from the beginning.

"Do you really think we can work together?" I asked. I was looking at her latest work on the easel, a cerulean blue tree dominating a scruffy field of orange grasses, dripping color onto the floor. The painting scared me.

"I don't know." she replied. She was a heavy woman, from a stern, country stock, wide-hipped and low to the ground. I thought of the terra-cotta images of the Old Goddess in my archeology books.

She said, "I've seen your work at the gallery. Your colors are weak. Almost feminine. It irritates me to see such a waste of canvas and paint. My work has more balls than yours." She jabbed her index finger towards the blue tree.

"No question, your colors are very, very strong."

She turned to look at her painting with the blue tree and softened her stance. "I live for color."

"I can see," I said.

"Sunset colors and the reds of pomegranate. The green of carbolic acid. They make people sit up and notice."

"You know, color can be many things. Complex, subtle, mixed, sophisticated...they rate as color, too. It doesn't have to be raw or explosive, like the blue, red and yellow of children's toys, to be color."

She was unmoved. "*Real* color is what I use. Namby-pamby pastels are what you use." Her pale blue eyes were electric with emotion.

Giving up the hope of winning an argument with Helena, I said, "No matter. We see things differently, I guess." It was unconvincing even to my ear.

I said, "How do you want to proceed with this? Shall I paint about half a canvas, then let you finish it?"

She said, "That doesn't sound promising. How about I start a painting, leaving a corner for you to finish. Of course, I can then rework whatever you have done."

"I don't cotton to your reworking my contribution very much either."

She laughed. I could see that she liked people who could carry their own end of a spirited scrap, an able adversary. For my side, I preferred accord and harmony, but threatened with a steamrollering from this Countess of Color, I had to stand firm.

After considering other stratagems, we finally agreed each to paint a vertical half of the 50x50 painting, individual canvases 50 inches high by 25 inches wide. The two separate canvases would afterwards be put together as a finished whole, a diptych. Spending as little time as possible in each other's company was the unspoken motivation for this scheme. Each of us could paint in our own space, untrammeled by the insufficiencies of the other.

She had the canvases stretched by a studio assistant while we waited, and we then tossed a coin to see who got which side. I won the left side.

She was not pleased with the outcome. "The left side is the better side, you know. So don't screw it up."

We concurred that the motif for the diptych would be a typical landscape of northern New Mexico, a motif we each claimed. To coordinate the project, we measured down from the tops of our canvases to establish where the horizon, cliffs, foothills, vegetation would be. We marked both of the canvases along the center divide with pencil like this:

"cloud"

and ten inches below that

"cliff,"

five inches below that

"horizon", and

"river,"

"willows",

"rocks and pebbles,"

"sagebrush and chamisa,"

"grasses in the foreground."

I was happy to leave her studio. Her brassy colors and sharp-edged personality gave me a headache.

Back in my own studio the next morning, playing Debussy and Fauré on the stereo, I blocked in my side of the painting in three hours. I started to refine the colors on the next morning, lightening here and modifying there. All was silvery and misty, the cliffs were gloriously indistinct and the sage and rabbit-bush established the foreground with pale nuances. With further distillation and the finest details rendered with a No. 1 fox-hair brush, on the fourth morning it was done.

When I sat down across from the easel to view the finished work, I was amused to see I had over-lightened the colors from my usual work. It was my unconscious rebellion against the heavy hand of Helena, I knew, but the longer I looked the more I liked the misty twilight effect. A few more highlights in almost pure white and the painting clicked into place.

I put in a call to Helena. She said, "What kept you? Been napping on your little studio daybed, huh? Sleepy snores and whimpers while the big dogs are gaining on you. I had my side done the first morning." Bragging was one her nicer qualities. I remembered that she had a contest with another popular painter to see how many paintings each could finish in just one day. She won it hands down with over one hundred pieces in a single twenty-four hours. My artist friends were outraged when I told them about the competition. Nonetheless, I was impressed with

her volcanic rate of production, whatever the merit. It accounted for her enviable income, the source of continued gossip.

I offered to bring my half of the diptych to her studio. When I got there she was on the phone. I went in and she motioned me over to a stack of canvases against the wall. I found her half and gingerly extracted it. As she continued to talk I cleared off her easel and placed the two halves side-by-side. I was wary as I stood back to look at the finished piece.

Helena interrupted her conversation, "Jesus H Christ, it worked". She hung up the receiver without a goodbye. We both stood and studied the work on the easel in silence.

The two sides together created a remarkable cohesion. Her more florid half energized the studied colors of my half, and my side enriched and refined the *alla prima* slap-dash of her work. Cliffs, clouds, river and willows all read beautifully across the centerline. As if orchestrated by a serendipitous conductor, one long blade of grass started on my side in the pale hues of unbleached titanium and by sheer chance, with only the slightest deviation, continued perfectly into hers with the shrillness of pure cadmium yellow.

Together the canvases had a contemporary, experimental quality that they lacked on their own. My side offered a filtered prelude to hers: muted colors that stifled her harsh qualities. The most amazing part was that we were, for a moment, in total accord. We both liked what we had wrought.

"Who would have thought?" she said.

"I'm impressed. Does that dividing line seem to sizzle?"

"Yes, but only on my side. My ability brings yours up, shows what could have been done."

"I was thinking that my side made it possible to look at your side without having a coronary."

In the excited success of this diptych, whatever our inbred differences, we immediately saw the wisdom of doing more. The thought occurred to both of us at once. Why not exhibit more of these triumphant diptychs, riding the crest? Neither of us was considered in the *avant-garde* of Santa Fe art, but this diptych brought us into an experimental mode. In the months that followed, before the opening of the council's large exhibit, we finished a dozen more of these bipartisan works, happily painting our individual halves in the unsullied privacy of our own studios.

"I want to paint the left panel of some of these," she said at the outset.

"No way. It works so beautifully this way. Let's leave it alone." She heard an unaccustomed resolve in my voice and immediately gave in.

"But then I get the sun or moon on my panel. Always." She hadn't lost her scrappiness. I actually did not want the image of a moon or a sun on my side, viewing it an infantile and overly naïve part of her paintings, and I was happy to appear to have relinquished something valuable in her favor.

"Agreed." All the paintings had my studied lightness on the left and her over-the-top brightness on the right.

Later when the pieces were all finished and photographed, we squabbled over the choice of a gallery for our exhibition. The gallery where I customarily exhibited my work was too staid, too middle-of-road she said. It suited my washed-out work, but not the glory of hers.

Her own studio-gallery on Canyon Road was called "Helena Touchstone's House of Color," and I told her it sounded

like a shop for women's fiesta dresses, quite unsuitable for a serious exhibit. We went back and forth, but when she offered to pay for the invitations, I finally relented and we had the show at Helena's.

The last dispute involved the title for the exhibit. I said, "How about *From Light to Bright?*"

"How about *From Almost Dead to Really Alive?*"

"*Silvery to Brassy?*"

"*Wrong Way, Right Way?*"

We agreed upon the bland compromise of *Left to Right: Two Painters with Separate Visions.* Our show opened on the night before the council's extravaganza with a crush of people and a total sell-out. It was an uneasy partnership for both of us, never to be repeated. I thought the reviewer in the local paper hit somewhere near the truth when he wrote "they have produced half-breed novelties, hybrid crowd-pleasers commanding attention neither accomplished nor deserved on his (her) own."

She stopped referring to me as "weak-spined and intellectual" on the promise that I stop calling her palette "the crayola colors of a dominatrix." We still greet one another at social occasions with something between standoffish respect and faint friendship.

I saw her again months later at the opening night reception for another painter. Helena said, "Another sell-out show for me, last week."

"Sales are good for me, too, this year."

"Our show together really gave your career a jump-start, didn't it?"

"What do you mean?" I said.

"Mere association with my name has that effect. A tide of talent that lifts all the other boats in the harbor."

"If that isn't a pompous bit of ego...."

"Temper, temper. But it's true, isn't it?"

"Absolutely not." I said, knowing she was winning this exchange.

"It's Okay. Everybody now wants to sit next to Helena Touchstone. And I'm big enough to give the others a moment in the sun. You included. Bye-bye, now."

# The Petroglyph Dining Room

Hayworth Roberts was the stranger at the dinner table, the seven others were locals who knew one another from long ago. They bantered the key words of stories they knew to the bone, laughed at jokes they all knew by heart and, with great politeness, stopped the conversation to listen to him and stories of his visit in Santa Fe. He had come for the summer opera, so they asked courteous questions about Puccini and Mozart. Everybody was civilized and thoughtful.

Katherine, his hostess, seated on his left, had a superlative nose, long and beautifully pointed, a stack of graying hair and intelligent blue eyes. She was a novelist, and the lover of the woman sitting at the other end of the table, the painter Alabaster Prynne, who had short-cropped white hair and broad shoulders.

Alabaster was the one who had invited Hayworth to dinner, when that afternoon he bought one of her painted hangings, a large, square rendering of three petroglyph birds and river grasses. The color was an earthy green, with highlights of sienna and ochre. It was an unframed hanging on coarse cotton and would fold neatly into his luggage. Alabaster invited him as he counted out the cash for the purchase in her studio gallery.

"Mr. Roberts, can you come to dinner this evening? Katherine would be so happy."

"Tonight? Let me think." Hayworth considered his other plans.

"We're having a few friends to dinner, mostly writers and artists. Local celebrities only, I'm afraid," Alabaster said.

"I would be delighted. Thank you."

"Six-thirty, then. And we're unstylishly on time in Santa Fe." She smiled.

Hayworth left the hotel in ample time for a leisurely stroll up Canyon Road, lined with old adobe houses converted to studios of painters and sculptors. He arrived punctually, but all the other guests were already seated, chatting amiably over cocktails.

Alabaster made introductions for Hayworth and the group lingered over cocktails until dark, when the cook, a small Hispanic woman, announced dinner. After Katherine seated the guests with care, with Hayworth rating the seat of honor to her right, she opened the conversation, "Our new friend, Hayworth, today bought Alabaster's latest hanging, the Frijoles Canyon Birds."

"I did indeed," he said.

One of the guests asked, "How did you discover Alabaster's secluded studio?"

"It was thanks to the opera program. I was entranced by the sets and costumes for the new *Magic Flute* production, so primordial and so right for the forces of light and dark. Zarastro as a bird shaman. I found the small paragraph about her and her use of the petroglyph images, so called for an appointment this morning."

A woman across the table, Gertrude, said, "You have a good eye, Hayworth. That's the best thing Alabaster has done in months."

"Is that a compliment, dear? I'm not sure," rejoined Alabaster.

"I just meant that you've been immersed in that dreadfully demanding opera since spring and we all know that your own painting has suffered. Let those New Yorkers do their own sets. Stage backdrops can be diverting, but your work will survive the comings and goings of theatrical fashion."

Alabaster responded, "It was a great honor to design the sets and I've always loved *The Magic Flute*, despite its length and musical fussiness".

"It's time our Alabaster was back in her own studio, doing her own work," said Gertrude, looking around for approval from the table.

Alabaster replied, "That 'dreadfully demanding opera', as you put it, paid me handsomely, and what with the economy, I felt extremely lucky to get that work."

"Nonetheless..." said the woman across.

Katherine interrupted, "It was this room, Hayworth, and these Anasazi petroglyph hangings that were the inspiration for the commissioned opera sets. We had a group of the opera people to dinner last year at this time and by coffee and brandy, everyone felt these were perfect for *The Magic Flute*. A petroglyph surround for Papageno. Alabaster received an offer within a week and said yes. She worked like a beaver all last fall and winter. We barely had time for lunch." Katherine waved her hand at the hangings on the walls of the dining room, the inspirations for the sets.

Conversation stopped while they all looked at the accused hangings, like ancient tapestries, with petroglyph images glowing in the candlelight. The main hanging, twenty feet long by eight high, was centered by an imposing shaman, long robes with the head of a bird. He was surrounded by a praying multitude with hands upraised.

Other figures, quite like an opera chorus themselves, held high staffs topped with animal icons. The white lines of the figures, very similar to the real incising of the cliff-face originals, stood out against burnt siennas, tree bark browns and deep purples of the background. The images were surrounded with constellations of stars, moons, suns, and spirals. When the breeze rustled the fabric of the hangings, the images seemed to move, to take on life, accentuated by the mystery of dim light from the table candles.

The other walls of the dining room had smaller hangings with shaman figures; long undulations of a horned serpent centered one panel and bear figures with impressively sharp claws strode across another. A third one was devoted to a stag with a tall rack of antlers and many deer and small animals below, skunks, squirrels, chipmunks and other bushy-tailed creatures.

Hayworth supposed he was in an archaic cave with these breeze-shimmering drawings of primeval animals, stars and holy men. It was a time-before-time place where thoughts went back to primal beliefs, current matters forgot.

The dinner party continued with vibrant conversation of art and music. He tried to follow the quick ripostes of the table conversation, but his eyes kept straying from the faces of the guests to the petroglyphs that surrounded and surmounted them. He thought how fortunate that little group was to have a dinner in a cave like Lascaux or Alta Mira, and to be next to the magic that

resonated from those walls. The dinner talk continued, witty as he remembered, but the shamans and bears came forward in his mind, obscuring the everyday with their extraordinary presence, calling to him from reveries of dark starry nights in the ruined pueblos.

"Mr. Roberts," said Gertrude, "can you come to dinner at my place tomorrow? With Katherine and Alabaster, of course." He was jolted back from ancient time to his place at the table.

"Thank you so much, but I leave tomorrow. Back to New York."

"Next year, then. Maybe you'll have found your lost tongue by then and stop goggling about this room, splendid as it is."

"I do apologize to you all for being such a pop-eyed bumpkin. However, I don't think I could ever just ignore these hangings, even after repeated exposure."

Katherine clapped her hands. "Good for you, Hayworth. Gertrude was just being her difficult self, once again."

"Indeed, Mr. Roberts. I meant no disrespect for our artist," Gertrude said with a sly smile sent to the end of the table. Alabaster sat there, impassive, a pillar of silent creativity.

After coffee and cordials, the others guests got up on cue and made their apologies, but Katherine motioned to Hayworth to stay behind. When the goodbyes had been said and the sound of the departing cars subsided, the three of them sat down again at the dinner table, candles by then low and flickering.

"It's early evenings in Santa Fe. People bed down so early. After thirty years here I'm still not used to it. More brandy?" asked Katherine.

"Yes, please."

She poured and asked, "Shall you come back next year?"

"I doubt it. I've agreed to go to Bayreuth with a friend, who's mad for Wagner. Can't think why. But, such a lovely evening here. I must apologize for being a dunce with your guests. I am completely spellbound by your petroglyph dining room, so much so that my mind kept wandering again and again from the talk."

"Alabaster painted them especially for the room. Years ago."

"I feel a magic at work here."

"Yes," Katherine said. "You know she received a grant in the late nineteen thirties to record the rock art in the Galisteo Basin. Quite an honor. Just with a sketchbook and on horseback, she collected them, thousands of images. Weeks in the wilderness. She put together a great volume the size of the Doomsday Book, only four copies."

"They must all have special meaning?" Hayworth asked.

"Oh yes," said Katherine. "Especially to me. When I'm in the house alone at night I sometimes hear what I take for the noises of pueblo life. Muffled voices, laughing, clanking and scrapings, crackling fires, rhythmic instruments. Strange sounds, different from what comes in through the window. They're not at all fearsome or ghoulish, they comfort me like old acquaintance." She smiled at Alabaster, whose eyes were beginning to glaze with the late hour.

Hayworth stood up in response. "I must go and let you get some sleep."

"And when will we see our new young friend again?" Katherine asked.

"Soon, I hope."

**116**

But it was not soon. Over the years Hayworth sent them cards from his travels in Greece and the Orient, holiday cards with promises of visits to Santa Fe, small gifts of Armangac from France and salted nuts from the Carolinas. His notes became spaced further and further apart, then came only at Christmas and finally stopped altogether.

Now it was forty years since that first visit to Santa Fe. Several years ago he read obituaries in *The New York Times* for both Katherine and Alabaster, spaced only months apart. Both were accomplished Philadelphia women who had the wisdom to flee to Santa Fe, a tolerant spot where life treated them well.

Hayworth booked two weeks at La Fonda Hotel in Santa Fe and tickets for summer opera, including a new production of *The Magic Flute* and a Strauss opera he had never heard. He was the first guest down each morning in the large dining room for breakfast, his inner clock still on East Coast time.

Most of the wait staff was Hispanic, but he kept being assigned the one Anglo woman, a stalwart young blonde. She was affable and talkative. Only on the fourth morning did he realize that she quite resembled a more feminine version of Alabaster Prynne. He tried to read her nametag but she moved too quickly. Finally he beckoned for her attention and she came by.

"You aren't by any chance related to Alabaster Prynne, the artist who lived here so many years? You look so alike."

"Yes, of course. I'm Caddie Prynne. She was my father's sister, Aunt Alabaster. We were horribly impressed with her talent and rather afraid of her when we were young. People who knew Alabaster often come up and ask me the same question."

"I had a wonderful evening with her, Katherine and their friends, now many years ago, in the petroglyph dining room. It

was truly magic." Hayworth told her about his admiration for the hangings and the mystery they held for him.

He said, "I read that both passed away several years ago."

"Within a month of each other."

"I was very fond of both of them. I have a Prynne hanging at home."

She left to tend other customers, but came by later. "Would you like to see the dining room again? Alabaster gave me the house in her will. She left my sisters and brothers a bit of money, but me, only the house."

"You're the lucky one, by my reckoning."

"I think so. I love the house and working at La Fonda makes it possible for me to live there. My day off is Sunday. Come by in the afternoon, say after six."

Hayworth remembered the way up Canyon Road, a short walk from the hotel. The simple adobe houses were now converted to art galleries and boutiques. The side road back to Alabaster's house was shrouded in trees and new buildings crowded into the formerly open fields. Nevertheless, it was surprisingly the same after all these years. The Prynne house was at the end of the lane. The top half of the Dutch door to the house was open and Hayworth could hear Caddie talking on the telephone in a far room.

He waited to knock, sat on the door-side bench and looked around. The cottonwood trees were much taller, giving the house a quiet country setting back from the hurly burly of Canyon Road. Caddie came to the door without his knock.

"I thought I heard you there," she said.

"It's so quiet here. Only a few yards back from Canyon Road."

"Let me show you around."

There were no obvious changes in the house, the same furniture and small paintings in the front hall. He could see the library off to the left, looking cool and inviting. The sitting room had the same collection of chairs that they sat in for cocktails on that night.

Caddie said, "I'm not a hostess like Katherine, few people come here now. I have it almost to myself."

"It looks exactly the same."

"I've made a few good friends here. Most of us work hard during the day and usually go out somewhere when we get together. Maybe someday I'll have parties again here and use the dining room like Katherine did. I would like that."

They came to the dining room at the end of the house and Caddie opened the double doors. Hayworth smelled the faint aroma of perfumes and cigarettes, and the shutters were closed on the large west-facing windows. She folded them back and opened a casement window.

"Here it is. Your petroglyph dining room. What do you think?"

Hayworth was saved from comment by the telephone ringing at the far end of the house. Caddie excused herself and raced away to answer it. He was glad she left as his first impression was a sense of loss. The room did not have what he remembered, that sense of primitive mystery mixed with urbanity was gone.

He pulled out one of the dining chairs and sat down. The hangings looked dry and lifeless, colors faded, and the figures themselves were more stilted and crude than his mind had them. At his age Hayworth was accustomed to disappointment and here it was again, an old friend.

A light breeze came through the casements and the hangings rippled and moved like that evening years ago. The fabric undulated gently in long, slow waves, the shamans moving with it. As the air reached the panels on the end walls, the bear and snake took on vigor on the moving cloth. Hayworth wondered if he had been too hasty, too quick to accept the death of magic. There was something still there.

The petroglyphs shimmered again, ever so weakly at first. Maybe candlelight or sunset was their natural light and they came to life only after the unforgiving light of day. He could hear Caddie talking on the phone at the end of the house, several rooms away.

Hayworth remembered the forest deer of his Virginia childhood, coming shyly out of the dark woodland at dusk to play in the open fields. In the hot afternoon hours they hid in leafy glades just inside the verges of the woods, then gained boldness in the dim cool light of dusk.

Outside, a low sun slipped behind a cloud and the soft light of evening crept into the room. Alabaster's figures came from their own dark woods and were now almost alive, awkwardness gone. The central shaman motif especially came to life in the folding cloth, waving the tall staffs in each hand higher. Hayworth drew in his breath, for he thought he hear muffled voices and laughing. Was his mind making this up?

The enchantment was still there, a creature now nearly extinct. It hid from the heat of everyday and came forward with caution in the cool of the early evening. The sounds that soothed Katherine were there as well to soothe somebody else. Hayworth was overjoyed. The mystery went on. The magic was still alive.

# Bad Eye

For twenty years I had the good fortune to work with the director of the Ludlow Gallery, who put forward my best foot while I stayed at work in the studio, avoiding the distractions of daily contact with the buying public. This was an old line gallery, with several generations of close connection to East Coast galleries and a tradition of selling contemporary realist and landscape work, the very type I wanted to work on myself.

Josephine Chalton, the director in question, said to me one day, "Would you like to paint a commission?"

"Maybe. What would the subject be?"

"A garden, a particular garden."

"What size and whose garden?"

"The garden of a local couple who have a large house on the Eastside. I've sold them many paintings over the years and Mrs. Brown has always admired your work."

"Couldn't you sell her one of my garden paintings already in the gallery?"

"She wants her own garden, and it's to be surprise birthday gift for her husband. In three months."

I tried to list quickly in my mind the problems that might come up. Suppose it was an ugly garden with purple and white

petunias? What if Mrs. Brown wanted to spend a lot of time conferring with me in the studio? I hate other people in my studio. Suppose their garden would just not work as a subject. Some don't, and it was hard to predict them beforehand.

Josephine interrupted my thoughts, "I quoted her seven thousand dollars. She will pay half as a deposit when you agree."

"Seven thousand. I could use my share of that."

"Let me know soon."

I thought about it for the rest of the day. As long as I could paint a painting that fit into my current work and it was a familiar size, I decided to do it. I called Josephine with the news. She set up a time that I could go by to photograph and sketch the Brown garden, when Mr. Brown was downtown in his office.

There were trepidations, still. I did not paint garden portraits, *per se,* but rather sections and corners of my own garden, which I expanded, diminished, added to and subtracted from as I saw fit. The finished painting quite often held no exact similarity to any one portion of my garden. So an actual portrayal of a real garden somehow seemed daunting.

In a few days, I drove out to meet Mrs. Brown at their house in the foothills. It was an expensive spread, but otherwise undistinguished from its neighbors in any way. I left my pick-up truck in the parking court and walked a long path to the front door.

"Hello, Josephine called you, I think. About the garden painting." I sounded nervous.

"Thanks for coming. I'm Helen Brown. Bryce has his men's club today so we have plenty of time for the garden," she said with a conspiratorial hush. I remember that she had small, intelligent eyes and that she walked with a fast-footed gait. The

interior of the house matched the outside in its lack of distinguishing qualities. Most elements of Santa Fe Style were well represented. A vitrine with modern Pueblo pots dominated the living room, small paintings with their own lights spread across the walls and Navajo rugs of many colors interrupted the rhythm of the quarry tile floors. Large sliding glass doors gave onto a terrace and there lay what must have been the garden.

She said, "I thought you might want to see our other paintings. So you'll know what good company your painting will keep."

"Thanks, let's take a look," I said.

"We have three Emil Bistrams, as you can see. And a William Penhallow Henderson over there. And this is our Fremont Ellis." She clearly counted the Ellis as the prize of their collection.

"You like collecting, do you?"

"We love it, but the walls are filling up. No more space. Let me show you where yours will go."

We walked into a side room that served as an office, with a large partner's desk and dark wood swivel chairs on each side. There was a row of two drawer filing cabinets along the only unfenestrated wall.

"I thought it would go well here," she said, pointing to wall above the filing cabinets.

"Fine."

"Let's go out to the garden."

We retraced our steps through the house and exited through the sliding doors to a walled courtyard beyond. There was, indeed, a perennial border along one side of the high-walled space. This was the first of August, when herbaceous borders in Santa Fe tended to sulk and go out of bloom. I could see the cut-

back stems of several types of perennials, but there were late daylilies and a bank of achillea still in flower.

"I have pictures of our Paeonia Tenuifolia in the spring and the Lilium Candidum and the Myosotis," she said.

"Those will come in handy. You know all the Latin names."

"I studied botany in college. We knew all the proper names before we were finished."

"That's impressive. Latin names make so much more sense. I'm so glad you have no petunias."

"Are they a problem for you?"

"A big one. I won't have them in my garden."

"Well, I don't personally hold anything against them, but Bryce won't let me plant petunias here, either."

"Good man. Let me get a photo or two of the garden the way it is right now." I took a dozen photos from different angles. The noon-day sun bleached out the colors and darkened the shadows, not the morning light that I prefer. I had an early notion of trouble as I looked through the lens because the so-called garden looked like nothing more than a cluster of foundation shrubbery. I wondered if I could add enough to this minimal framework to give some interest and design.

She said, "Ours is really a spring garden. It would be nice to include the May bloomers, even though they have passed over now."

"I guess I have to warn you that I like composing canvases in my own way. I'm not sure that I can include everything in full bloom like a seed catalog."

"Oh, I didn't mean anything like that. I only wanted to give you a sense of the full garden. Of course, you must have *carte blanche*."

"I believe I can do your painting from what I have now. It will take a month or so."

"I'm very excited."

I did not begin work on the painting immediately. There were two canvases that I wanted to finish before I could start and the flurry of social activities at summer's end took their toll. It was well into September before I got started.

The photographs, when I consulted them, did nothing to raise my hopes. I had two of the photos enlarged to an eight by ten inch size so I could inspect closely what actually grew in the Brown's garden. With a magnifying glass I found several perennial varieties that I had not noticed on my visit. Mrs. Brown's snapshots also held some interesting blooms in the dark corners.

The actual painting went very quickly. I took one of my photographs for the basis of the composition. It sported a high wall with an unusual shadow at one end, a good backdrop for the piece. I situated the wall to angle from the high left edge of the canvas down to the right-side middle, letting trees and shrubs from outside the garden tumble over. More angles from the pathway and a sharp-leaved perennial gave a nice sense of geometry. The flowers all but painted themselves after this basic structure had been established.

I could see in the photograph where a large delphinium clump had been pruned down, so I restored it to its columnar blue splendor. A suggestion of a pink peony behind that, and a row of Shasta daisies, long ago dead-headed, was reincarnated into a trail of white. Touches of Myosotis here and there, a few dozen dots of different blossom colors, unidentifiable as actual plants, and it was done.

I was happy that a painting could be put together from such bits and pieces. It looked quite like the Brown border, as if enhanced in a parallel universe. In my mind, any canvas should sit unseen for a while, like rising bread or opened wine. I turned it to the wall and went on with other work.

In several weeks, I turned it back around. Happily, it still held the satisfaction I saw before. I asked the framer to expedite his work and in a day or two, there it was, a finished commission.

At the gallery, Josephine was pleased as well. It was a Friday morning and she was overseeing the installation of paintings for the solo show of another painter. The reception for the artist was scheduled for that evening. She said, "It's a handsome painting. The Browns are very lucky."

"It's great to have it out of my studio."

"Help me just now and we'll hang it on the far wall of this side room."

After we raised it a bit and centered it on the axis of the room, Josephine typed up a small card to identify it as "Not for Sale." She went back to work in the main room while I gave the painting one last look. Maybe I was starting an adjunct career as a portrait painter of gardens, a surprise turn of events. Surely the phone would be ringing with offers from other Eastside estates as the word spread, and no sitting room wall would be complete without a garden portrait from my studio. Years of hefty checks awaited.

I left the gallery when Josephine told me that Helen Brown was on her way over. It was better to let the gallery people do their selling work on their own.

There were still some painting hours left to the morning, so I got to work. I expected a call from Josephine and it came in about an hour.

"I have bad news."

"What?"

"Helen didn't accept the commission. She told me she was devastated that it did not look *anything* like their garden. She said it could have been anyone's border."

"What did you say?"

"I told her it was a beautiful painting and we could easily sell it somebody else. She mustn't worry, we would refund her deposit. And I did."

"What a bother. Better luck next time, I guess. Thanks, Josephine."

I avoided the reception at the Ludlow Gallery that night, as I thought it easier to skip the awkwardness that a chance meeting with the Browns might bring. They were steadfast opening nighters and would certainly be there.

The next morning when the full truth sunk in that my new career as the horticultural lapdog of the rich was stillborn, I turned to practical pursuits. I spent an hour cleaning my paint table, sorting the tubes into an organized rainbow, reds on the left through violet-blues on the far right. Earth colors and whites in the row behind. I cleaned all the brushes and dried them, a task I had put off for several months. As I clamped a freshly stretched blank canvas onto the easel, ready for work, the telephone rang.

"It's Josephine. Now I have some good news."

"What?"

"Helen and Bryce were here at the reception last night. I was talking to them as we walked into the small side room. Bryce spied your canvas and said at once, 'Look, Helen, a painting of our own garden. We must have it.'"

"How funny. What did Helen say?"

"She was most contrite, but she saved face by claiming that Bryce had the good eye of the family. She was so glad."

"So they bought it?"

"Yes, indeed. And, you will be happy at this, I had already raised the price to eight thousand on the sticker next to the painting."

"That is very good news."

"Helen, of course, spotted the difference and asked for her original, lower price. I told her that since it was not a commissioned piece anymore, we could easily sell it to somebody else at this higher price. It pleased me to say to her, there's a penalty to be paid for having the bad eye of the family."

# Fair Warning

"I absolutely hate that woman with all my heart and mind," said Peter, unusually animated so early in the day. He was having his first *café latte* of the morning with Phillipa, also a Santa Fe painter, at an outdoor café just off the Plaza.

Peter had just spied Susanna Horwitt, yet another painter, holding forth at the large table reserved for regulars. He said, "I hate her paintings and whatever it is that they are supposed to represent. Rows of Navajo dogs in every cute pose imaginable."

"What on earth do you have against dogs?" said Phillipa.

"Bugger the dogs; it's the money she makes. She announced loudly at the art supply last week that she makes six hundred thousand a year. Can you imagine?"

"Do I see a patch of green? Is this just early morning envy?"

"Yes, of course. But why do buyers give in to such blatant fraud, paintings so obviously made to be smarmy and available to even the dimmest mind? Navajo dogs sleeping in the hogan. Dogs with kittens in a striped blanket. Dogs playing with a squash blossom necklace. Ugh."

"I think you just hate *her*," said Phillipa, adjusting the bandana kerchief around her long neck. "You've always had a problem with strong-willed, successful women, Peter."

Peter did not acknowledge her response. "Furthermore, I can't abide to watch her cavorting around in those Shamaness outfits. Just look at the creature in her black velveteen skirt and a neck covered in silver jewelry. I know she's waving to people she doesn't even know, just to make her bracelets jangle. Jingle, jingle, smile, smile, sell, sell."

"Leave it alone, Peter. You are going to make yourself sick."

"I *am* sick. What hypocrisy."

"I, for one, think she looks very attractive in those Navajo get-ups. She has a natural way with clothes that I wish I had. Look at all that wonderful thick black hair done up in a tribal twist." Phillipa absently patted the long strands of her own thinning blondeness.

"It's only more of her charlatan ways. She masquerades at being an Indian to make sales. People love to feel guilty about what the government did to the tribes. *Mea culpa.* Buy a painting from Susanna and be forgiven."

"Be kinder, Peter. It's as old as Rome, dressing up to wow the locals. Exotic attire for personal gain. It may be what fashion is all about."

"Of course, you're right. She's little more than a talentless *arriviste.* I should pay no attention and rise above it." He finished off his *caffè latte* as Phillipa paid the bill. "And did you think to slip in unnoticed that bit about my fear and loathing of successful women? Quite to the contrary, I assure. I adore *you*, after all."

"But I'm harmless, not at all in Susanna's league. It's a lucky year that I get forty canvases painted and there are not six figures on my tax return."

Peter did adore Phillipa. Theirs was the perfect symbiotic relationship and Peter, when he reflected on it, often thought of

the white cranes that perched on the backs of water buffalos pecking away at the troublesome insects. Only he could never decide which of them was the bird and which the buffalo.

They walked through the Plaza and headed east on Palace Avenue slowly toward their studios a few blocks away. The town was just opening for the day, or, in some cases, cleaning up from the night before. This was a choice time of day for them both, looking in shop windows, peering into gallery displays to discuss nuances of the paintings their peers had produced.

At nine they arrived at their adjoining studios in the former carriage house of a bygone merchant family. Peter's studio occupied the front half and was everything a stylish workplace should be. His unfinished sketches artfully lined the walls and dusty canvases were stacked deep in the corners, faces to the wall. A collection of Victorian art school plaster casts crowded the shelves and table-tops with over-sized hands and feet, torsos in armless poses and large noses and ears. A dark woven arras was pulled back with tasseled cords to reveal a corner daybed smothered in India prints, a place for trysts and secrets rather than innocent naps. The half-finished canvas on the easel gathered cobwebs.

If Peter's easel was dusty with disuse, his writing desk was not. His real genius was writing about art. From magazine articles, studio brochures and monographs for the estates of deceased painters, he received a handsome income. He could create a long and stylishly informative tract with ease about virtually any artist; he was seldom critical, unearthing the perfect comparison or citation from his ample hoard of painterly lore. This open hostility for Susanna Horwitt was unlike Peter, so

supportive and tolerant, so quick to accept even the lightly talented.

Peter hosted, for a fee, cocktail parties at his studio for museum and opera events. Every summer week-end Peter's soirees brought out a crowd that spilled outside onto the terraces and the sidewalks beyond. "My little gatherings," he said, "bring together the rich and powerful with the talented and helpless, a roiling sea of artful opportunity."

The talk was of art and more art and the white wine was by the jug. It was a local honor for newcomers and long time friends alike to be included. Peter constantly circulated among the guests, winnowing out the uninvited and introducing painters to potential collectors, the unloved to those willing to love.

Unlike him, Phillipa Messel was a dedicated painter, working each day in her studio to hone more tightly her skills. She painted small abstractions, taking weeks to complete each canvas. When she finally moved onto a new picture, the finished one was as polished and refined as a gemstone. No piece left her studio without its being worked and reworked many times. Her friends thought her the very picture of a serious painter.

Phillipa's friendship with Peter assured her a favored place in his reviews, and for this she repaid him with companionship at the stream of museum and gallery events he felt compelled to attend. At seven that evening, artistic Santa Fe would convene at the Fine Arts Museum, an annual invitational charity auction of forty paintings from local studios. It was expected to bring a large sum for the acquisition fund.

They agreed to meet at their studios at eight for the short walk to the museum. Peter worked all afternoon with the hanging committee, assuring that each painting was in its right place. He

found the precise location for Phillipa's entry across from the main archway.

That night, she dressed in black, tall and urbane. Her blonde hair was teased into swirling piles on her head with an assurance granted only to the socially adept. She knocked on Peter's studio door.

"*Listo*, my dear?" she said.

"A moment with my bow-tie." He stood before the pier-glass tying the black satin. "I can modestly predict tonight will be a public relations victory. Your painting is to be auctioned in the number twelve place out of forty. Perfect position, I thought, to let the crowd get settled and for the momentum from serious bidders to build to a crescendo. After you, the enthusiasm, brought low by drink and the full realization of the many items to come, will diminish slowly to almost a whimper at the close. You are to be the pinnacle of the event." He kissed her on the cheek.

"You look after my interests with care, Peter."

"Sometimes I think I understand totally the intricate travails of Cardinal Richlieu, working without thanks for the king he loved."

They walked arm in arm the three blocks to the museum. The reception rooms were already filling with festively dressed citizens, eager to be seen in the close bosom of the museum elite. Peter expertly guided them behind the receiving line to establish their position in the middle of things, near the archway. Phillipa's piece all but gleamed on the wall across.

He said quietly, "I spent the entire afternoon with Madame over there and the hanging committee. Nothing too difficult for my beautiful one."

"Again, you cosset me beyond thinking."

"Look, Madame has seen us and is coming our way." The director of the event, Janis Dorray, joined them and they went through short pleasantries about the evening.

She then said, "Peter, I had second thoughts about our program after you left."

He said, "Indeed?"

"Yes, I think, as you do, that Phillipa's painting is one of the gems of the evening. So I moved her to number Thirty and switched Susanna Horwitt's row of smiling Navajo dogs to number Twelve. There was just barely time to reprint the program, so I didn't call you."

"How horribly unwise. What came over you?"

"I think the bigger prices will come near the end of the evening, contrary to what we talked about. Most people are nervous at the start and the accomplished bidders wait to see the lie of the land." She looked straight into Peter's glower and said, "And, since I am the director, I made the change."

Peter said, "It's absurd. How could you?"

Phillipa interceded, "Peter, it will be fine, I know."

Janis said, "I must mingle. The bidding will start soon enough." She walked off to an adjoining group.

Peter said, "A palace rebellion when I turn my back. I am livid beyond…." His further diatribe was interrupted by the gong announcing the beginning of the auction. There was a rush to be seated in the ballroom chairs at the end of the museum hall. Peter and Phillipa found a position in the middle and the tardy stood in back of the last row.

The auction began and the first items on the agenda sold for very low prices. The Santa Fe crowd was, as Janis predicted, skittish about the bidding process, so the paintings disappeared

without healthy competition. Number Five sold for a mere three hundred dollars. Number Eleven went for one thousand. Number Twelve arrived and the auctioneer tried bravely to push the price up in five hundred dollar increments. The crowd was unmoved with his efforts and slowly pushed up the total in stolid hundred dollar jumps.

Phillipa put her hand on Peter's arm, "Maybe Janis was right. I think Susanna's piece is going to go for less than three thousand." It sold for twenty-three hundred.

"I have no comment," he said.

"Let's see where it goes from here."

The bidding remained similarly dull until Number Twenty-Four. There was a noise at the back of the museum hall as Erik Carpathy and his entourage made their entry. His dinner party at the restaurant across the street had come to a close, and he now brought the group to the post-prandial prize of the evening, the last selections of the museum auction. The crowd opened up to let the party stand directly behind the chairs, laughing and chatting. The men were dressed in black tie and the women aglitter in sequined gowns.

Peter said, "Well, we might see some real action, finally."

"They are impossibly rude, however," Phillipa replied.

"Carpathy owns all the oil in some county in East Texas, so he thinks he has a born right be rude."

The bidding picked up with the addition of the newcomers. Twenty-Five went for six thousand. Twenty-Eight for nine thousand. Twenty-Nine, a large garden painting, broke into the five digits for fifteen thousand. It was now at Number Thirty, Phillipa's entry, which the attendant took off the wall and brought to the podium. He held it high for all to see.

The auctioneer said, "Number Thirty, a lovely small jewel by Phillipa Messel. Do I hear ten thousand to start?"

Several paddles went up together from the Carpathy party and within a minute the price broke through twenty thousand. It was obvious to the whole room that there was a keen, liquor-inspired competition among the Carpathy guests, as they laughed to outbid one another.

The auctioneer was ecstatic, "Do we have twenty-five thousand?"

Carpathy himself put up his paddle and cut across the proceedings with, "Thirty thousand. After all, it's a very good cause." The Alpha dog had bested all the others and they quietly bowed out to his wisdom and wealth. Fair warning and sold.

With as much chatter as on their arrival, the Carpathy contingent strolled out to the lobby and back to the restaurant for after-dinner drinks, dropping their paddles in a pile by the door. The auction struggled to continue without them, but prices quickly diminished to three thousand, two thousand, and the last item, only fifteen hundred. The evening had come full circle.

Peter kissed Phillipa on the cheek as the walked slowly out with the audience from the chairs.

He said, "I must apologize to Janis. I can't imagine why a person otherwise so misinformed was so prescient."

Phillipa said, "She's a smart woman."

"Or an extremely lucky one."

In the crush of pushing to the exit doors, Susanna Horwitt came up against them.

Peter said, "Susanna, you look radiant all in Navajo. What a nice piece you entered and weren't you lucky to get twenty-three hundred for it?" He gave emphasis to the price.

"You think so?"

"Absolutely. The museum acquisition fund is all the better for it and the citizens of Santa Fe benefit all around from your two thousand three hundred bucks." More emphasis.

"Peter, you can just fuck off. Phillipa, I'm happy for you. You deserve it, but I can't think why you go out with such a miserable snake."

Peter's smile was steely and firm. As the crowd oozed away from Susanna to the street, no more conversation was possible. The couple headed down the street to their morning café, this time finding a table inside. They ordered a carafe of red wine, and the waiter poured out a glass for each of them.

"Wasn't that a delicious triumph?" said Peter.

"You were especially mean to Susanna."

"At least I spoke to her. See how well I'm adapting to intercourse with strong-willed, successful women?"

"But she is not the successful one this evening. I am. She is the defeated one."

"Alas, you're right. The evil huntress brought low by her own dogs."

"That may be the way you like your women, groveling and beaten. So different from the kind Peter I know."

"Am I such a cad?"

She took a long, slow drink from her glass. "Perverse as you are, I love you anyway. Tell me, though, will my heady success eventually threaten you? Will you turn on me when I start earning half a million a year?"

"What a question. Have some more wine, my dear," he said, pouring from the carafe and correcting the slant of his bow-tie.

# Dipping into Principal

**P**arsley Tiddle was an old man who lived at El Zaguan, an ancient adobe hacienda on Canyon Road now converted to small apartments. He was considered by many to have been the sixth, mostly unknown member of the Cinco Pintores. He lived in Santa Fe in the same years as the fabled five and he knew them personally.

Maybe because he was somewhat younger and notably less productive, he was excluded from formal recognition. A few long-term residents still knew the truth. Some said his real value was in the happiness he provided for all of the wives and lovers, so the five painters could spend their time painting instead of being concerned with the running of their houses and other domestic matters. While the Cinco Pintores were painting *plein air* and having good-old-boy nights at the Canyon Road bars, Parsley was busy bedding their women, plowing fields often neglected.

The Cinco Pintores were said to have treasured Parsley and his contributions to the cause of art. All of this was mere rumor, of course. I knew that he was fully capable of such shenanigans from the sparkle that transformed Parsley's face when

a beautiful woman passed by, and that he knew many more stories than he told.

His paintings were simple, naive interpretations of Pueblo ceremonials, not unlike those of his friend, Dorothy Brett. They were small paintings, eloquently colored, painstakingly detailed; collectors were eager to buy the few paintings he painted each year. There was talk that he had recorded many erotic versions of the ceremonials, pueblo orgies, if you will, mostly inventions of his over-active libido.

I saw him carrying an expensive, but battered leather suitcase down Canyon Road on a late summer day. He was laboring to carry it and, as I drove by, he gave up the struggle and sat down on it for a rest. I parked my car and walked across to him on the other side of the road. He was wet with perspiration.

"Parsley, can I help? It looks so heavy." I said.

"Thanks, no. Just sit with me a while." He motioned to the adjoining low wall.

"A plane to catch?"

He nodded. "First, it's the bus to the airport. In thirty minutes."

"Well, then, let me give you a ride. My car is just there."

"How thoughtful."

We headed downtown in plenty of time for him to catch the bus to the Albuquerque airport, ultimately to arrive in Mobile, Alabama. His elegant light tan linen suit had a matching waistcoat, all of it frayed and rumpled, and he had on a fine Panama hat with a jet-black band and a planter's brim. I asked why he was going to Mobile in the dog days.

"To confront a man personally," he said.

"Who can that be? An old adversary?"

"A trust banker named Snelling. I've been grappling with him for years, it seems. You would think the money was personally his, he is so slow to parcel it out. It was Grandmother Tiddle's, not his."

Snelling administered the trust fund that provided him with monthly income. Parsley was distressed that it slid lower each year and he planned to confront the man face-to-face for an explanation, hoping for an increase even if it required dipping into principal. After all, he said, Grandmother Tiddle did not intend her favorite grandson to blow away in the wind. How could a dip now and then hurt very much?

I drove him to the hotel from where the airport bus departed. We waited in the car until it arrived and talked about art. He painted only two or three paintings a year and each sold easily for prices in the several thousands. It wasn't the selling of his work that was the problem, it was doing it. He hadn't the energy or the will to paint more at his age. He felt lucky to accomplish the little he did. Although rent at El Zaguan was low, he had a hard time making ends meet, and with the trust income also diminishing, he was at rope's end. The bus came and he was off.

I saw him next in late September, sitting on the portal facing the garden at El Zaguan. The ancient horse chestnuts were golden yellow in the afternoon sun and Parsley was savoring a bottle of Mexican beer.

He motioned me to come sit beside him. He had changed from the proper three-piece suit and tie to his distinctive version of a cowboy outfit, with a silk bandanna, pants tucked into his pale leather western boots and a tall crowned black Stetson. A

large silver-circled turquoise anchored his bandanna. He was reading a volume of Louis L'Amour. I asked about his trip.

"I forgot what a cauldron the Deep South is. How I suffered," he said.

"But you're back in the cool nights of Santa Fe, now."

"What would we do without the cool nights? What would I do without you and my other young friends? I would perish in Mobile, now, although it was quite satisfactory when I was a nipper. Humid as a swamp."

"How did your interview with the banker go?"

"Not well. That villain Snelling gloried in his feigned incorruptibility. My sister wasn't a wiggin of help, quite changed from the sweet companion I remember."

"No dipping into principal?" I asked.

"He would have none of it. Actually blanched white when I suggested it. Bloodless wretch. When I asked to have the trust repay the expenses of my trip there, he even refused that."

"Why in the world?"

"Simple fiduciary responsibility, he said, with an oily smile. My nephews, who haven't missed so much as a single dessert in their twenty years, inherit after me, while I'm facing more years of Junket. Sister sat there like a stick. I left in high dudgeon."

"So what will you do?"

"A painting sold last week, so the rent is paid 'til spring. The old crocodile that runs El Zaguan disapproves of my young girlfriends and suspects orgies. She would cast me out like a pile of rubbish if I were so much as a day late. With innuendo, she implies that I'm no better than a child molester and quite

unsuitable for the high standards of El Zaguan. A Puritan in the wrong century, she."

"Do you have any money?"

"I'm nearly done with two more paintings, which will see me through the other expenses of winter. I remember when one painting would get me through till the next summer. Now it takes two, or three if the winter is long."

"Can I help you with the painting?"

"Oh, no. I never could abide anybody else touching my work. Besides, you have your own paintings to do."

A friend invited me to spend the winter at his house in Barbados, so I did not see Parsley until the following spring. The horse chestnuts were in bloom and a zephyr rustled the young leaves. Parsley and I sat in the aging wicker chairs, facing west into the garden, so green and full of anticipation.

I said, "You look well, Parsley, and have obviously survived the winter in high form. Any news?"

"Alas, Sister arrives with one of her widow friends next week. She hopes we'll 'take' to one another as the widow has piles of money. Three dead husbands in a row, all rich."

"What does she look like?"

"The first thing I asked, too. Sister said I should remember her, as she always had a crush on me in grade school. I haven't a clue, however. Can't picture any girl liking me at all in those trying years. I hope she's not short and fat."

"Could be a dangerous time coming up, Parsley."

"Quite. Would you like a beer?" I assented and we sat mostly in silence enjoying the fulsomeness of the spring day, a breeze wafting the perfume of lilacs. I thought about Parsley's

love of the young ladies on Canyon Road, who delighted in his courtly randiness. His prowess these days was entirely talk. Would any older woman fill the fantasy that his young friends provided?

I said, "Courtney, Sarah and Martha Ann would be very sad if old Mobile spirited you off. Who would take them to the gallery openings?"

"My pretty little minnows. They were so good to me this past winter. Covered dishes, bottles of Merlot and such beautiful company at teatime. And Sarah tapes *Sex and the City* for me."

"There you have it. You just can't go off and marry in faraway Mobile."

"I honestly do not have the strength to paint every day any more. Sitting here I can waste a whole afternoon. Small slivers of guilt pass by in the wind and I think maybe tomorrow I'll start a new canvas. I don't know how, though. The Deer Dances at Taos have been going through my head."

"Did you go to the dances this last winter?"

"Yes, the girls took me. An icy still evening, even the blankets didn't keep out the cold. But when they finally got around to the dance, it was stunning. A primordial glimpse, a moment the same as a thousand years ago".

"What time did you get back here?"

"Four in the morning, Christmas Day. Took a week to warm my feet up again."

More months passed before I saw Parsley again. It was a Friday night reception for a young woman artist at a gallery down the road; the peak of summer brought the hordes out for the free wine and the promenade. He was there with his young companions and the roar from the reception crowd made conversation quite impossible.

**143**

"Let's go outside and talk," he said.

We pried our way through the gossiping clusters to the cooler and quieter air of the street. Parsley motioned to the steps of the house across the street, where we sat down with our plastic cups of white wine.

"A lovely lass, the painter. Pretty legs. She'll go far," he said.

I was anxious to get information about the widow and the impending union.

"How did it go with your sister's friend?"

"She is taller than I imagined, quite the woman of authority, like a willowy Margaret Thatcher. Sharp and quick-eyed, moves like a hawk. I instantly remembered Meribel as a schoolgirl, tall and commanding as a general. Oozed power and sexuality even in pigtails."

Parsley was getting off the subject. "When did you tell her it wasn't going to work?"

"Oh, I didn't. Quite the opposite. I fell head over heels for Meribel. I whispered to Sister that her friend gave me the biggest hard-on."

"So what happened?"

"Sister slapped me and broke into tears."

"Oh, dear."

"I was afraid it wasn't going well, so I went right to the heart of the matter. Meribel, I said, you big women make my motor turn, so let's fuck. It was my best line, has shock value and directness. In the olden days, I could always get laid with that."

"Meribel didn't respond to that?"

"Didn't have time. Sister took her by the arm and said I wasn't welcome in Mobile anymore. The years in Santa Fe had

turned me into a nasty-mouthed satyr, and I deserved to die alone in a fleshpot. Sister flapped on that Meribel was much too good for me. They all but ran away from the table and I got stuck with the restaurant bill. The two of them left for Mobile the next day."

"No word since?"

"Not even a postcard."

"Parsley, what exactly is a fleshpot?"

He smiled silently, without an answer.

People raised money for Parsley that winter and made elaborate ruses to prevent him from feeling the object of their charity. With perfect timing, he had a burst of creativity, finishing several Taos Deer Dance paintings. He also discovered a new, active market for the Pueblo erotica, stacked away so long in the closet. I saw him with the girls at several festivities over the winter, but found no private time to talk. I knew, however, that Parsley's star was ascending again.

It was once again late spring when I saw him alone on the wicker chairs looking into the El Zaguan garden. I joined him for a beer.

"Any news?" I asked.

"The best news. I can't wait to tell you."

"Please."

"Meribel went back to Mobile and married that scoundrel Snelling. Some strong women, really independent and authoritative otherwise, are so needy. She cashed in some of her CDs and took them on a world cruise for their honeymoon with Sister along for the company.

"While Snelling was away from his desk, the bank auditors discovered that it was he who was dipping into principal. Other people's principal. Dozens of trusts had been pilfered. He jumped

ship in Rio with all of Meribel's cash and traveler's cheques. Living in protected poverty by now, but abject I should think."

"What about Grandmother Tiddle's trust? Did Snelling take it all? Are you broke?" I said.

"No, no. Mobile's premier bank could not stand the publicity. They made good all of that rascal's dealings and doubled my income in the bargain."

"So happiness is restored?"

"Happiness is restored."

# Studio, Studio, Burning Bright

There were a dozen friends seated for dinner at his house in the foothills and all were anticipating the meal Henry Fallston was about to serve, for he had the reputation as one of Santa Fe's best cooks. Because of his gourmet cuisine and the general excellence of his ample supply of wine, guests endured an evening of his withering opinions and sharp dinner-table talk.

The long dining table, an exile from an Italian monastery, faced a bank of picture windows giving out on the river valley with Monte Sol and Monte Luna in the distance. A line of iron candlesticks was reflected in the windows, increasing their number in flickering rows in the glass. The sun had just set and the lights came on in the other houses in the far hills.

The guests passed around a platter of gnocchi in an asparagus cream sauce for the first course, a Fallston specialty and the table conversation turned to the subject of art, as it often did in Santa Fe. Jeremy Ramage, husband of the portrait painter, Constance Ramage, was the one who started it.

Jeremy said, "Tell everybody, Connie, what you told me this afternoon".

Constance did not like to have their private discussions brought into the bright light of the public arena, but Jeremy took

a perverse joy in doing just that. He long ago decided that she spent too much time alone in her studio and that chatter at dinner parties was a needed ballast for so many solitary hours. He firmly thought he was doing her a favor, despite her obvious discomfort.

She replied, "I just today finished a group portrait of seven members of a Greek family. The father requested that they all be dressed as gods and goddesses at the Temple of Aphrodite at Delphi. In many ways it was upsetting." She paused and considered her wineglass for a moment.

"Go on," pressed Jeremy.

"Don't rush me, Jeremy," she said. "I'm not good at telling stories and want to get the words just right. I enjoyed painting the family because they have interesting Mediterranean faces with dark eyes, that lovely olive skin. The photographs and sketches I painted them from were all good and easy to work with. That makes a difference.

"I sent the father a preliminary drawing of the family in their shaded sitting room in Kolonaki, a setting sun picking them out with a horizontal light. It would have been my first opportunity to use that Sargent technique of a darkened background with the subjects on the edge of blackness. I've been to their house in Athens and had those sketches to work from, too." She paused again.

Jeremy was about to urge her on but thought better of it and remained silent. Constance looked around the table and said, "But this is all too boring for all of you. Tiresome worries of a portrait painter." She took a drink from her wine glass. Of course, that brought a small explosion of pleas to continue.

Seated across from her, Janice Gilson, a painter of still-life, asked, "Constance, tell us about the Greek family. How did you meet them?"

"Jeremy and I went on a Christmas trip to England two years ago. We were out at a country inn in Sussex called Gravetye Manor and the whole family was also there for the holidays. Two of the boys were in a boarding school nearby."

Janice asked, "Did they know about you and your portraits?"

"No, actually not. We had dinner with them one night, as we were the only guests in the whole inn. They were all so charming. On the day we left, the father, Vasilios, asked us to visit them in Athens, which we did the next year. The family owns the Poseidon Cruise Lines out of Piraeus. We stayed with them three days in Athens. I did some sketches of the family and it was Jeremy who suggested they let me do the multiple portrait.

"In the interim, Vasilios had looked up my listing in Artists of America. He also called the Texas family I did a group portrait for, and luckily, they gave a glowing report."

Janice interrupted, "Not 'luckily' but 'deservedly'."

Constance acknowledged the flattery with a smile and said, "During dinner on our last night there Vasilios said he thought Jeremy had a good idea and asked me to paint the portrait."

Henry said from the end of the table, "I have a mental image of your Sargentesque portrait, like that splendid painting of the Stanley sisters in evening light of their drawing room".

"That idea was destined not to be. Vasilios found my maquette a la Sargent unsuitable and he insisted I continue with his idea of a pantheon at Delphi. He even picked up the costumes from a V&A publication on Classic Costume, marking this one for his daughter, Penelope, and that one for his wife, Olivia."

"How cruel of him, even choosing the women's dresses. He sounds like a control freak," Janice said.

"That's too strong, Janice. Let's say he is very detail oriented, what with running a cruise line and all. He's a most elegant man, impeccably dressed, always in a perfectly tailored suit and the best Italian shoes. In the Greek culture the father decides everything. The family accepts and learns to depend upon his meddling in the smallest daily routine matters. They never argue with his choices," Constance said.

"I'll stick with my judgment that he's a controlling, elegant, macho swine. Albeit, a handsome, Mediterranean swine. You, the kindest of women, are just trying to white-wash him," Janice said.

Constance continued her story, "I flew to Greece a couple of months ago and got sketches of Delphi and the temples there. It was so beautiful that it quite raised my spirits about the whole project. I retained that raking, horizontal light since I worked all that out in the maquette, but put them all in the cliffside temple at sunset.

" Then I had fun painting the landscape of hills and olive groves, with the Sea of Corinth beyond. All washed in a peachy, Pre-Raphaelite light. It turned out very well, I must say. Even though Vasilios had stage-managed and art-directed every corner of the painting, even asking to change some of the costume colors, I was proud of the result. Vasilios flew in today. He accepted it and gave me a check for double my asking price."

The whole table broke into applause. She had more to tell them, however. "Well, he had another envelope to give me besides the check. He told me to wait until he had left to open it, and how pleased he was with the family portrait. I saw him out and got diverted afterwards, going immediately to the bank with that large check and then waiting at the studio while the shippers arrived to pick up the painting."

"What was it, a sordid love letter? Is he a macho pig, after all?" Janice said.

"I'll tell you presently. After the shippers left with the painting in tow, it was the end of the day. Jeremy came home and I told him that this was the last commission I would ever paint. The money is wonderful, but I can't describe how emotionally un-rewarded I feel.

"And sullied, somehow. Vasilios had ordered up my talent as he might use a charwoman to clean up a spill. He was elegant and charming all the while, but demeaning, nonetheless. To be fair, all commissions lead you right into that. That's why I'm rethinking the whole idea of accepting commissions."

Henry Fallston, at the head of the table, was the first to make a comment. "Constance, my dear, why would such a victory make you feel sullied? At double your usual price? That makes no sense at all. You're being ridiculous." Henry, who had lived his life in the insulated comfort of inherited principal, was always amazed at how preposterous his artist friends could be.

"No, Henry, it's not ridiculous." Constance resented Henry's implication that she was, after all, being just a silly woman. "I really am determined to paint for myself alone, no art directors nor Mediterranean men, whatever their charm. This experience with Vasilios proved it's too sacred to compromise."

Henry replied, "You young artists all want newness and freedom, as if that alone made art. Restriction, parameters, limits and a sense of what went before have always been an integral part of art, not just novelty and freedom."

That was too much for even Jeremy. "No painter wants restriction or needless parameters, Henry. You're being too academic and old-fashioned."

Henry answered, "Working within an established framework has given the world great art. Freedom has given it anarchy, bonfires in the streets."

Janice interceded, "Now it's you being the elegant swine, Henry. Constance wants to ignore the demands of men like you, who claim that 'you women' just can't get it right."

Henry was not about to give up. "Now that you bring it up, you women painters do tend to be more illogical and hysterical than men. There's a long tradition of wonderful art painted on commission. Think only of what masterpieces the popes commissioned, the Sistine Ceiling being just one of many. Rome would be empty without commissioned work. And think some more... Rembrandt, El Greco, Velasquez, and in our century Bonnard, Matisse and, even, Picasso. You're all over-reacting, my dears."

"I'm not, Henry," Constance said. "Mostly I'm just tired of the auras that other people leave in my studio. It takes days to clear it out after they've gone. I want to be alone in the studio with my own ideas. Period."

"Absolute poppycock. Now I must bring in the rest of the dinner." He left to bring platters from the kitchen.

Constance asked, "Why is Henry so crabby? What have I done to make him so annoyed with me?"

Janice said, "He's always crabby. He's not mad at you directly, it's just what comes from being a testy old man with the wrong opinions about art."

Henry returned with a platter, a mock frown on his face. "I heard that. Please skip Janice when passing this Chicken Parmesan." The conversation started to turn to other subjects.

Jeremy said, "Before we move on, there's the final matter of the second envelope. Constance, you must tell them about what was in it."

She sent him a glower and said, "It's a commission from the cruise lines that the Greek family owns. Twelve large panels for the dining room of their new ship, now being built in Finland. The suggested fee is nicely in the high six figures."

"You're surely not going to turn that down, are you? High six figures," Henry said.

"The fee is quite generous, that's true. And the subject suggested is Heracles and his twelve labors. Just my sort of work: big canvases with figures and animals in symbolic settings. But I think the gods are testing me here, giving me such an impressive commission just as I determine never to accept another. I *am* going to turn it down. I'm not going to do it."

"You're a fool, Constance. A beautiful, talented fool, but a fool, nonetheless," said Henry.

Constance did not have time to reply to Henry's riposte. Another guest at the table interrupted by pointing out the window to the hill beyond. He said, "Look, there's a house on fire over there".

Jeremy knocked over his chair as he stood. "Connie, my god, that's *our* house", he said. He ran to window to get a better view. Henry called the fire station from the kitchen phone. The dinner guests stood as the fire grew.

Connie was speechless, but her face was twisted in alarm. She said, "Let's go, Jeremy." They raced out of the door, Jeremy pulling Constance across the darkened garden and to their car.

It was a ten-minute drive to their house from Henry's, down to the ring road and back up the twisting dirt trail to the

fire. But in those ten minutes the fire had come into full and awful bloom, engulfing the entire house. The dinner guests witnessed in helpless dread as explosions billowed out of the windows and frame walls collapsed, one after the other. They could see the fire engines arriving too late to make a difference.

Conversation came to a stand-still for several more minutes. Henry broke the silence. "I hope Constance and Jeremy don't get too close. There's nothing they or anybody can do. What a horrible thing to happen to them. To anybody." With murmurs and whispers, the dinner party dissolved into the night, cars crunching down the gravel drive.

The Ramages moved into Henry's guest room and stayed there in the days that followed. Jeremy went each day to work, but Constance remained in the room most of the day. Henry took her a tray for lunch and double trays for them both at dinner, but they ate very little. As well as all their personal possessions, she had lost everything in her studio: sketches, records, finished and unfinished work, easels and paints. All black ash.

Henry wanted to offer solace and advice to Constance, but she begged off any conversation when he tried. He could talk to Jeremy in the evenings about other things, but early on Jeremy asked if they could not discuss the fire. For two weeks, they had quiet breakfasts together at the long table and Henry saw Constance, then Jeremy, gazing out across the valley to their hill. Constance returned to the guest room and Jeremy went to his office. Henry understood the need to mend and gave them the sanctuary needed.

In the third week, Constance met Henry for breakfast fully dressed, hair combed and set in a long pony-tail. Jeremy had left early for the office. After finishing the eggs and toast he had

prepared, she walked around and kissed Henry on his balding head.

"Henry, you've been the best. Absolutely the best," she said, sitting down again.

"Is there something else I can do? What do you need? You can stay here, as I told you, as long as you want."

"No, thank you so much, but we'll be leaving today. Jeremy's rented us a furnished guesthouse on the Camino and we'll start pulling things together there."

"Does it have a studio?"

"No, we'll deal with that later. Right now we need to start a home again."

"What about money? Can I help out there?" Henry could have his practical side.

"There's enough for right now with Jeremy's paycheck coming in. I am so glad I deposited Vasilios's check that day and also that I shipped the painting immediately instead of belaboring the small details, as I usually do."

"So you have enough to rebuild?" Henry asked.

"No, but enough to live on for half a year or so. Jeremy says our insurance was insufficient to replace the house, but it is a good start."

"I can lend you some money."

"Thanks, no. I think the gods have, in their special way, made it impossible for me to turn down the Heracles commission. I am grateful, Henry, for your not gloating about that, or even mentioning it. The commission will build house and studio. Perhaps a good distance between them this time." She winked at Henry.

"Curious how it turned out," he said.

Constance's agent in New York set to work. She bargained for the details of the commissions, including an increase in the fee, and the Poseidon Lines accepted. The steelworkers in Finland were already putting together the hull, so the long process of sending maquettes back and forth was dispensed with. The ship's designers agreed to fly in and approve the individual panels as she painted them. The deposit from Poseidon Lines saw them through the coming winter.

Constance leased a large studio in the rail-yard properties, a former dance studio with hardwood floors, adobe walls, and a large skylight. With a forced enthusiasm she started work on the First Labor. The first panel, seven feet by seven feet, had Heracles wrestling down the Nemean Lion, a rampant man-killer in that village of ancient Greece.

Constance used the owner of a popular gym, David Brand, as the model for Heracles, signing him up for daily sessions during the months of the project. The scale on many of the panels was her familiar half-again larger than life-size, a scheme she had learned to advantage years ago when rendering a series of paintings based on the Tarot cards. This technique gave immediate authority to the subject, converting her sketches into imposing designs that were hard to ignore. In the seven by seven framework, this required her to have David bent this way and that in the action of the stories, in this one a kneeling position to finish off a monster.

"Tell me about Heracles," David said one day as they were working. He was vigorously choking to death a large throw pillow, with biceps bulging. Constance was on a ladder painting the top of David's head.

"Actually, today we call him Hercules, which sounds to

me more like a Madison Avenue brand name. Heracles sounds so much better, so ancient, so Greek."

"What did he do?"

"Legend has him the bravest and strongest man in all of ancient Greece. His father was a god, Zeus, and his mother a mere mortal, but a gifted woman. He was *the* hero to the Greeks and the trials were put to him by the oracle at Delphi. It's a complicated story from there. You're the perfect model for him, David. Don't move."

"I like modeling. I've never done it before but it feels right."

"You're very good at it. You fall into poses naturally."

"Will I be famous after this?"

"Only among Poseidon cruise passengers and only if you stop moving."

Constance started in the upper left corner drawing the whole composition in soft sienna pencil and proceeded downwards and to the right until it was all drawn in. She then corrected the cartoon here and there, pulling in an elbow, enlarging the victim's eyes. Then, she painted the whole painting top to bottom without going back or correcting in any way. When she reached the bottom and the canvas was high on the easel, the painting was done. On most paintings, she never made major changes after this.

For the next month Constance was totally absorbed in the wonder of the Heracles legend. She used David in all the paintings, but took the animals and other embellishments from books and her imagination. The Nemean Lion derived from a book of English Heraldry she found at a local used book shop, filling in the outside margins with memories of the Corinthian hills and valleys. The

actual painting went smoothly, without problems and she finished that first piece in six days.

On their visit to her studio the ship designers were elated with this first painting, propelling Constance into stratospheric high spirits. Her work on the other panels continued in a white heat, her efforts as much to erase the memory of the blackened studio as to finish this complex commission. Some of the panels posed more trouble than that accommodating first canvas. Jeremy provided quiet meals and steady support each evening, discussing details of the day's work

"They are quite elegant, Connie. There is an excitement about the panels. It may be your best work," he said.

"They are good, aren't they?"

"What do you make of it? Just when you'd decided against commissions."

"I must have been wrong. In it all I see a curious otherworldly quality, as if the old gods punished me for even thinking such things. If the fire had not made me change my mind, I might have missed this opportunity."

"I think so, too. But surely the gods can get your attention in a less painful way," he said.

The painting of the Fifth Labor went especially well, wherein Heracles diverted two rivers to wash out the befouled stables of Augeias. Constance found a water motif in the frieze along the bottom of an Attic vase in a museum catalog and adapted it for the more stylized feeling of this canvas. The blue-greens of river-water swirled around a kneeling Heracles, as if he had lifted the gateway standing in the middle of the stream.

One stormy morning in their rented guesthouse, a flock of

ravens announced themselves in the neighboring field with raucous calls. Jeremy saw them first.

"Look, Connie, they seem to be waiting for you," he said. The birds stayed in a noisy cluster at the top of a small tree, occasionally flying upwards as if on notice and slowly subsiding back to their positions.

They loitered nearby for the entire morning, graciously offering themselves to Constance as models for the screeching and menacing Stymphalian Birds. Even the roiling, dark clouds of the morning Constance included in the background of this painting. Jeremy retrieved more pencils and paper from the studio when the supply ran out. The Stymphalian research was all done in a morning. If the gods took away, they sometimes also gave.

She enlarged the ravens and metamorphosed them into the dangerous foes they were in the legend. A deep border design of African castanets weighted the bottom of the canvas, symbolizing the rattles that sent the flock aloft and into Heracles' arrows. Heracles was in this canvas a small figure, shooting his arrows into the alarmed but deadly birds. Scenes of the Black Sea and Bulgarian coast filled the voids, and in the lower right corner on a cliff above the sea there was a house afire, the flames as orange-red lines reflected in the dark waters. The light from the fire under lit the clouds with a sense of menace.

In seven months Constance completed the twelve pictures. The designers wanted her to send them on piecemeal as each was completed, but Constance insisted on keeping them all together until the end, thinking surely another fire was not in the cards. She made small changes here and there on each canvas. It was her favorite part of the painting process, the small details that clicked into place in the last days.

On the final afternoon before their crating and departure, she had a small reception at her studio for all the guests at Henry Fallston's on the night of the fire, plus David. Still wary of keeping finished canvases a minute longer than needed, she asked the shippers to be on standby to pack them up immediately after her celebration party.

The panels were in the large studio room, some leaning against the walls, three still up on their easels. Twelve versions of Heracles in glorious intensity, they resonated with the artist's excitement of the subject.

The guests arrived in twos and threes and, with champagne flutes in hand, viewed the panels. When they had all arrived and had time to inspect each of the paintings, Constance asked for attention and seated them in the folding chairs provided. She first gave the two shipping workers in white overalls their own glasses of champagne then stood in front of the small group.

"I feel you are conspirators in this project, since you were all there, except David, on the night of the fire. I've thought often about the many coincidences of that occasion: why did the fire start when we all could see it from Henry's table? Why did I ship that portrait off the day before? Why did I not call my refusal of this commission that afternoon, before the fire? So many things conspired."

Janice spoke up first. "I think it was just bad luck, pure and simple."

Henry said, "But I think Constance believes it was some sort of malevolent divine intervention".

"I do believe the old gods had their way with Jeremy and me that night. It might have been something we did in a former life, even. Payment for stepping on the wrong beetle. But currently

they smile upon us. Unlike Janice's view, I have come to accept that the fire was good luck, pure and simple.

"I would never have gone into the Heracles legend on my own, and here it is, my best work. So please give a toast to Heracles. He has given us back our life. We signed the contract for the new house and studio yesterday." The group assembled raised their glasses in a salute.

"Henry, I have interesting news to pass on. I had a visit yesterday from Vasilios's brother-in-law, who was, by chance, he said, in town for a visit. He asked to come by the studio for a social call, but what he really wanted was to see the Heracles commission. It appears that these Greek brothers-in-law still have a very active rivalry, because he offered me a commission for sixteen panels of the deeds of Apollo. For his new cruise ship of the same name. At a staggering fee. What do you think I said, Henry?

"My dear, I haven't a clue. You can't have turned him down, I hope."

"Well, I accepted. I mustn't stir with those people from Olympus again. I'll be more than a year on the project and I would love to include all of you as models."

There were sounds of approval from the group.

"Henry, I must have you as a crabby, misogynistic Zeus; I have some suitable, purple robes for this important role. You can't say no."

Henry responded, "Purple makes my skin all blotchy. Why not maroon? And Constance, why do you think I hate women? I don't hate them, they just supremely annoy me. As for posing, it would be a honor."

Constance said, "I promise you some very magisterial poses with stacks of Maxfield Parrish cirro-cumulus clouds behind you. I think it will start the career you have always been searching for, posing for serious god-like personages."

"Janice assures me I *am* a god-like personage," he replied.

The shipper's men loaded the panels with blanket surrounds; the party all walked out the overhead doors onto the loading dock, as if waiting for a boat to the Greek islands, to watch the truck bounce across the rail-yard road until it was gone, leaving a wake of dusty curls.

# The Menace of the Creeping Buttercup

Blythe and Stark Landlock looked forward to their museum-sponsored week in Santa Fe, which included two nights at the opera, meals in the best restaurants, guided tours of the local museums and exclusive visits to the studios of several painters. The Cincinnati Museum sent along a curator and many of their associates from the Friends of the Museum came on this midsummer trip.

Stark, 37 years old, was a fifth generation Cincinnatian, an Ivy League graduate and a partner in a large law firm. His interest in art itself was slight, but he saw the wisdom of the well-connected friendships that museum participation might generate. He took lessons at the museum school in sculpture and produced several creditable non-objective pieces, which sold well at the Christmas Collectors Circle.

Blythe, also 37, had a degree in Fine Arts and loved the twisting turns of the art world. She could find something worthwhile in every painting and something agreeable about every painter, because art mattered. Blythe spent hours in the garden, bringing a long herbaceous border into a climax of summer

bloom. Her friends considered her an accomplished woman, who thought nothing of devoting five hours to the preparation of individual tomato quiches for one of their sought-after brunches.

The Landlocks told their friends they were childless by choice and viewed their siblings' unruly collection of offspring with disdain. In their extended family in Cincinnati, they were the only couple of their age without the chores of child rearing. Instead, they filled the hours as docents, museum board members and summer trips with fellow board members on the pilgrims' path to Santiago de Compostela and the Piero churches of Tuscany. The siblings, weighted down with the duties of growing families, sometimes voiced envy of Stark and Blythe's life of travel, art and community involvement; but in the end it was pity they most felt for the couple. After all, they had no children, and ergo an empty life.

In Santa Fe the planned portions of the visit went well with one richly portioned dinner following another and the premiere performance of an avant-garde opera was a masterful achievement, according to their knowledgeable co-travelers. Blythe let the others make critical decisions about music, waiting her turn with gardens and paintings. She gave a short, telling lecture at the O'Keeffe Museum in their morning visit there. The Landlocks' days in this bohemian town were drawing to a close when the arranged tour of Harold Bronson's studio came up on their schedule.

The museum brochure depicted Bronson as a painter of gardens with a good regional reputation and the owner of an imposing Territorial adobe studio with adjacent perennial borders. He was included on the tour as much for gardens as paintings. Blythe looked forward particularly to this visit because she read

**164**

that Bronson grew delphiniums with stalks thick as broom-handles. Award-winning delphiniums had always eluded Blythe in her quest for a flawless garden.

Bronson was working on a square painting of red poppies when the museum group arrived at his studio. He was a large man with short-cropped white hair and he stood at the easel with a tranquility that bespoke years of happy work in that same place.

The curator gave a short introduction to Bronson's paintings and then the artist showed his work in progress. He turned around, one at a time, a stack of canvases, each painting nearly complete. Fielding questions from the group, he explained his system of working from sketches and photographs and sometimes painting preliminary paintings out in the garden.

He patiently answered questions about his technique and his life at the easel.

*Why do you start a painting without first sketching where everything goes?*

"I prefer to get into the middle of things. If it doesn't work out I'll just throw it away and begin again. The start of a painting is the best part."

*Why did you quit oils for acrylics?*

"I like the way they dry."

*Why is your paint table such a mess?*

"It's not a mess to me. I can get right to any color I want."

*Do you ever wash those brushes?*

"Sometimes."

*How long does it take to finish a painting?*

"Some go faster than others. The best ones go very quickly."

*How can that be?*

"Art is not so much a function of time spent as it is of dexterity and mood."

*Why don't you paint bouquets?*

"I do, but not very often. Gardens have more verve to my eye. Oddly, the weeds, dead branches and yellowed foliage in a garden can give it vitality. Bouquets are often too perfect, dead, like a body in a coffin."

*The brochure says you hate petunias. Why?* His face showed amusement, but it was clear he felt strongly about this. He ended the question/answer period by walking away.

Bronson was a single man who radiated contentment and stability. He painted every morning, weekends included, for three hours, sometimes four, and that work centered his days and his entire life. Instead of one easel, there were three in a row in his studio, with paintings in various stages of completion. The stacks of canvases piled face to the walls evidenced his abundant output.

He took the group on a tour of his gardens, four separate spaces adjoining his studio. The spring garden was now in disrepair. Blythe noted with disapproval the way the unpruned flowering shrubs hung over the shriveled foliage of the spring bulbs, now long passed over. At home in Blythe's garden the foliage of spring bulbs was neatly braided and laid down in parallel rows.

Bronson's other gardens were in full summer exuberance, with long beds of poppies and white daisies in abundant bloom. Even the vegetable garden with corn and tomatoes was scattered with rows of flowers and the encircling walls were covered with rampant climbing roses. Morning glories encompassed one patch of cornstalks in a blue-spangled, deadly embrace.

Blythe, looking quickly away from this horticultural disorder, asked Bronson, "Don't you have a gardener?"

"Yes, but I never let him do anything but water and mow the grass. He would pull up the poppy and lily seedlings mistaking them for weeds, if I let him loose. He prunes like the felon he is. I like the garden the way it is, in deep disorder."

"I see," Blythe said. She saw that the Shasta-daises wanted deadheading and wondered what Penelope Hobhouse would think about this Bronson's garden.

It was a true painter's garden with emphasis on drifts of one color and on the strong architectural lines of the pathways and surrounding walls. What showed up in his paintings as mannerist affectation was revealed to be actuality in these careless-ordered gardens, as if he had minutely planned, flaunting all the experts, these horticultural blunders.

Bronson led the group across the gardens at the back of the property to his residence, a single bedroom cottage with thick adobe walls. French doors led to the outside, propped open all summer. They gave the house an air of impermanence, a garden pavilion more than a proper residence. The walls inside were covered with the paintings by Bronson and other Santa Fe painters; it was furnished sparsely with Mexican pine country pieces and pots of jade plants, large as trees.

Everywhere was fulsome evidence of a good life. A large kitchen table in disarray testified that Bronson was an amiable host. Dishes and glasses from a dinner party the night before were strewn about among half a dozen empty bottles of wine. Two cats eyed the visitors with suspicion from safety atop a sideboard. A battalion of candlesticks had burned low, candle-wax encrusted

on the table below. Soufflé dishes in the sink were scraped empty and piled full with crumpled napkins.

"Sorry about this mess," Bronson said, waving his hand at the clutter. In actuality, Stark thought he did not seem at all sorry.

"Who was here? Clients?" Stark asked.

"Mostly other painters and a couple of writers. Two friends kindly did the cooking and I was allowed to pour the wine. We were celebrating the publisher's acceptance of a friend's new novel. Too much celebration, it would appear."

"At home, Blythe would have to get everything spick and span before we could go to bed. No one sleeps in the untidy cottage."

Bronson laughed. "Not here. I treasure my sleep, and there's plenty of time to clean it up this afternoon. Morning hours are too good for painting to waste on this and I can't really disappoint the cats. They've learned to like my dinners."

Stark pondered how different Bronson's life was from theirs. How appealing it was to have artists and writers to dinner with interesting conversation and ample bottles of wine. He could almost hear the laughter and clink of glasses. This was a life in an intellectual and creative paradise, away from the false urban pressures and family demands. He briefly considered Cincinnati and the hidebound circle of their friends there.

The more Stark saw, the more he beamed with approval. As the rest of the group strolled through the disheveled gardens, he took Blythe off to one side and asked her, "Don't you think this is great?"

"No, not really. It's all so messy," she said.

"You could do wonders with these gardens; I love it here. Just as it is. Bronson is truly a happy man."

"Too happy, maybe. What's wrong with a maid and an occasional sweep of the broom?"

"He's a bachelor, Blythe. And he seems very satisfied to be one, it would appear."

She was not convinced. "Something's not right, that's all. A grown man in all this disorder is an embarrassment."

"He obviously has many artistic friends and an active social life."

Blythe was disappointed with the lack of harmony and cleanliness in Bronson's house and gardens, everything too exuberant and untended. Vines cascaded over walls, into windows of the house, creepers almost obliterated the garden paths, and there were whole drifts of lilies and delphiniums with shriveled seed-heads where blossoms should be. With a sigh she checked the delphiniums, standing brazenly tall without artificial support. Alas, the stalks were indeed as thick as broom-handles.

This was not the message her garden books told her. Borders should be neat and tended, not left to this complete *laissez-faire*, no matter how floriferous. In Cincinnati before they came on this trip, she had the notion that Bronson was a slim and fastidious fellow gardener, somehow a male version of the image that she had of herself. She had felt a kinship with Bronson already.

When they arrived, she pictured that he would be out in the garden staking and pruning his own flower beds, patiently getting things together for the perfect painting that would result, no horticultural procedure too time-consuming or difficult. He would also have looked rather like Jacques Cousteau. Improbably, but absolutely logical in her mind's eye, he would combine a

**169**

Japanese aesthetic with a strong dollop of French flair. A thinner, taller Monet with bonsai secateurs. A thoughtful, ascetic plants man with a brush, but not this not-so-benevolent, overweight dictator.

Bronson's paintings were sloppier than the reproductions in books revealed. The surfaces were distressingly varied, some sections glossy and other large portions flat and dead. Blythe saw dog-hair stuck in one bit of paint and many drips and blotches on the bottoms of the larger panels. The floor beneath his easel was an archipelago of drips and stains, the brick floor despoiled with careless droppings. She could not look at his painting table with its piles of disorder.

"I had so wanted to like his garden and house. Look at this willful disorder," she adjusted her Italian straw hat with long ribbons and gestured around the vegetable garden. Lettuces crowded against lilies and tomatoes exploded out of their wire frames, occluding the marigolds below. Everything was over-energetic and unconstrained.

"I don't know what you expected, sweetheart. Remember my work at the museum. Art is a messy business," Stark said. He hated it when Blythe turned against someone, as the door to her own court of appeals slammed firmly closed. Nothing could bring the focus of her disfavor back into favor.

Stark said, "But he does this by choice. This is what he paints; these are his motifs. Remember how he told us that he hated those Dutch gardens with flowers assigned to rows like soldiers. He likes gardens in chaos. *Le jardin débauché.*" Stark hoped his approximate French would amuse Blythe, but she kept the determined set of displeasure to her jaw, not even a flicker of delight.

"It's the life-style here of validated sloppiness, like the turning of hogs loose in the streets. It makes me nervous. You know how I am." She pursed her lips, and Stark knew this signaled an end of their discussion.

He, however, was enchanted by what he saw. Although it was clear Bronson was not a lover of sports and hunting like other men, he enjoyed the strong masculine quality of having things his own way, not bending to the pressures from others.

He ordered life and work to his own suiting, protecting his energy in the single-minded pursuit of his own goals. His studio and gardens were as invasion-proof as any Arab kingdom. No one could interrupt his mornings at the easel. He even rescheduled this group tour to the early afternoon, explaining only that mornings were not possible.

How unlike Stark's own life, proscribed and delimited by his wife, his family and his law firm; striving to live up to their expectations, he buried his own desires so deep that only today did he realize their loss. Whereas Bronson sat firmly in the middle of his life, Stark knew he himself perched only tenuously on the outside perimeter of his own world, looking in, almost a foreigner.

In the bus back to the hotel, Blythe and Stark bickered about their differing views of Bronson. Blythe felt threatened by Stark's approval of this wayward artist and his selfish ways. How could Stark have applauded such a perverted version of egotistic indulgence?

Stark could not dismiss Bronson and his verdant compound. Something had clicked in his mind about the painter's choices, mostly the things he did not do. He did not seem worried about conventional goals and patterns, and he did not care that others saw his paint table and gardens a total mess. He was only

concerned with his own work and its sources. Stark felt that Bronson had been given the permission to be different that he had been denied.

They returned to their room at the hotel, studiously avoiding any discussion of Bronson and their visit. Stark, however, continued to turn the events of the day over in his mind. Possibly the time had come for Stark to take charge of their lives, because in the end it would make Blythe happy too. After dinner that night, he reached across the table to get Blythe's attention.

"Sweetheart, what would think about this?" Stark said.

Blythe tried not to flinch.

Stark continued, "We're still young enough to make a sea change in our lives. What if we sell the house and the practice and move here? We would have enough money for four years or even more. I'll take up sculpting and you could have your garden. A new, larger garden. You can show Bronson what one really looks like."

Blythe looked away, not answering.

"What do you think? Your cooking would give them all a run for their money. We would make friends with artists and writers."

"It's ridiculous. Why throw everything away we have worked for on a willow-the-wisp? What about our friends?" she said.

Stark was not listening. "I could come here first, and get things set up for us. And then you could come later, if you want, after a summer in your garden."

"What about our families in Cincinnati?" she repeated.

"They would love to visit us here. They will forgive us, I am sure."

Blythe was quick to pick up a turn in the argument. "There it is, then, that's the crux of it. We would be doing something that requires forgiving and redemption. It must be wrong if all our family and friends must pardon us for it."

"No, it's really they who are deluded, living their hidebound little lives," he said.

"But you've just been made partner, and I have just got the house the way I want it."

"You can start another one, a better one. The other partners will be envious, I can assure you. There's something terribly appealing about starting afresh. Please think about it."

"All right." Blythe was not happy.

Worse still, how could Stark even for a moment contemplate moving to Santa Fe without her, pursuing painting or sculpting and forgetting the domestic obligations that were so much a part of him? Blythe had the sinking feeling that their life together would never be the same. She had lost control. She felt alone on a raft. That man Bronson opened a door in Stark's mind, a door that would never be closed again.

She was deeply sorry they had come on this trip at all. She thought back to the time when she brought a rampant and destructive ground cover into their garden, a creeping buttercup that insidiously overtook all the shaded parts of the borders. Christopher Lloyd, she later discovered, called it a "terrible garden nuisance, to be avoided under all circumstance." She remembered it was *Ranunculus reptens flora plena*.

At the garden center, it seemed so innocent and attractive with its long curling stems of green sporting double buttercups along its twining length. That single plant had spread deceitfully by underground stolons and now it was impossible to root out. It

robbed the peonies and lilies of their strength and sullied the strong points of her herbaceous border.

She never looked upon her garden again without guilt. It might be the single reason that the garden club had passed her over for a Medal of Honor. Now she had done the same thing again with this trip to the studio gardens of this Harold Bronson in Santa Fe. His dreaded example was growing in the fertile ground of Stark's mind, a creeping peril, never to be fully rooted out.

# A Bothersome Knee

The Vigil House was crumbling back into the ground, pieces of window trim angling down from plumb and the stucco falling off in places to reveal the adobe bricks beneath. Like all the farmhouses on Canyon Road, it hugged the road so that the small landholders could farm the land behind with precious ditch water. The ditch still flowed daily on summer days in the 1970s, delivering water to the few remaining fields, but new houses and elaborate studios edged into cornfields and orchards. What remained from the previous centuries were these road-side adobe farmhouses, one by one being converted to galleries and shops.

The painter Alabaster Prynne owned a cluster of these adobe houses, including the Vigil House, properties that she purchased from her painting sales. For years she had rented the house to a widow who lived there and ran a small antique business from the front room on weekday afternoons. Florence Reilly sold the elegant detritus from Eastern establishment families who had run to ground in Santa Fe. She loved linen napkins, odd pieces of silver, small tables, chairs with cabriole legs and old porcelain, particularly Limoges, and there was always plenty of it for sale in her shop.

One day I bought six Limoges dinner plates from Florence, hoping to inspect the interior of the thick-walled Vigil House. Since her private quarters were shut off with a tasseled cord, I could only examine the main sala. It was a dark room, narrow and long, with a massive fireplace pushing itself into the floor-space. A row of French doors and windows gave onto a south-facing porch where a large black dog snoozed in the sun. It must have been a day near the winter solstice, because the noonday sunlight angled deeply into the room to make my dusty stack of dinner plates glow in translucent white. I knew right then that I wanted to live sometime in the Vigil House and work in the walled garden behind, thickly overgrown with shrubs and trees.

It was a few years later that the opportunity for just that appeared. I had met Alabaster Prynne at the gallery where we both exhibited our paintings. She maintained her own studio gallery, but her arrangement with the Ludlow Gallery offered other, better connections and longer hours. I found an opportunity to ask her if I could some day rent the house where Florence lived, of course when she no longer wanted it. That one day came when Alabaster phoned me.

"The Vigil House is empty now. Florence was called back to New Orleans on family matters. Permanent family matters. Would you like to rent it?"

"It depends on the rent, Alabaster."

"Six hundred a month. You must pay all the utility bills as well. You can start on the first of the month."

"That's a lot for me right now. Let me call you back tomorrow. Don't rent it to anyone else, please."

"I'll hold it for you."

It was a financial risk, but the next day I decided to take it. That was start of the ten years I rented the Vigil House for my studio. It had seven rooms and, at first, it was too large for me alone. I sublet the back bedrooms to a woman who kept books for several businesses in town, a young Englishman took the large bedroom with street access for his antique shop, and the middle rooms went to a woman painter, who used them only on weekends, painting one canvas over and over again. This considerably diminished the bite that six hundred dollars took. The four of us shared the kitchen and small basement for storage; I kept the French-doored sala and back garden for my own.

I expected that I could add a skylight to lessen the darkness of that room, but the layers of roof above roof, false ceilings and sheets of black paper thwarted me. So I bought artificial lights and installed them over the easel. I immediately liked coming into the house in the mornings and my work there went well, despite the gloom outside that pool of incandescence.

Alabaster's own studio was just behind the Vigil House and she lived at the far back of the compound in a house with her friend, Katherine, and many dogs. Another painter rented a studio off to the side of the Prynne compound. I felt a quiet support each day in having other painters at their easels nearby.

Alabaster strolled about her small compound with the aplomb of a duchess in her own county, arriving unannounced and opening doors without a knock. She was seldom without her dogs, a flotilla of mixed breeds: beagles, salukis and wolfhounds. Since my studio was at best a semi-private place, what with the three sub-lessees, I took no affront at her surprise arrivals. Quite often the visits coincided with the day that my rent was due. On one of these occasions, she came in and sat down while I painted.

The dogs closely inspected the baseboards of my studio and a muffled shout evidenced that they had invaded as far as the back rooms of the Vigil House.

She said, "You've come a long way. That painting on the easel has an unknown, dark presence in that upper corner. My eye goes right to it, and such mystery is an admirable trait in any painting. I like it."

"Thanks. I've finally learned to leave some parts alone."

"It is hard to know when to stop. I constantly remind myself to stop sooner rather than later. This one on your easel is done, is it not?"

"I suppose so." How could I dare to continue?

"I think I may have some collectors for you," she said.

"That's good news. Who?"

"A dear man from Oklahoma City and his wife."

I had known Alabaster long enough to know that "dear" was her code for "rich." She was generous in sharing with younger painters the dear people that came by her studio.

"Do they like landscapes?"

"I'm sure they will want your work. They always buy several pieces from me on their visits."

I asked, "Are they in town?"

"Not yet. This Saturday we'll have you to cocktails so you can meet them. They will be charmed, I know, and ask you to dinner. If they don't buy a painting, at least you will have a good steak under your belt." There was a long silence as we sat, a silence I learned meant that it was the first day of the month and Alabaster would leave with a rent check in her pocket.

"Let me write you a check for the rent."

Saturday arrived and I went at the appointed hour to Alabaster and Katherine's house. The Griffiths were already there, along with a small group of Alabaster's artist friends. After introductions were made, I sat down next to the Griffiths. Mr. Griffith, balding and portly, was the talker of the two.

"Miss Prynne tells me you are an up and coming artist, here," he said.

"I'm glad she thinks so."

"Can Bella and I see your work?"

"Certainly. When do you want to come by?"

"What about right now? Isn't your studio over there?" he said, pointing the way.

Alabaster excused us, winking at me, and we walked the three hundred feet to the Vigil House. I unlocked the door and turned on the lights. The studio was a mess. I took an unfinished canvas off the easel and replaced it with a completed landscape, a medium-sized painting of cascading waters through mountain evergreens. The mountain motifs had taken my interest and I had a number of them finished or under way.

Mr. Griffith was quick to act. "I'll buy that one. How much in cash money?"

"Six hundred." It seemed properly symmetrical to have a price that matched my rent.

"Fine. I have it right here." He counted out six bills from his wallet. "I like doing business in cash."

"Me, too. It doesn't happen for me very often, though."

"Here's my card. You can have it shipped to that address."

Bella said, "It's a privilege to see your studio."

The evening ended with the Griffith's dinner for all of Alabaster and Katherine's guests at the restaurant up the road. I

sat across from Alabaster and next to Mr. Griffith.

He said, "Thank you, Miss Prynne, for introducing us to this young man. We now have a prime example of his new work. His painting reminds me of the old Taos artists, brushstrokes vigorous and colors strong."

"I was happy to do it."

"Bella and I both enjoy searching for the art of deceased American painters and we've bought a lot of it over the years. We have good friends who own galleries in the City and we go to all their openings."

Alabaster said, "What is it exactly that you like about deceased American painters?"

"For one, their works are plentiful. So many *Plein Air* painters worked in California and the West, now totally unknown to the art buying world. My gallery-owning friends also say that by specializing in deceased artists, they don't have to deal with the demands of disagreeable living painters. Both of you, of course, are very easy to deal with, but, as you know, many artists can be ornery and unreasonable."

"I don't know that, but when we are deceased, presumably we will be easier to deal with."

"Bella likes the company of artists."

"And we're very glad she does." Alabaster looked up at me as she sliced off a bit of rare steak.

Mr. Griffith made a pageant out of paying the bill for everybody with more of his cash. The underground strata of Oklahoma apparently provided an endless supply of big bills. Despite his interest in my work and the instantaneous sale of a painting, there was something distasteful about the whole evening. I did not like becoming a person who was immediately available

to entertain buyers whenever a painting sold. Did the act of selling a painting grant the buyer a lifetime right to a dinner companion? And did he buy only because my work resembled the very dead Taos Seven?

Time passed, and Alabaster came into my studio from the back garden doors, now walking with a cane due to a bad knee. She sat down before speaking.

"Guess who's back in town? The Griffiths."

"I suppose that I'm happy to hear that."

"Katherine and I could use a good steak. We've had nothing but chicken enchiladas and green chile stew lately."

"A dinner with the Griffiths may come at too high a price for me."

"Mr. Griffith and his Bella are simple, harmless people. You must learn to tolerate collectors of all sorts."

"I do, really. But I think the function of the artist is to make art, not to be colorful and amusing escorts for potential buyers."

"Nonsense. Other people love to be around artists, in the artistic ferment, and for that they should have to pay. It makes only a very small dent in the Griffith hoard and in return we provide them the warm feeling of socializing with Santa Fe insiders. It's a fair exchange."

"Would you be mad at me if I don't go?"

"No. But I won't lie for you. You'll have to make your own excuses."

I did tell a lie to get out of dinner. Mr. Griffith was insistent, however, about coming by the studio the next day. He and Bella had an important announcement for Alabaster and me, and he would wait until we were both together. We gathered at ten the next morning in my studio.

Alabaster got right to the point. "So what's this bit of news?"

Mr. Griffith said, "Bella and I have bought a gallery in Oklahoma City. It's in the best shopping center, right next to an exclusive, gated community and we'll officially change the name to Griffith Fine Arts next month."

Alabaster said, "It's a thankless lot to own a gallery. The artists get nervous if you don't sell their work and the buyers never come by when you need them. Are you sure you really want that?"

Bella nodded enthusiastically and Mr. Griffith said, "I'm now retired from the oil business with plenty of time on my hands and Bella will keep the books, pay the bills."

"Good for you, then. Both of you."

"The real good news is that we want to mount a two-person exhibit of your works. In October, it would be our very first show."

Alabaster said, "Why haven't you chosen one of your deceased Americans for your first show?"

"Bella thinks we should let the City know right off the bat that we have a broader scope. Naturally, the deceased artists from our collection will be the bread and butter of the operation."

At first blush, an exhibit in a shopping center gallery next to a gated community did not sit well with me. Alabaster had a different take on it. She looked directly at me and said, "You need more exposure in your career, new galleries with new buyers. I'll say yes for both of us. The young and the old together."

As I considered how to extract myself without offending potential collectors, Mr. Griffith said, "Fine, it's settled, then."

I had been swept into agreement without a word and we moved on to discuss details of the exhibit. Mr. Griffith asked for twelve pieces from Alabaster, paintings and terra-cottas, and

twelve paintings from me. The opening night was four months hence and he offered to buy outright six from each of us before the show opened. Santa Fe galleries were never so generous, so Alabaster and I left the meeting with profound sense of financial delight.

The four months went by, and since I already had a head start on the paintings needed, it was an easy project. Alabaster, too, found several unfinished panels in studio corners that she brought to a fine polish without much effort. Two weeks before the opening night, we watched the truckers as they loaded all our work onto a van headed east for Griffith Fine Arts. Alabaster came back with me to my studio.

She took her accustomed chair and said, "By the way, my dear, I cannot even think of going to Oklahoma City. Katherine is not well, as you know, and I'm not feeling on top of the world, myself. My knee, you know."

"You mean that you're leaving me to face those people alone?"

"You're an agreeable and sociable lad. It will work out just fine."

"You never planned to go, did you? Even from the beginning?"

"This will give you a chance to spread your wings, to be the sole focus of the evening." She paused and looked intently at the new canvas on my easel.

"Is my rent due again? I'll write you a check."

A few days before the exhibit, I drove my pickup truck the six hundred miles to Oklahoma City. I checked into a downtown hotel, having turned down the Griffith's kind offer of their spare room. The morning before the opening reception, I

found Griffith Fine Arts in its shopping center and parked nearby. I saw immediately that our work was handsomely installed and perfectly lighted; the Griffiths had put together a quality operation from top to bottom. It was a display of professionalism that any Santa Fe gallery could boast about. I felt a rush of guilt over my early suspicions.

Mr. Griffith welcomed me, "So glad *you* could make it and what a shame that Alabaster is missing our gala opening night. We have the City's best caterer and an open bar."

"She is getting very frail and her knee is a bother."

"I understand. But look at the vigor in her work. Like a much younger woman. We've already sold most of her pieces and I'm sure the opening nighters will pick up some of yours, as well as the remainder of hers."

"So nothing of mine has sold so far?"

"No, but not to worry. Bella and I have chosen the six we agreed to buy from you and marked them with a green dot on the side of the frame. See here." He showed me.

"That's very generous of you, Mr. Griffith."

"Since I'm sure all of Alabaster's fine work will have sold by tonight, I'll have Bella send her a check today for the full amount."

"So you're pleased about having a new gallery?"

"We are thrilled."

He went back to his office and returned with a check for my six paintings. I filled the rest of the day with sightseeing in Oklahoma City and arrived at the evening reception only a few minutes late. A large crowd came and filled the gallery, consuming trays of canapés as they were passed and heading repeatedly for the open bar.

Mr. Griffith was on target when he said that some of my paintings might sell that night; he proudly pasted the red dots on the cards nearby. As I talked to the guests, it was clear that Alabaster had a large collector base in Oklahoma. She was the one everybody had come to see. A dozen different people claimed to own Prynne paintings or sculptures; how sorry they were to miss her. Was she really all right? How old was she actually?

The next morning I went by the gallery again before leaving for Santa Fe. The hubbub of the reception was over and I could see exactly which of my paintings sold. When I looked around, it became clear that none of the six with the green dots had sold on opening night. Only the other six had the red dots indicating a sale.

What a curious outcome that he had chosen in advance only those paintings that did not sell. Since I could not make sense of it, I decided not to mention it. "Are you happy, Mr. Griffith?"

"Delighted. We'll keep the gallery open evenings for the next week. We've got to strike while the iron is hot."

"What's your next show?" I asked.

"A woman painter from California. She died peacefully in her sleep at age ninety and her estate has more than thirty paintings. Lovely pieces. Lovely woman."

"I'll be going on, then. Back to Santa Fe."

"We couldn't have had a better launching."

"I'll let Alabaster know about her success."

When I got back to Santa Fe, she was waiting in her studio door with her dogs clustered about. We went into her office and I related the events in Oklahoma City as the young beagle from her pack hopped up into my lap.

I said, "I spoke with many of your collectors. They hoped to chat with you and wish you well."

"There are so many dear people up there."

"You seem to be walking better now. Without a cane. Is your knee really better?

"Much better, thanks. There is a great therapeutic value to missing your own opening night."

# A Delicate Balance

I made, what I later realized was, the great mistake of recommending Erik's place in the country to my friend Charlotte Rothenberg, who had arrived on my doorstep without prior warning. She was a loved but rackety friend from my New York days, the editor of a house magazine.

Late one morning I answered a loud and repeated knock. It was Charlotte, beautiful and stylish as ever, dressed in black pants and black silk blouse to show off her slim figure. "Charlotte, what are you doing here?"

"I caught the red-eye last night and I'm here to claim your guest room for two glorious weeks, you lucky boy."

My heart fell at the thought. "Not a chance, my sweet. Why didn't you call?"

"Because I knew you'd say no," she said. "I need a quiet place to write for two weeks. My own work, the novel about Elsie de Wolfe."

"And I do say no. I've got paintings to finish for my show in just one month. I need a quiet place myself."

"I'll cook your breakfast and wash your smalls, like the Dalai Lama's chief boy. Be ever so quiet and demure."

"No."

"Pleeeease." It was her best little girl whine.

"Absolutely not. Let me think." I knew the downtown hotels would be full. I could not foist her off on my in-town friends, so I called Erik. He was a fellow painter and the owner of a bed-and-breakfast in Nambé. I called and there was one room left.

"Don't even bring your bags inside. You're going to Nambé. Country walks and fresh air. Perfect for your writing project. I'll see you in the evenings for dinners."

"Sounds grim. Country walks mean snakes. You don't love me anymore." She pouted her fake pout.

As we drove north, I described Erik's Nambé establishment. Although nothing about Erik was less than manly and brave, the perfection of his life and work seemed somehow fragile and endangered. Describing him brought up an issue of continuing trouble for me.

I have the notion that a talent for painting is a delicate thing, easily broken or even smashed to bits without hope of mending. What to the outsider appears a roiling eternal flame is in fact the most delicate taper, flickering in the many winds that threaten it.

Friends and family treat the talent of their beloved artist roughly, depending on it for income and status, and they mistakenly take it for a strong, lifelong force. They believe it is their own mountain spring always gushing forth, forever there to nurture and reward them. A family resource, like a coal-mine or an orange grove.

Not so. I have seen even well-meaning spouses smother a talent so totally that not a wisp of smoke remains and spouses who are jealous of their mate's abilities are more common than you would imagine. Others rarely appreciate the long meals of

solitude needed to keep a talent alive. Glenn Gould thought that a certain minimum number of hours of seclusion were needed to produce just one hour of artistic production. There are other enemies to the creation of art. Self-doubt, indirection, depression and disappointment are just a few of the others. But how does this affect Erik?

He arrived fresh out of art school in Stockholm to make his way in the minor tumult of artistic Santa Fe. His sister lived here with her scientist husband and encouraged him to come and try it. He moved into the guest apartment at his sister's house in an unfashionable, non-artistic part of town. He painted at night, alternating with a succession of day jobs from waiter to hardware store clerk.

He was tall and nordically fair, and he quickly cut a path through the ranks of young Santa Fe artists. The young women of town were agog with his beauty and tried many ploys for his attention; to no avail, however, as art was to be his mistress for the next few years. His compass was set.

Erik and I got to know one another through repeated encounters at the art supply store, framers and packing companies. He had a solo exhibit at the Ludlow Gallery in the autumn of 1979: forty paintings of his trip to Spain that summer, loosely painted scenes of hillside villages with Fauvist colors and strong dark outlines. They were all about the same size, a comfortable dimension to roll up in carry-on baggage for the flight home. The work was joyous and colorful, and it was an instant hit with the buying public.

That winter he went back to Europe, painting winter scenes of the Alps and the Swiss lakes. These also sold well the next spring at Ludlow, and the pattern of his work had been established. Two

months off in Europe painting then back to Santa Fe for an exhibit. Some years he had a big midsummer exhibit and others he had two smaller ones in the spring and fall. Virtually all of them were sell-outs.

Erik was careful with the money he earned from painting, bringing together enough to make a down payment on a rambling, run-down adobe in Nambé, a valley fifteen minutes north of Santa Fe. He worked on the house himself, keeping true to the spirit of long ago. After whitewashing the rooms, he collected simple furniture from flea markets and second hand shops. His untutored Scandinavian taste suited the earthy adobe hacienda, with his paintings lending the only bright colors; even the curtain fabric was white painter's canvas.

He had a direction and design for all this homemaking: a bed and breakfast inn. Word spread and he soon had full rooms for all the summer months. Erik cooked and served the breakfast himself, then disappeared into his studio in the middle of the day. Those first years he did almost all the work himself: cleaning the rooms, cooking the breakfasts, keeping the books and reservations, cozing with the guests. How he managed to find time for his studio and paintings, no one knew. But he did and took trips to new sites in Europe as well. I remember a series of the Norwegian fjords, the Portuguese coast, Rome, and picturesque German villages.

I admired his work, but mostly I admired his incredible energy. He did so many things well and maintained a joy of life while doing them. In the later years when he did not cook the breakfast himself, he still appeared personally to greet the guests and tell tales of this artistic backwater. He told me it centered his day and he would not think of giving it up. When he left the

breakfast group for the studio, he was energized and directed, and then able to dive into many hours of painting.

I sent several visiting friends there the first summer and they all loved being included in the tasteful core of a painter's household. His appealing work and sunny disposition won their devotion. Only a few pictures were on display at any one time, the long white walls offering a clean stage. Many of the guests bought a painting from Erik, admiring how he put together his inn with his gallery. The house had the spare beauty of O'Keeffe's without the remote location. He had a natural, unstudied good taste that appealed greatly to the city-folk who came for summer stays, and now, Charlotte would become his newest fan.

When we turned off onto the dirt road, she moaned an Oy Vay. After several miles, I slowed to veer down the long overgrown drive through a bosquet of cottonwood trees and tamarisks. The way was muddy and irregular; I swerved to miss a watery pothole. A hand painted sign announced the *Danielsen Gästhusse*.

Charlotte sounded more worried. "What the hell is a Gästhusse? Do you suppose he knows what a bagel is?"

She was not happy. I reached across and patted her leg.

"Erik will take good care of you and you'll love the place," I said.

"How well do we know this Erik?"

"I'm sure you'll like him. Calm down, sweetheart."

"I don't see why I can't just stay with you, in your guest room. Like I did last time. Now it's the Bate's Motel with me."

"Because I'm busy painting for a show and you're just too attractive to ignore. I won't get anything done. You're too high maintenance."

I could see that all her urban paranoia was right on the surface. Charlotte was a true urbanite, deeply suspicious of things country and sylvan. I continued slowly along the rough drive past a small pasture with a flock of grazing black sheep, wooden rail fences encircling. The long house came into view, sitting comfortably on the hill above the pasture. Surely this picture of bucolic safety and happiness would assuage her.

Indeed, Charlotte breathed a sigh of relief as we parked in the well-tended gravel forecourt and walked through a line of green poplars to the open door.

"See?" I said.

"Very nice, very nice."

It was cool in the house. The door at the end of the long center hall gave onto a portal overlooking the bright pasture and the Sangre de Cristos beyond. Country pine furniture lined the hall with one of Erik's paintings in the center of each wall. The pale old pine or lightly painted pieces gave a bit of country Sweden here in Hispanic New Mexico. The waxed furniture mingled its scents with the morning coffee. There was no one about.

"I like him already," Charlotte said, looking around with approval. Her house magazine editor's eye took it all in. "What does Erik look like? I should do a story on this." I could see her curiosity was piqued and operating at full tilt.

I called out for Erik as we walked through the house, but no answer. The dining room had a refectory table with an informal row of brass candlesticks in the center like disorderly soldiers. Blue Willow china was still uncollected from breakfast and the mismatched pine chairs in disarray. We continued through to a small library with comfortable old armchairs and floor lamps. Each room had a single painting on the white walls with no other

ornament to detract. Still no Erik. We wandered farther through the house, along a hallway with a chapel to one side.

Charlotte asked, "Are the Swedes Catholic?

"I don't think so. Erik likes the look of the chapel and collects candlesticks and churchly things. It's more aesthetic than spiritual. Let's look in."

It was a small room with a deep red painted altar and flickering votive lights, a *prie-dieu* to one side. A large, particularly bloody crucifix hung above the altar. The sidewalls each had a single painting, Erik's versions of two of the Stations of the Cross.

"It's creepy. Who would want it in the house? Does the priest actually come here?" Charlotte asked. We continued on down the hall and turned into the studio where he was focused on the painting on the easel.

"Charlotte, this is Erik."

Years later, I wished I had driven her to Chimayo or Taos instead. Charlotte and Erik met, became attracted to one another, and married the next spring. In short order they became one of the more popular artistic couples in the valley. Charlotte finished her novel, published it to faint praise and started work in the field where she belonged all along, interior design.

As Charlotte's career burgeoned, Erik's came under pressure to remain the same. The house in Nambé, no longer a bed and breakfast, was now a smart, much-photographed showcase for Charlotte's ability as an interior designer. Several home magazines had published major spreads on her transformation of this "unpromising" old house.

I arrived early for a luncheon to celebrate the publication of Charlotte's new coffee table book, *A Painter's House in Nambé*. It was a detailed account of how she wrought her miracle on Erik's

old adobe ruin. The small black-and-white photos of the place before Charlotte showed none of Erik's spare accomplishments, only dark, unhappy rooms.

Colorful pages were devoted to Charlotte personally covering the sofas with bright slipcovers and how she organized the bookshelves with her collections of bric-a-brac. There was a whole chapter on how she personally reworked the small chapel, with a two-page spread of her painting the walls in a kerchiefed head and designer pants.

The party was also an occasion to introduce her father, the publisher of the book, to their Santa Fe friends. All of the art community would be there, as well as many of Charlotte's New York friends, flown in for the occasion.

The maid let me in. A table in the hallway held a stack of the books. I thumbed through the illustrated volume, inspecting the photographs of rooms I had seen many times before. Now the walls were sponged with three different shades of tangerine, and patterned sofas, chairs and lamps filled the rooms. A new large minimalist painting of a Manhattan artist replaced Erik's in the place of honor in the dining room. It was smartly chic, a far outpost of New York design, instead of the simple comfort that Erik had created. I wondered what had happened to all of Erik's paintings, perhaps now only in back hallways.

Charlotte came in. I said, "It's a beautiful book, sweetheart."

She looked down and noted that I had opened the two-page spread of her colorful new office, formerly the chapel. "That smelly chapel had to go. Years of smoke from the vigil lights to be cleaned, and the plain walls were so boring," she said.

"It's not even the same house. I can hardly recognize it since you've worked on it," I said.

"Don't be too snippy about my changes. It was time for some color in here. Smart as white, beige and bone are, the world has seen enough it. Besides, the Viking loves what I've done."

The Viking was her pet name for Erik. She told me that they had to cancel his summer painting trip to Spain, because the book publication had been moved up. It was a wonderful season, anyway, in Santa Fe this year, she said, and they would go next year.

"He stays so busy outside on the farm land that I just can't get him back into the studio," she said. "Ludlow Gallery is calling him for new work, but he only drives the tractor now. So I'll just have to chain him to the easel, I guess."

Erik came in and we greeted one another warmly.

Charlotte continued, "Don't you think I'm taking good care of him? Isn't the Viking as handsome as ever?"

Erik smiled. My heart welled up in guilt at what had been done to his ascetic life here in this old hacienda. Had the golden structure of his former life really been shattered to bits? Was I putting my personal strictures on the new stylish life that Charlotte brought to this country house? Erik's eyes had a curiously hollow look, a flatness, but he was, indeed, as handsome as ever.

# An Artist's Artist

Michael Bates, who has been painting in Santa Fe for the last thirty years, has the reputation for being a perfectionist, one for whom no expense was too great nor any procedure too difficult or convoluted in the pursuit of his elusive goal, the perfect painting. He ground his own colors from minerals or squeezed them out of plants, melding the concentrate with archivally correct mediums. He fashioned his brushes from native materials like yucca stems, fox hairs and splayed flax stalks. With a mallet he pounded out his own papers from tree-barks and bulrushes and he wove all the fabric for his linen canvases.

His work attracted a small, very loyal band of collectors, mostly other artists and museum hangers-on. Truly, he fit the description of an artist's artist. When women complained of never finding a straight artist in Santa Fe, his name was cited as the exception. To own a work by Michael Bates was a badge of membership for the serious inner circle of Santa Fe art.

However, gallery owners found Bates uncooperative and unconstrained, a condition that seriously impeded his climb up the ladder of financial success as a gallery artist. He had short relationships with most of Santa Fe's better galleries. Since his serious intent and absolute integrity were undeniable, the newly

chosen gallery at the outset was justly proud of their illustrious new participant.

Shortly after the introductory exhibit at the new gallery, things started to go wrong. Bates tired of the subject matter and painting style that the new gallery invested thousands in promoting. After this first show sold out, potential buyers complained of being left out. Demand was high and spirits good, but Bates refused to provide new material for sale. He had already gone on to new ideas, new ways of putting paint on canvas, never to return to the now popular motif. Although the gallery felt cheated, Bates was adamant, and they parted with bad feelings and recriminations. He was a most ethical artist, said his followers, never replicating an image for the sole purpose of making a sale.

The Galleon Gallery was the latest to champion his cause. For them he painted a new series with a new motif: large works on paper with life-size portrayals of goats and goat families. Black goats, spotted goats, subtle gray goats and large gatherings of baby goats and their mothers. Nanny goats nurturing their young on grassy knolls. The colors were natural, the images as delicately wrought as Sung Dynasty scrolls. The hand-made papers were as thick as cardboard, luscious with matted stalks and lotus leaves. Bates's line was as delicate as hair, weaving with a sure hand around each goat silhouette.

It was a brilliant success. His admirers marveled at his close understanding of goat motherhood, even though he was neither female nor a mother. He caught the very essence of goatness as well as whispers of the Great Mother. Woman collectors, especially, stepped forward and bought most of this new work; Bates captured the female ethos in these goat sketches and it was natural that women should respond so positively. The enigma of

a resolutely male artist who could create such ephemeral, female-like images only added to their desirability.

Monica Galleon, the gallery owner, was overjoyed. She was a middle-aged widow, still pretty but losing the battle with food and drink. The gallery was her sole source of income, so a sell-out show meant a great deal to Monica.

A steady stream of visitors came to see the exhibit. Reviews in the local papers were glowing and all concerned were pleased. On the last day of the exhibit, Bates came by the gallery for his share of the proceeds.

"Monica, I'm leaving for a couple of months in Morocco tomorrow. Thanks so much," he said.

"That check could be bigger. Do you have any more work at your studio? Sketches or preliminaries?"

"No, I tore them all up."

Monica was visibly distressed. "Oh, no. I could have had them all framed. They have great value in a successful exhibit like this. You mustn't do that again."

Michael shrugged. "I like to get rid of all the early drawings. It clears the deck."

"Even scraps are valuable," she said.

"Not to me."

"You should let me get involved with that decision."

"Burning the scraps is my way of starting something else. It feeds the next project with the ashes."

"Well, so be it. Leave me your hotel number in Morocco."

A month later Monica was still fielding calls for the goat paintings. Demand, rather than subsiding had grown to a fever pitch, and she decided to try once again to convince Bates to resume this work. She called him in at his hotel in Tangiers. After

pleasantries about the Kasbah and the food and the weather, the conversation headed to relevant waters.

"Michael, dear, I appreciate your wish not to repeat an image. It is what true art is all about. Going on, experimenting, finding the new path."

"Repeating is for factory workers," said Michael, almost intoning a mantra.

"What would you think of just changing animals in your motif? That wouldn't be repeating, would it? Sheep, perhaps, or llamas or chickens or horses. Everybody loves horses. Wouldn't that be new and appealing?"

"Nope."

"Well, then, what about changing mediums. I could set you up at Hand Graphics for some mono-prints when you get back. They're very popular now and I think you could get interested in *chine collée* prints of the goats. Smaller works on paper would sail out of this gallery."

"Nope, again."

"Mind you, dear, I'm not pressuring you in any way. If I am to help you in your career, you need to listen to me. It's a pity to waste our list of potential customers. I get a call or two every day. I could sell sixty of your works on paper. Unicorns or griffins, if you must."

"Sorry." He clicked off. Bates had already started thinking about a new series. He would never do another goat and, besides, he had found new love in the shaded ways of the Kasbah, extending his sojourn into autumn.

When he did return to Santa Fe, he painted portraits of his new Tangerine lover, in a completely new style. These were large paintings with thin washes of turpentine and oil colors; sketchy,

bold outlines went right over blotches of dripping color. This was a totally new technique for Bates. Olympia was a graceful, slim black woman and for the next few months Bates painted dozens of Olympia images. Olympia nude, Olympia as the Scourge of the Desert, Olympia swimming and Olympia as Olympia.

When Monica finally came by the studio to view the new portraits, she had trepidations about what she will find. Olympia herself answered the door warily.

"Yes?" She looked Monica up and down. Her expression was flat, unfriendly.

"Michael. Is he here in the studio?" Monica asked.

"Wait." Olympia shut the door. Monica wondered if this was the face that would launch a thousand paintings. Perhaps hers was the type of charm that improved when transferred to canvas.

The door opened again. "Yes, he's here. You know where."

Monica walked through the small, cluttered house to the studio behind. Michael, who was working at the easel, said. "Give me a minute. Look around."

She looked through the stacks of paintings facing the walls, angling them out from the top. Some she turned around while she stood back for the full effect. Her face revealed her disappointment when she finally had studied all the large canvases. She started through a pile of small pictures, holding each at arm's length. Then she went over behind Michael at the easel.

"Michael, these won't do."

"What?"

"I can't sell these. Your goats had the appeal of psychic distance, a poetic objectivity, and even a certain charm that these

don't have. You're too absorbed in these portraits, not paying attention to technique or form. Maybe you are too involved with the subject herself. I'm disappointed. They're not up to your usual standards."

"How can you be *too* involved?" Michael stopped painting and turned around. He wondered if Monica would have liked anything he did after the goats. Specifically, after he refused her request for more goats. Women like Monica did not like to be refused. Was this whole interview some form of female revenge?

Monica continued. "Well, there it is. Perhaps when this work goes on to a more finished stage, is less experimental, I would be interested again. But for now I'll pass on these new paintings. I'm already late for another studio visit."

Gallery opposition galvanized Bates like nothing else. For the next several months, in a burst of productivity, he painted dozens more of the Olympia portraits. The canvases stacked deeply against the studio walls.

Income from this new work was nil. Bates could not support Olympia as in the palmy aftermath of the goat frenzy, so she tired of her newly frugal bohemian life and left Santa Fe for her house in Tangiers. The one-day garage sale of all the Olympia paintings for fifty dollars each proved that Bates, as many times before, could let go and move on. His friends supported his decision to detach himself from the commercial world of art and his ability to find closure. What cannot sell in the gallery went quickly at the low prices in the garage sale. All the paintings were snapped up before nightfall.

If art was the mechanism that spun his life apart, manual labor was the glue that put it together again. Work he did, painting walls and woodwork for Santa Fe building contractors. Bates spent

the next several years away from the art scene, doing the menial tasks he preferred in times of retrenchment. He tried to avoid art completely, even shunning his artist friends, favoring construction workers for drinking companions.

His life returned to order and serenity without the demands of art and a lover. Eventually the muse struck again and pulled him into the tumult of a new series. This time the motif was Mother-Daughter, a subject Bates brought forward from his own family experience, a mother and a sister locked in a lifetime of continuing quarrel. It was an idea that had been slowly coming to a simmer in the back burners of his mind for years, and his shoddy treatment from women of late brought it to a steaming boil.

He produced terra-cotta figures in a naïve style, with a fearsome mother embracing a single, small daughter. Dozens of these groupings ensued, as he expertly modeled, striated and incised them with the Paleolithic patterns of fertility and the spirals of continuance. Several of the mother figures recalled Goya's drawing of a horrific god eating his children. In two of the groupings, Bates had a fierce daughter, snarling back at the attentions of a mother momentarily distracted. The daughter rebelled against the massive force of Mother, a fruitless gesture.

His friends and followers came in small groups to his studio, and they found many more classical parallels in this new work. Bates's exploration of the Old Goddess pushed into a new realm. As the Greeks once did, they say, he warned today's generations of the gravity of the matriarchal threat and the ability of the female to inflict pain on the unsuspecting, especially on the daughters. Bates landed on his feet once more, besting the onerous pressure of commerce to create true art.

A new gallery in town discovered Michael Bates and his terra cottas. They published a smooth-papered catalog of the sculptures, moody photographs by the best photographer in town, with glassine fore-pages. A solo exhibition followed in the new space of the fledgling gallery; all the walls and the pedestals were painted a deep forest green. Pinpoint spotlights picked out each of the groupings on their individual bases.

Response was electric. Santa Fe's most discerning collector was the terrifying Englishwoman, Rosalind Whitethorne. She bought three of the new pieces on opening night and installed them on plinths in the sitting room of her north-side house. She devoted several days to calling friends around the world with the exciting news.

"They're so unlike other young men's work. Thrilling depictions of a strong mother," she reported. "I quite hated my own, you know, and here a parallel to my odium in three dimensions."

People listened when Rosalind found something new. Her friends in Santa Fe made special trips to the gallery and the New York and London contacts called in orders to the gallery sight unseen. Within a week the exhibit was sold out. The gallery coffers were full and the young owners pleased.

Michael Bates, predictably, moved forward into new territory the same week. He smashed the maquettes for the statues and burned the sketches in the studio fireplace. The stage was cleared once again for a new arrival of the muse. When the gallery requested new figurines to catch the tide of enquiries and Bates said there would be no more, the gallery owners thought surely he jested. The terra cottas were over.

The new theme was the timeless form of the male torso, a gender switch for Bates. In a technical break-through, Bates scanned magazine and newspaper illustrations into his computer. Enlarging them and combining them with peripheral items, he silk-screened the result onto rough linen canvas. Multiple images were overprinted and over-painted in primary colors, and he titled these *Rainbow Torso Number One, Number Two* and so on.

It was as if another artist entirely conceived and completed this jolting new work. Word of the series spread among his pack of supporters. They came by his studio in small groups and thrilled at the originality, the boldness of these new panels. He had reinvented himself once again. Nothing of what went before was seen in this new undertaking.

Weeks passed and the new gallery continued to wait for the requested Mother-Daughter figurines, for which demand was now huge. The only works to come out of the Bates studio were the Rainbow Torsos, so the gallery relented and hung some of the new paintings. The owners said they would test the waters before a full-blown exhibit.

Just as this new series snagged the delight of his inner circle, who happily awaited the garage sale to come, it was a flop with the buying public at his new gallery. Women buyers were not thrilled with the torsos, finding them unattractive and threatening. With no new sales, the torsos built up like cordwood against the walls of the studio. Bates forged ahead with his computer, weaving variations of the theme.

Patience at the gallery ran out. The staff rehung the walls with the bright new garden paintings of another artist and returned the new work to Bates without comment. The inevitable garage sale netted him barely enough to live a month or two, so he

returned to painting walls and woodwork as before. It was time for Bates to regroup once more. Years may go by before Bates would listen to his inspiration again.

His followers marvelled at his staunch and ethical stand, his bravery in the face of gallery pressure. Never will profit dictate to Bates the definition of art. His perfectionism was complete and unsullied. His collectors continued to cherish the excellence of their Michael Bates pieces as no others; he was, after all, an artist's artist.

# Catching the Cane Fields

**R**obert Fenwick looked up from a breakfast of sliced tropical fruits and strong coffee to see Henry Carrington, the owner of his rented beach cottage, puffing up the hill to the terrace. Carrington wore white trousers, raspberry espadrilles, and a green cotton shirt open at the neck with a long canary yellow scarf, a tropical plate himself.

"Top of the morning, Fenwick," he said.

"Good morning, yourself. I've seen you on the beach, Carrington, but we haven't actually met before, have we?" Fenwick replied. He decided that the correct response was to remain sitting, considering this uninvited invasion.

"Your tenth year in Barbados?" Carrington said as he stood across the table from Fenwick. "Mrs. Hackett, my office manager, tells me you're almost a native now. You must know the Bajan ways well."

"Allyson Hackett is a joy to deal with all these years, but the Bajans remain a mystery to me."

"Fifteen years here myself and I still don't understand. Lovely island, though, with acres of unspoilt land. But let me get to the reason for my visit. You are a painter of sorts, I understand."

"Of sorts, yes, indeed." Fenwick motioned to a chair at the breakfast table. Carrington pulled it out and sat down.

"You're a landscape painter. Hackett showed me your brochures. Good work, I must say."

"Thanks, Carrington. People seem to like what I do, so it makes me a living. I consider myself very lucky."

"How long have you been at it, this painting business?"

"I've painted all my life, but only in the past twenty years have I sold enough to work full time at it. Santa Fe is a good place to paint most of the year, with a month or two off here."

"Have you ever done scenes right in Barbados?"

"Yes, my first seasons here I did a series. But I've been lazy since. The easel remains dusty in the closet."

"What would you think about painting some island landscapes for our development up at Tempro Heights? We would feature them in the model homes, which we furnish completely, and use them as gifts for the people who purchase the villas. What do you think?"

"It sounds interesting. How many paintings are we talking about?" Fenwick asked.

"Eight. Landscapes of the cane fields around the old Tempro Hall. About this size." He outlined a two-foot square painting with his hands. "The decorators would have them framed, so no need for you to worry about that."

"And when do you want them?" Fenwick was rearranging his year in his mind.

"End of spring, early summer. Our models will be finished and decorated by then, in plenty of time for next season."

Fenwick paused and with his fork moved the papaya sections around on his plate. He knew it was up to him to establish

the price. "For the eight paintings, thirty-five thousand Barbados dollars. That's about half my gallery price."

Carrington smiled in obvious approval of Fenwick's canniness in the world of commerce. Artists were not supposed to have such bargaining skills. Although the heat of the day was yet to come, Carrington mopped his wet brow with a tangerine-colored cotton kerchief. "Thirty thousand would fit the budget better."

"I wouldn't be at all surprised. Thirty-four five would fit *my* budget better."

"Thirty-four thousand even, then."

Fenwick considered that sum for a few seconds. "Done. It will give me a good reason for my stays here. I'll get things ready to start this week," Fenwick said.

They shook hands and Carrington said, "There are a couple of other matters. Could you work with the decorators and their colors? They're very fussy you know."

"So am I. No, absolutely no. They can adjust their decorating to *my* colors. What's the other matter?"

Carrington paused to frame his words, as the first request had been so expertly shot down. "We have asked an island painter to do work for us, too. Do you know Billy Alleyne and his work?"

"Yes, I painted with him and a group of other islanders my first winter. I thought he was one of the best of the lot. We spent all the time doing seascapes on the south coast at Worthing and we gave the paintings for a National Trust auction."

"Since you will be our featured off-island painter, it might be indelicate of you to discuss our financial arrangements with the locals. We wouldn't want hurt feelings or the like."

"I don't discuss my finances with others," Fenwick said. He suspected that Carrington planned to pay Billy and the others a pittance for their work. The colonial suppression lived on.

"Splendid. Bring the paintings by my office when they're done and we'll cut you a check. Cheerio." Carrington hummed as he plodded down the stairs with his chair left out from the table. Fenwick picked up the fork to spear the last slice of ripe mango. He felt that he and Carrington, although lacking in any mutual admiration, understood one another clearly. Bargaining with businessmen and winning always pleased Fenwick.

He smiled at this turn of events, since he had very nearly come to the decision to paint the cane fields on his own, without the support of a commission from Tempro Heights. He wondered if some commanding and primordial part of his mind, deep in the brainstem, had summoned the unsuspecting Carrington out of his house and up to the cottage to do his bidding, quite like the curse of the Red Shoes. He savored the thought that his own powers had transported Carrington trippingly up to the breakfast table in those raspberry espadrilles.

Winters were better for Robert Fenwick when he got away from Santa Fe for a few months to Merriweather Cottage, a rental house on the west coast of Barbados. The sloping land nearby was covered with mahogany trees, palms and flowering shrubs as well as four other cottages, usually fully rented during the winter months to migrants from the north. Barbados weather stayed bright during these months, clear with passing showers and the sea was gentle and undemanding.

Carrington's own large house bordered the cottages he rented. It loomed up on the footings of the bulldozed previous house, said by neighbors to have been the embodiment of the

traditional island grace. His new villa, named Henry's Folly, with a hard-edged, contemporary design, commanded an imposing stretch of the beach. It blocked the cottagers' direct view of the sea.

A narrow walk between high walls, now overgrown with rain-forest creepers, was reserved for the cottage tenants' access to the beach. Fenwick had indeed seen Carrington on the beach, usually cavorting in the waves with groups of pale Englishwomen, houseguests at Henry's Folly.

Fenwick felt guilty when he told his fellow painters in Santa Fe that he was leaving for the Caribbean, abandoning them to the accumulating snow. Now he had the forces of Mammon on his side, a justification for his flight to pleasure.

Before such matters of art and business, Fenwick prepared for his morning swim along Sandy Lane beach. He changed into black swimming trunks and, with a towel around his neck, headed down the narrow walk to the beach. The beach was almost empty, but Bunty Goodwin was there already, sunning on the float in front of the hotel. Fenwick swam out in the clear, calm sea and tread water beside the float.

"Sorry I'm late, Bunty."

"Hello, love, what news?" She slipped down the ladder into the water. From a distance, she looked in her forties. In good shape for her age, closer up she had the sags to give it away. The years in the seaside sun had taken their toll, but her eyes were still bright blue, unclouded.

Bunty was another winter refugee, fleeing the gray monotony of Bristol and an English winter. She rented a seaside cottage on the adjoining beach each year for three months and

claimed the hotel float as her own island. Nothing happened on the beach without Bunty as a witness.

"The best. A commission for eight paintings."

"A call from the States, then?"

"No, from Tempro Heights, here on the island."

"What a surprise. So did you finally meet the infamous Carrington?" Bunty asked. They swam along the shore, far enough out to miss the line of undersized breakers. The water was so clear Fenwick could see their shadows twenty feet down on the sandy bottom.

"Not a disappointment, at all, and I believe that the people at Walt Disney designed his clothes. Such a rainbow."

"Tell me more."

Fenwick explained how Carrington would use the paintings but avoided any mention of the fee. "He will commission some local painters as well. Billy Alleyne was mentioned. I've seen some nice new work at his gallery."

"That should make his season. A purchase from Tempro Heights."

"I'm not so sure. I think Carrington'll pay him a low-ball price for his work. He made a point of not wanting me to talk about my fee."

"Poor dear."

"Billy just doesn't have the scrappiness to deal with the likes of Carrington. Should I call him up and give him ammunition for the fight?"

Bunty said, "No. Most islanders won't fight anymore. But don't feel too sorry for them, they have quiet ways of making life possible."

"I *do* feel sorry them. It's so unfair."

"Feeling sorry may be a waste of time."

They swam in silence the rest of their circuit along the beach, picking up their swimming form as they went. The speed of Fenwick's Australian crawl matched Bunty's almost exactly and each took tacit delight from the companionship of their morning swims. They continued the three hundred yards along the beach and back, crossing right in front of the resort's blue umbrellas that sheltered the bloom of European industry from the tropical sun.

"Tomorrow, dear," Fenwick said as he swam to shore. Bunty waved a farewell as she carried on around the headland to her own beach. Up at the cottage, he retrieved his painting equipment, stacked in a locked closet since his early forays into the cane fields. After a thorough inventory, he knew he needed to drive to Bridgetown for new canvas and paints. The brushes, easel and umbrella were in fine shape.

During his first years on the island, Fenwick used the small convertible car that came with the cottage, careening with gusto around curves and roundabouts in the English style. Locals learned to stand back when his car appeared. After several close scrapes, he saw that driving on the right was too ingrained for him to be a safe driver on the other side. Now he traveled around the island with the services of the inestimable Mr. Walcott, owner of a spotless taxicab.

The answer machine at Majesty Taxi picked up his call. "Mr. Walcott, I need you for a trip to Bridgetown, please. Sometime soon."

In about an hour, Mr. Walcott's black sedan appeared at his door and they were off to the south of the island. The nicest part of Mr. Walcott's service was the immutable slowness of his

driving, plowing safely down the narrow roads. After several minutes of silence, Fenwick queried his driver, "Mr. Walcott, what do you think of Tempro Heights and Henry Carrington?"

"Mr. Carrington's given the island a lot of work, that's sure. My sister's house is alongside Tempro and she's watched all the building going on there. We grew up in those parts and all of us worked afternoons for Mrs. Tempro. A fine old lady. I guess the golf is better than the cane."

"I've often gone past your sister's house there. Didn't she want to sell it to Carrington?"

"Only a bomb could move Cissy out."

"Good for her."

"Mama bought that land from Mrs. Tempro in the Twenties, and she made Mama promise that no Walcott would ever sell that land, *ever*. Cissy's not about to go back on Mama's promise. She'll die in that house."

They drove in silence for the rest of the trip to town, but on the way back Fenwick asked, "Could we go to the cane fields around Tempro for me to paint this week? When you're not busy with high paying airport work?"

"Yes sir. You want me to wait while you paint?"

"Please, Mr. Walcott."

"Tomorrow at eleven, then. No planes due until four."

Fenwick started his work on the Tempro Heights commission, painting for two to three hours each day with Mr. Walcott waiting nearby to take him back when he grew tired. They went out on painting trips every day except Sunday. In two weeks Fenwick completed six of the total number, each a different view of the bright green cane fields interwoven with rows of palm trees and dark gulleys. He composed the scenes with diagonals and

sharp breaks to give tension to the otherwise sylvan quietude. In the shadows of the cane he inserted shadings of Chinese red to further excite the overpowering greens, a technique he remembered from the landscapes of Gauguin.

Mr. Walcott brought a large black umbrella on their trips and, without a word, held it over Fenwick and his easel when tropical rain showers passed by. At first, Fenwick was uneasy about such obvious servitude, but Mr. Walcott smiled broadly on each occasion, and Fenwick fell into the colonial ease of being looked after. When the rain subsided, Mr. Walcott closed the umbrella and returned to the taxi.

On most days, Mr. Walcott listened to the Bridgetown cricket matches on the radio while waiting for Fenwick. It was an easy murmur, interspersed with subdued applause, an occasional cracking sound and the ever present rustle of the long leaves.

At the beginning of the third week of work, Mr. Walcott said, "They say that Billy Alleyne is painting at a cottage over at Bathsheba on the east coast. He's there every day for Mr. Carrington's project. Would Mr. Fenwick want to do some pictures of the seacoast there, too? It's an easy drive."

"No, Mr. Walcott. These cane-field scenes are going so well, I think I should just stick with them. Besides, Carrington specifically wanted me to paint the sugarcane."

"I understand."

On the fourth week, Mr. Walcott had a further suggestion. The cliffs on the north coast were bold and much admired, he said. He could drive right down through the farmland of a friend to the beach where the waves broke high on the cliff. No problem.

"Thanks, again, Mr. Walcott. These fields around Tempro have enough variation to keep my interest without going on such

a trek. I'll stick to the sugarcane. The variation of greens and the darkness of the gulleys are perfect for me."

By now, Fenwick had the eight paintings well in hand, with only small adjustments to do here and there. He brought all eight of them along on the last trip, changing a horizon color slightly on one and switching to work on the foreground of another. This was his favorite part of painting, the fine-tuning of almost finished canvases. Then after four hours of this polishing work, the project for Carrington was done.

The next day Mr. Walcott drove him and his paintings to the Tempro Heights offices. He waited while Fenwick presented them to Carrington and his aides, all Englishmen in dark blazers and open-necked dress shirts.

Carrington looked at each in turn, leaning them against the wall in a row on an office credenza. "Fenwick, they are top notch. I can almost hear the wind in the sugarcane. I'll have Mrs. Hackett write you a check. Thirty-four thousand for the eight. Right?"

"Yes, thanks."

"Billy Alleyne finished his eight paintings a few days ago, so we're all set."

Fenwick rode silently back to Merriweather Cottage thinking about the injustice of island ways and the pittance that Carrington paid for Alleyne's work. He would call Bunty, and they would take Billy and his wife out to the new Italian restaurant on St. James Beach for a lobster dinner. It would be a celebration and a token acknowledgement of the unfairness that no one on the island could discuss.

Fenwick and Bunty arrived early to choose a table at the front of the restaurant, directly by the sea with the sound of the

gentle Barbados surf. They sat down and ordered four special dinners of lobster from the Grenadines, with all the side dishes, and two bottles of a good French Chablis.

Bunty said, "This is entirely unnecessary, you know, making up for imagined ills. But there's nothing like American guilt to give the rest of us tasty meals. I could live a month on what those lobsters are going to cost. Yum, yum."

"It's only necessary for me. To let Billy know that I understand."

Billy and his wife approached the table. He was dressed in a well-tailored black suit with a black shirt, open at the neck. There was a glint of a gold necklace between the collars. Billy's wife was also in black, a stylishly long dinner dress with more golden glint around the neck.

"Mr. Fenwick, my wife, Gwen."

Fenwick said, "Gwen, we met at the South Beach Auction years ago. Good to see you again. This is my friend, Bunty Goodwin."

The evening started with rum punches for them all and then proceeded leisurely into the dinner. The prized denizens of the Grenadine waters were served with tails cut open, a dish of hot butter and lemon wedges. When the wine arrived, Fenwick raised his glass for a toast.

"For my dear guests, Bunty, Gwen and Billy, a long productive life and may the paintings find good homes. And for Carrington and the Tempro Heights, I guess the acceptable toast should be: more villas, more paintings."

Billy and Gwen silently raised their glasses. Billy said, "I hope you liked painting the Tempro cane fields as much as I did

the sea-coast cottages on the east side. There's wild surf and moody skies on the eastern shore."

"I did enjoy the Tempro paintings, Billy."

Gwen said, with a cultivated voice, "We really appreciate your taking on the Tempro cane fields, Mr. Fenwick. They asked Billy to paint them, but of course, he had to say no. The seacoast was what he and Carrington settled for. Only an off-island painter could paint those sugar fields."

"Why is that?" asked Bunty.

Gwen turned to look at Bunty directly. "We all loved old Mrs. Tempro. 'Abigail' is what we she told us to call her. She always had a pitcher of cool drinks for us schoolgirls on the way home, but that's not the whole story. No amount of lemonade and cushy summer jobs for the kids could make up for the truth. The Tempros from centuries past were the worst of the island's slave owners. There were horrible whippings and unnecessary cruelty in those fields. The family imported poisonous snakes to keep the slaves in their houses at night. The land itself at Tempro seems to call out with misery for any islander. My father looks the other way every time I need to drive him past there; he says just glancing might give the old suffering new life."

Fenwick said, "So Carrington knew I was the one for the scenes of the cursed cane fields, a dumb old North American".

"You didn't know. I'm afraid that's so."

"As a matter of fact, he probably wanted Billy to paint all sixteen pictures."

"Yes again, I'm sorry. Carrington insisted on having the fields of the Tempro estate and when Billy turned him down, he also suggested that you could do them."

Fenwick raised his glass again, eyeing the fine Chablis in the candlelight. "Well, at least Carrington had to pay handsomely for his duplicity."

"Indeed, yes. Our sixty thousand came just in time for us. Billy just yesterday bought us the cottage near Bathsheba so my father can stay with us. Not to change the subject, but this lobster is superb."

"My pleasure," Fenwick said. His face betrayed nothing, but even without looking her way, he felt the amused intensity of Bunty's flat gaze.

# The Encouragement
# of Zacariah Mendoza

**S**ince my early days in Santa Fe, Zacariah Mendoza and I were regulars at Crime and Punishment, the artist's bar on Canyon Road. I lived a short walk away and, as often happened, the painters would disperse at closing time with deeply impaired abilities. We imagined that great drafts of alcohol bred talent, opened the senses. Easily available drugs were just about to come on the scene for the same purpose.

On snowy evenings of late winter Mendoza and I waited until closing time to stagger into the pristine night. He customarily spent the night on my sofa rather than face the long walk to the other side of the plaza. We became good friends and allies in the difficult task of making a living at the easel.

A tall, robust man, Mendoza had an exuberant beard and mustache, shiny black. His hands and arms were usually covered with smears of paint although his clothes remained immaculately unstained.

Mendoza affected the dress of a European peasant of the 19th century. He wore a beret slightly cocked to one side, on the street and in the restaurant. Dark trousers were topped with an open shirt of coarse fabric and on his feet, sandals. How could

anybody not take him for a painter? He was, in attire, an amalgam of Monet, Van Gogh and Gauguin, everything good in a painter. In the summers when he painted bare-chested in shorts, the passersby whispered the name Picasso.

We were a group of young, untried painters in Santa Fe then. Men and women hoping to be seen, to make a difference in the world or merely to make a living. Although competition was keen, the group acted more for support than for rivalry. Mendoza had a big, open spirit to match his demeanor, encouraging other painters in their low periods and exuding good cheer.

He found a livelihood from art as simple as breathing. For ten years he painted street scenes and city landscapes in Santa Fe, often selling a canvas right from the easel to a passing tourist. His output was prodigious, four or five paintings a day for weeks on end. He was a landmark on Canyon Road, setting up his easel in busy locations up and down the road, with completed canvases strewn about on bushes and walls. Some days he sold them all.

Visitors took quickly to the affable Mendoza, chatting with him as he worked or suggesting changes in his picture. He often delighted the potential purchaser by adding a quick rendering of the tourist's spouse to the scene already painted. He was caught up in the joy of art, joy of life, joy of self. People loved Mendoza immediately, as he was quick to hug and kiss a stranger, always opening a closed circle to the newcomer.

He extended this generosity especially to other painters. Encouraging visitors on Canyon Road to explore down the long side lanes to other painters' studios, he stopped work to take them personally to the front door. He frequently guided his own potential collectors through the purchase of a canvas from a struggling artist friend.

"What can you lose? This painter could be the new O'Keeffe, or more valuable than Picasso himself. In addition, you have that wonderful and curious thing, 'pride of ownership,' while the investment grows. You win on every front. Come, I'll show you the way." They often went and bought.

Depicting the human form was an effortless exercise for Mendoza. He could draw figures in any mode of activity with a deft flourish of brushstrokes. These sketches were popular with buyers, so Mendoza never felt obliged to take his figural work beyond the sketch stage. Since a saleable nude sketch came in minutes, he never pushed himself into the finished paintings, the more resolved canvases preferred by galleries. Why try the hard when the easy sells?

He did many landscapes in the hills immediately around Santa Fe in all weather, an easy walk with easel and paint-box. He became a master of the white wine light of the Sangre de Cristo autumn. Typical Mendoza landscapes included a small house in the foreground with the surrounding foothills and mountains bathed in a low, pinkish light. *"Evening on the Camino," "Sunset Light, Upper Canyon Road," "End of Day, Monte Sol"* were among the canvas titles. They were painted with a beauty of color, composition and line and they earned him an envious income.

Early in the eighties, Mendoza won the Cinco Pintores Prize. Some early Santa Fe painters had established the prize with a small endowment seventy years ago; it had grown to a comfortable sum given for the single painting judged best of the year by a jury of peers. Since attention was now paid to current political correctness, the jury prided themselves in discovering minorities and the unpopular of all stripes.

Considering the number of paintings completed in Santa Fe each year, it was a prize any painter might covet. The money gave Mendoza a long trip to Mexico that winter, painting new subjects and colorful scenes.

I saw him at the bar the night before his departure, looking thoughtful. In answer to my question about what he would do in Mexico, he said, "My friend, I will look for something to do. Santa Fe has become a hothouse for me, too close, too humid. I need to stand back."

"Where will you go...to the coast?"

"No, inland near Oaxaca, I think. My father's people come from a village south of there."

"Will you look them up?"

"I hope to. If the village market there is good, I'll paint that."

This was the first juncture between Mendoza the happy-go-lucky street artist and the Mendoza of grander fame that would follow. A year later at the Halcyon Gallery, he exhibited his versions of the markets of southern Mexico. He pushed himself beyond those simple figurative sketches of the past to market scenes alive with groupings of people, dozens of brightly clad figures in Colonial Spanish settings. Instead of quick studies, he spent time to organize and refine each canvas. He continued his stunning use of light and mood, however, now with scenes of profuse activity and interaction.

The new paintings were built of happiness and sun and, not surprisingly, they sold quickly. All the local reviews were glowing and several national publications gave favorable notice.

The owner of the gallery, taking the opportunity to extract more profit from the motif, arranged a commission of large wall

panels of market scenes for the bar and lounge of the new Cielo Azul Hotel then under construction. The decorators would coordinate the construction of furniture and weaving of fabrics to match to panels.

Gossip had it that the price for the commission hit a local record. Another trip to Mexico was required. No one knew the exact financial details, but when Mendoza returned from his second sojourn in Oaxaca, he moved to a house on the eastside with a large new studio. Winter came and I saw his studio lights still on after midnight.

By spring, the word was out that his work on the murals was not going well. Otis Snavely, the local art columnist and failed painter himself, sniffed out troubles and reported "things going amiss at the biggest new studio on the Acequia Madre. (Who can that be???) The promised new panels for You-Know-Which New Hotel are being slashed and angrily repainted. In fact, there may be *nothing* to deliver this summer as promised. Has one hombre gotten too big for his britches...*pantalones cortos*, that is?"

Mendoza told me later that he finished the murals by May of that year, never slashing any part of them. The hotel's representatives had not seen the work yet, but finally a time was set.

He arranged the panels around the walls of his studio and awaited their arrival. The gallery owner was the last to arrive at the studio, after the architect and the interior designer. There were three people in all, plus the artist. The high-ceilinged studio held them without crowding, as well as what they had all come to see, the newly painted murals.

At first, there was no conversation. They mingled around the panels, then sat in the chairs provided, then mingled again.

**223**

More silence. The decorator, Fiona Barclay, consulted the pages of a notebook. Mendoza sat on a stool, off to one side observing this ritual of formal approval of his commission.

"The panels seem to be too big to fit the space. Are you sure of your dimensions?" the architect said. He hooked a yellow measuring tape on the top of one panel and pulled it down to the floor. "Hmm."

The gallery owner interceded. "They have been stretched archivally and are exactly as ordered. I've had them checked and rechecked. Their size is *exactly* right. I think the one on the left is particularly effective." She was trying to veer the morning into a new, more optimistic direction.

"What's this bit here?" said Fiona. She had an English voice and was the important member of staff at the designer's offices. She pointed with a long red nail. "I can't make it out. A bird? And where are the flocks of white birds in glorious flight, as in the invitation piece for your gallery show? Your people seem somewhat larger and more poorly dressed than I expected."

Mendoza remained silent, realizing her question was a statement.

"The colors are so cheerless. Where are the swatches we gave you?" Fiona continued.

More silence.

The architect jumped into the fray. "All these people appear to be loitering around unsavory parts of town. Where are the charming colonial streets and buildings? Is this a junk-yard in the background here?"

Fiona brandished a color swatch. "I am not sure how you achieved this muddy purple, so unlike our chosen shade. Did you

look at our samples at all? We will have to repaint the rest of the room entirely."

More silence.

Fiona's and the architect's statements were couched as questions to which answers were neither expected nor given. They moved from panel to panel, talking as if Mendoza were not in the room at all.

The gallery owner tried to be positive as the others continued to find fault. Mendoza watched silently from his corner. The negative breezes were growing stronger and soon a squall would come. It was out of his hands, however, and he just watched as the gallery owner turned up damage control, without much result. Finally silence again.

The architect plunged his hands in his pockets and took a spokesman-like stance. "To be honest, Zacariah, these aren't what we had hoped for. The tone is quite apart from the happy scenes we had in mind. There is a sadness here that just doesn't say Five Star Hotel. I can't image a guest enjoying a Margarita Grand Gold in this setting."

Fiona said, "I can't speak for tone, of course, but I can say that the color range is quite apart from our other arrangements. We're used to professional laser matching, and these...." Her voice trailed off.

The gallery owner said, "Zack agreed to use your suggested colors as a starting point only, and in the end he had the right to make all the choices. Please read our agreement, a gallery association standard, by the way."

But the injury was done. The massive machine of disapproval was rolling and would not be stopped. "I think we

need to sort things out and get back to you," the architect said. He and Fiona left.

The gallery owner sat down. "Zack, I don't know what to say. The work is first rate. Period. We have a contract with them for this. Let me call the lawyers and see what they say."

This was Mendoza's first major setback and the beginning of the big change. After the panels were officially turned down, each side consulted attorneys. The contract held up to the scrutiny, and in a few months, Mendoza and the gallery were paid in full. The hotel took delivery of the panels with no public comment, but carried out the decoration of the hotel bar with individual canvases from a popular local painter of cactus and desert scenes. No one outside of that small group from the studio had actually seen the panels, which now sat like crated hostages in the basement of the hotel.

Other painters wondered how bad *could* the panels be? Mendoza was a local hero, known for his talent and charm. Had something snapped in Mendoza? Otis Snavely took potshots at him several times in his column. Disgrace hung over Mendoza's head like a shadow that autumn.

He showed me one day the notebook sketches he had used to produce the larger pieces. They were extraordinarily good, exciting, and very reminiscent of the Mexican muralists of the 1930s. The figures had an Art Deco cast to them, sinuous and strong, which echoed the weighty message of the designs. In some way, they recalled the solid women of Picasso's classical period.

Mendoza had in his own mind not been able to paint the larger scale work to his satisfaction. He told me that the sketches lost their verve when enlarged. "Perhaps," he said, "I shouldn't

work in the heroic scale at all, as it just amplifies the faults that were there all along.

"Also, I saw the darker nature of Mexico and the Mexicans. The family I stayed with in Chiapas was all killed in the uprisings. It's not the same as it was. I don't see joy and sunshine in the markets anymore."

"And the hotel wanted that joy and sunshine. Not killings and darkness."

"Exactly. But where did I say that I must paint what I don't see?"

"Were they the right size?" I asked.

"Yes, but I enlarged the figures in the panels. I thought that would suit the gravity of purpose. Also I used black right out of the tube and heavy impasto."

"If they are anything like these notebooks, the paintings are wonderful … but the hotel people wanted something else, something more decorative. Fiesta dresses and red castanets, I suppose."

"Mexico has changed from the simple village of my father. Corruption, crime, and fear are waiting just around every corner. Life there is not innocent and noble anymore. Here was the chance to paint what is."

"It is a shame the hotel didn't see it the same way," I said.

The appearance of failure troubled him. Leaving the matter unexplained, he took the proceeds from the commission for another long winter stay south of the border, spending six months sketching his newly perceived darkness.

When he returned the following summer, he spent busy hours in the new studio. He stopped coming to the regulars' night at Crime and Punishment. Driving home along the Acequia Madre

after dinner parties that summer I could see studio lights still burning at Mendoza's. Clearly, he was aflame with some new series. When I asked to see his new work, he invited me to the studio.

He had lost weight, his beard and mustache trimmed shorter, his dress more modern and stylish, less influence of the European peasant. He seemed to have lost several inches in height, as well, but that can only be my impression.

Now the market scenes were darker still. There was alarm and fear in the markets now. Natives were running in all directions with baskets of fruit tumbling across the pavement. Women screaming and falling, a child in horror, chickens aloft and pigs running for their lives.

On one canvas, the reflection of military uniforms and rifles off to the left was a foil for the terrified natives fleeing to the right. Another had no people, only un-caged iguanas and chickens running helter-skelter through piles of corn and squashes splayed across the cobblestones, hooves of a fallen draft animal beyond fallen baskets, all under a smoke-stained sky. The terror on the faces spoke of the new Mendoza, Political Realist.

Six feet high by ten wide, these canvases could not be ignored, especially on the high walls of Santa Fe's most cutting-edge gallery. On opening night, there was a hushed quality to the gallery-goers, unexpectedly viewing these powerful panels instead of the cozier, warmer scenes from the Mendoza exhibit of several years before. The red dots appeared early in the evening and the exhibit was sold out before nightfall.

Many thought a new Goya had been born, screaming revenge for the Latin military might directed against innocent citizenry. Otis Snavely found much to grieve about in Mendoza's

new work, as expected. "Although technically brilliant, Mendoza's paintings of markets in turmoil reflect a sophomoric view of violence in Meso-America. He does not take us beyond a girlish sense of horror and offers no solutions. Totally irresponsible work. He incites us without giving us a direction to escape."

In the weeks following his exhibit at the Halcyon Gallery, he basked in the admiration of the town and came to appreciate fully what higher prices mean. He admitted to guilt in the profiting from the misery of others, but a new Range Rover appeared in the Mendoza driveway, nonetheless. I noticed a general upgrade in his wardrobe, as well.

In the year following this stunning show, Mendoza continued to paint smaller versions of these Markets in Turmoil paintings. He had Snavely to thank for the series title. Some were mere drawings on raw canvas, almost cartoons for the larger work. More drawings ensued, sienna chalk on Kraft papers, blood red inks on deathly white papers. Expensively framed, these smaller versions appeared in smart sitting rooms on both coasts and abroad. Prices soared.

And in the years beyond, the paintings and drawings got even smaller and more expensive as Mendoza squeezed the last harvest from this motif. He would never paint bolder than this, and the Markets in Turmoil turned out to be his life's motif, the one seminal idea of a lifetime. This was the subject matter that comes to mind first when the name Mendoza is mentioned.

He now works only on paper, mono-prints and multiple editions from the local lithography studio. Each is a study in tropical horror. The Cielo Azul Hotel has found the disgraced panels now in favor, the uncoordinated color and unsavory backgrounds forgotten. Installing them proudly on the bar walls,

the hotel designers exiled the cactus and desert paintings to service areas and upper halls.

I met some friends recently for drinks at the newly renamed Mendoza Room. Fiona Barclay was sitting with another group across the room. I walked over to her, "Fiona, look at what the decorators found in the basements. The Mendoza panels all in their cheerless colors and natives in awkward clothes."

"You're being sooo tiresome, dear. It was way past time for a re-do," she said. "But, don't they look smashing in here? Won't you join us?" Fiona's tone was decidedly uninviting.

I declined and joined my friends at another cocktail table. As the waiter brought our drinks we read the small tent-card that described the hotel's leading role in the youthful encouragement of this now world-famous painter, one of Santa Fe's living treasures.

# Leg-O'-Mutton Sleeves

Robert Quarterman, a painter living on the coast of Maine, received a letter from a Santa Fe lawyer. The letter states that Yiannis Patmos, also a painter, is dead and the will has appointed Quarterman executor of the artistic estate.

Quarterman's wife, Harriet, watched him read the letter. "Bad news from the looks of your eyebrows."

"Johnny Patmos is dead. Two weeks ago. Why did nobody in Santa Fe let me know?"

"If we watched television or read any of the papers, obviously we would have known."

"This is from his lawyer. He asks me to be the personal representative of Johnny's estate, that is, in all matters pertaining to his actual work. They will pay my way to Santa Fe to see the studios and the accumulated paintings. The duties will consist of decisions about the cataloging, with the actual work done by the studio staff. The fee would be a hundred thousand."

"You'll work hard for that hundred thousand, my dear, and you won't get any painting done for months."

"You are right, of course. But I think I ought to do it."

"Well, you were his best friend. Even though you didn't get together very often."

"I will miss old Johnny. Queer duck, really, but aren't we all?

"Do you want me to go with you?"

"Absolutely, if and when I actually start the executor's work. The lawyer asks me to come now to Santa Fe to make the decision. A first class ticket, no less. The cataloging will be done later in a month or so. "

The next day Quarterman flew to Albuquerque and was met at the gate by Delta Patmos. A car and driver waited to take them the sixty miles north to Santa Fe .

"Oh, Robert, I'm so glad you're here now," Delta said as they were leaving the airport. "Things will be right with you as executor."

"Why wasn't I told that John was sick? *Before* he died?"

"You'll have to ask his companion."

"Still those bad feelings between you and Margaret? I would think you had resolved everything by now. After all, Delta, he remained married to you all these years, despite his various companions. You are his widow, not Margaret," Robert said.

"I've never stopped loving him."

"That is true."

"That's why I'm glad you're here. You remember the old days and what it was like in New York when we were all together. It's been so difficult, Robert."

Delta was still beautiful, but the years in the western sun were starting to take its toll on her complexion. She had the ability to fill her eyes with tears on demand, a talent Quarterman noted early on. He thought of the fake stage snow in productions of *La Boheme*.

"I know it has, dear, and I'm sorry."

"So you'll say 'yes' about the executor-ship?"

"I haven't decided yet. That's why I've come. It'll take me a day or two to decide. By the way, Harriet sends her love and, of course, her condolences."

"Harriet remembers how it was, too. I always loved her."

"They were good times, weren't they, those years in New York?" Robert said. While the car took them the miles to Santa Fe, they reminisced about their student days when all four were young and full of hope and excitement. The more Delta talked the more Quarterman knew that he liked the elegant Margaret better and that the executor's job was going to be full of difficulty and emotion.

As they turned into Canyon Road, she continued, "Now I just want everything about Patmos's estate settled and I am sure you are the one to do it." Quarterman thought of John as John or Johnny, so when had everyone else started referring to Yiannis Patmos only by his last name?

He thought about Delta in the years before, especially remembering her coolness and expertise in the domestic crisis when Patmos openly took his first mistress. These were the big money years for Patmos, his ego at high tide, when everyone in the world wanted a Patmos painting, or so it appeared.

Delta was hurt and embarrassed about being replaced in her husband's affection, but she was quick to point out to Patmos he had much to lose in divorcing her. Perhaps they could work out a *modus vivendi* and still stay married. Of course, that arrangement was one wherein Delta got a major monthly stipend, a handsome portfolio and the New York loft in her name. Remembering her finely honed ability for self-preservation, Quarterman said, "I'm sure it will all work out, Delta."

In the years that intervened between that first mistress and now, there had been others. Delta managed each new instance ably, adding to her financial position in the same measure as Patmos enlarged his libidinous horizons. As Patmos's income soared she saw to it that her share soared as well. Delta would now revel in her new role as the widow artistic, keeper of the flame. Stylish black outfits were surely being shipped from New York, Quarterman was sure.

"I received a copy of the will. John was very generous with a long list of people and institutions," he said.

"Yes, it seems the whole world benefits. There were some obviously overlooked, however."

"You were handsomely provided for, by my reckoning. Who was overlooked?" said Quarterman.

"He didn't mention my brother or father at all, after all they have done for him. They just gave him all those years of working in his studios for no more than minimum wages."

Quarterman remembered her Brooklyn family from the days in New York. A more worthless bunch, he couldn't imagine. They lounged about jobless at the Soho studio, asked Patmos for loans, and often needed to be bailed out for misdemeanors.

Delta continued, "Then he throws away a hundred thousand for Lucy, his cleaning woman. I just don't understand. Furthermore, he should not have been quite so generous with Margaret and her brood."

Quarterman said nothing. He thought about Margaret St. James, Patmos' companion of many years and a Caribbean beauty. It seemed only right that she should be a major beneficiary. She had shared the difficult later years with Patmos, when he traveled worldwide in the pursuit of his art.

**234**

Margaret was a woman of simple but graceful tastes, loving her home and family, and much preferring to stay at home in Santa Fe to being his official consort at international solo exhibits. If her natural charm did not win over the guests, her Caribbean cuisine did. Everybody thought Patmos a very lucky man.

The will gave Margaret the large house on North Hill that they had shared for many years, half the remaining paintings, and liquid assets ample enough to support her and their children. That seemed to Quarterman to be a very reasonable bequest.

Delta inherited the working compound of studios and houses on Canyon Road, a quarter of the remaining paintings and a smaller total of liquid assets. As they turned into the gates of the compound, Delta said, "I don't know what to do with this place." She gestured with a circular hand movement. "It was always half mine anyway, so maybe I will make it a place for my own family. They'll have little else from Patmos, you know."

She personally led Quarterman on a tour of the staff, studios and outbuildings. The compound consisted of state-of-the-art studios and storage facilities, now closed and locked by the probate court with vast numbers of the more recent Patmos finished paintings. His incredible energy during his later years yielded hundreds of paintings annually and countless stacks of works on paper. The old adobe outbuildings contained earlier canvases leaning against the walls, dozens deep. Several houses were reserved for staff and guests, extensive gardens, and Delta's own large house completed the compound.

After the tour, Quarterman asked to be left alone in the studios, where he mused over his days with Yiannis Patmos forty years ago. The two met in art school in New York, where they quickly established a relationship of friendly rivalry, punctuated

with the acrimonious interludes they both enjoyed. The friendship had survived their bickering and in the years following art school, they fine-tuned their fundamentally different views of what constituted "Art."

Patmos fervently espoused all non-objective art as the only new direction, the only art that mattered. Significant art must be abstract and nonobjective. Realistic art was not to be taken seriously, merely for postcards. His own paintings reflected this philosophy.

There were several easily recognizable periods or "clusters," as he preferred to call them. It was the last cluster that catapulted Patmos to international fame. They were all pale suggestions of mist and clouds and they were titled for nuclear power plants around the world; Four Mile Island Nos. 1 through 94, Gulf Shores Nos. 1 through 50, Maine Yankee, Diablo Canyon, Bombay Shoals. The critics were thrilled with the environmental sensitivity of the work and collectors lined up to own these stylish political statements.

Patmos appeared at many rallies against the electrical generation industry worldwide. He was forcibly ejected, with massive media coverage, from France in 1980 for leading a demonstration against the opening of a new facility in the *Haut Savoie*. He was also *persona non grata* in a dozen other countries. No critic dared to fault his activist politics. Painting prices soared while Patmos's reputation grew as a prickly advocate for antinuclear movements throughout the world.

Patmos moved to Santa Fe, buying the three-acre compound on upper Canyon Road. He lived and painted in the existing buildings, rambling adobe houses. As time passed and success mounted on success, he added several new art studios

and a new residence. He built a lithography facility to produce numbered prints of his popular images. Smaller buildings were put up in the late 80s to have nearby quarters for his lithography staff. Yiannis Patmos had become big business, so a business office was the latest addition, which he candidly called The Counting House.

Robert Quarterman remained on the East Coast, housing his studio and growing family in a succession of rural rentals. Recognition came slowly in his more objective path, painting portraits of his own family life and country scenes on the outskirts of New York. He studiously ignored the tumult of Abstract Impressionism that all his friends and fellow students investigated. His wife, Harriet had a small legacy that saw the family through the sixties while he happily recorded the small world around them.

He was not completely forgotten, however. Several galleries in New York bravely championed his work, albeit at markedly lower prices. By the early 80s the winds were changing for Quarterman with the odd snippet of praise here and there. A New York Times critic found "an appealing melancholy to his new work, adding intellectual interest and avoiding the saccharine nature of what went before."

He had a deep, cultivated voice and could express himself in accessible, well-turned phrases. PBS asked him to narrate a long documentary on the Post-Impressionists, which spread his name and work across the nation. This association with Bonnard, Vuillard and Matisse, even as a mere voice-over, gave a subtle rise to his reputation.

Indeed, the 80s were good to Quarterman. He painted a group of portraits of his family in period 18th Century dress. Harriet was in voluminous white cotton gowns with leg-o'-mutton

sleeves, the children cavorting nude on a grassy knoll or in the gentility of light cotton stockings and buckled shoes. The paintings recalled the English portraitists, happy pink-skinned people in agreeable country settings.

When success came at last for Quarterman, it did not come in the great measure that Patmos had been accorded. The two men continued to respect each other for nearly forty years, yet they savaged each other's work in national art publications and whenever they found the chance on television interviews. Both were sought out for their articulate, warring views.

In a television interview several years ago a particularly prodding arts reporter brought the two men together. She started the program with a leading and provocative question for Patmos: "Mr. Quarterman's last show was a sell-out with rave reviews. What is it you don't like about his work?"

"I admire Quarterman dearly as a person, but he is, alas, misguided. We have had continued difficulties over our views of art, but I love him still. What distresses me most is I think that he may have taken *willfully* the wrong path early on and even with his great ability cannot find his way out. Poor dear."

"…Willfully the wrong path? Exactly where is that path going?" she prodded.

Patmos sighed. "Yes, it's willful when he knows the truth but ignores it. I, and everybody else who counts, know that art is an abstract pursuit, very like music. The great works of music don't imitate life by mindlessly reproducing bird song, thunderclaps and horses hooves, but instead comment upon life with a lyrical new language. Abstract language. It's made up of unspoken words in the infinity of mental space.

"As a Mozart Symphony in C Major radiates sunniness and good cheer, music can also be dark and sparkling like Brahms or Mahler. Quarterman has chosen to paint merely the shallowness of the birdsong and not the great ideas underlying it."

Quarterman could be silent no longer. " Nonsense! I'm perfectly capable of describing what I paint, thank you, and you're miles off base, Patmos. Painting is the physical result of seeing, seeing with joy and excitement like Matisse or with horror like Goya or, sometimes, with pity like Picasso. Good painters paint with their eyes. Since we can't actually see ideas, maybe Patmos should have been a composer instead, writing art songs about radioactivity and ditties with cute rhymes about fall-out.

"I think a painter must see with his heart, see something, see someone, someplace. I paint the people I love, people who excite me, amuse me. Painting aspires to depict with color and line the people and objects and places that make your heart sing. Not the sad gray afternoons of mere ideas."

The interviewer followed with "Tell us more about the sad gray afternoons of Mr. Patmos."

Quarterman was warming to his subject. "Ideas belong on a page, in an essay. If you are communicating political thought, isn't the printed page the more direct way? Why waste canvas and paint as Patmos does? I think he should buy a typewriter, a cheap one would do, and throw away his brushes."

Both Quarterman and the interviewer turned to Patmos. He took a long pause before answering, then replied "Ideas move mountains; aspiring to depict an idea is a noble thing. Aspiring to depict a chicken or a peasant or a farmhouse is not. Even when you put them in period dress like Quarterman does, chickens cannot make the mind tingle and the viewer rejoice."

The interviewer: "So you think Quarterman paints trivial paintings?"

Patmos: "He attempts to ennoble the simple life, certainly, by putting it in long skirts and fancy sleeves. His beautiful technique is perhaps more suited to the centuries past. We are concerned with modern ideas now, what man can aspire to. How much better to go right to the soul of it with abstraction. The idea is half-digested in the mind already, the sooner to go directly to the heart.

Quarterman: "Half-baked in the mind, you mean. What a crazy notion. Good art is not modern or old-fashioned. It is timeless as the crowds in the museum rooms of the Cinquecento Masters testify. If non-objective art is the joy of the people, why are there crowds each day in front of the Irises of Van Gogh or the Mona Lisa of Da Vinci?"

The interview continued with the two men thrusting and parrying, until the hour came to an end. Walking out of the studio, Quarterman put his arm around Patmos shoulders. "I think you were in good form today, Johnny, and clearly won this round. You made it almost appear you were on the side of reason and right. Curious, that."

Patmos smiled. "Perhaps too much heavy pasta for lunch, my friend? Not so agile in front of a camera anymore? Mind filled with family things, huh?"

"Keep looking over your shoulder because I might be gaining on you. The wagons of truth are rolling your way," Quarterman said. They smiled and parted.

Several years later, Margaret and Harriet organized a month of adjoining rental houses in Barbados. The Quartermans had along several of their grandchildren, and Patmos and

**240**

Margaret included two of their own children. As the women and children took to the clear waters, the two men remained under the umbrellas to hone the fine points of their differences, sometimes reminiscing, sometimes quarrelling.

It occurred with amusement to the two as they watched their families bonding on the beach, that although they had taken different paths they seemed to have arrived at the same place. Art was an unexpected vehicle for arriving at a comfortable old age. Neither of them could have anticipated discussing their portfolios and property taxes forty years after art school. They agreed to visit Barbados more often.

Quarterman now thought about their month on the island, just a few years gone as he sat in Patmos's studio. He decided to accept the offer to become the Patmos executor. He went to see Margaret on North Hill before leaving. She greeted him without tears, but Quarterman saw a sad heart.

"Johnny died so quickly. He had only three weeks notice from the doctor and it was over," she said.

" I'm so sorry, my dear. I wished you had called me. I had no idea until I got the lawyer's letter."

She said, "I asked him several times to let me call you, to have you come, but he only said Robert will understand. I've seen to it. What do you think he meant?"

They talked about their times together, happy times from the past. Quarterman saw Margaret as a strong survivor, able to face whatever comes. She told him she would move the family back to Barbados soon, sell the house in Santa Fe.

Harriet and Robert Quarterman returned to Santa Fe for an extended stay while he compiled the inventory of artwork and assets. Each painting in the estate must be examined and

numbered under Quarterman's scrutiny, as per the will's request. The studio assistants brought each painting before him while it was numbered and entered into the estate logbooks, condition noted personally by Quarterman. After two weeks of intensive work, nearly half the paintings were examined with the works on paper yet untouched.

As Harriet and Quarterman were washing the dinner dishes one night, he said," You know I've been looking at Johnny's work for days now. There are many I quite admire."

"Really? After all those years of putting them down."

"That was more a posture we were locked into for media occasions. I never doubted his talent."

"You mean you were a hypocrite all this time? Saying one thing and believing another," Harriet said.

"No, not at all. I guess I just hadn't looked at his work that much. There is a stillness beyond description in some of them. The soft palette and amorphous shapes begin to beguile you after a while. They are urbane and utopian, two very good qualities."

"So you might have been too closed to his ideas?"

"I think so. I also think I would like to come back to Santa Fe this fall and start a series of abstract paintings myself. With Johnny, the apparent adversary, now gone, my working on non-objective pictures would not be mimicking, but something like a tribute to his ideas."

"A winter in Santa Fe would be fun. Let's do it."

The next morning he was anxious to be done with the estate duties and onto painting again himself. Although it was a weekend and the staff was off-duty, he started personally the inventory of work in the old hacienda, six rooms jammed with paintings face to the wall.

In the third room, late in the day, he turned the first piece to affix the estate number and was astonished to see a portrait of Margaret St. James and the children. It was quite similar to what Quarterman had been painting all these years. He almost laughed at Margaret and the family in white cotton with leg-o'-mutton sleeves and shoes with buckles. Quarterman turned around another canvas of a family group, and another, and finally a dozen of the anomalous works. When had Patmos painted these?

The dates on this figurative work were all in the recent years, all after their month in Barbados. The canvases were hidden away, unspoken of, out of view in the old hacienda. Had he lived, Quarterman wondered, would Patmos have revealed these? And to whom? Patmos, as the end approached, knew his old friend would find them if he accepted the executor's tasks and now quietly acknowledged his respect for Quarterman's talent from the grave.

Printed in the United States
26100LVS00002B/1-15

9 780865 344266